"Finally. A well-written and en
guidance to unlock what's sta
in very human terms, Comp
examples to give high perforr

MW00478319

MARY MCDOWELL, CEO, Mitel Network...

"This insightful yet unusual book will be powerful for anyone who is seen as successful by others but inside feels stuck, insecure, or unhappy. It reveals how transformational it can be to work with a great coach while also helping you tackle your own challenges. Most of all, you'll realize that you are not alone in your struggles."

SUZANNE SKYVARA, VP Marketing & Editorial, Goodreads

"If there's anyone who knows how to excel under pressure, it's Kate Purmal. *Composure* should be required reading for those of us who have to lead in complex high-wire environments."

MARK LEVY, Founder, Levy Innovation LLC; Author of *Accidental Genius: Using Writing to Generate Your Best Ideas, Insight, and Content*

"With this important book, Kate Purmal shows us how WE CAN replace self-doubt, inadequacy, and worry with confidence, self-worth, and courage. She is a brilliant writer and teacher who provides volumes of warm, yet practical guidance and advice to help women accelerate their path to the C-suite and boardroom."

ROBIN TOFT, CEO, Toft Group, a ZRG company; Cofounder, We Can Rise, Inc.; Author of *WE CAN: The Executive Woman's Guide to Career Advancement*

"*Composure* is both practical and inspirational. Through three key steps— awareness, resolution, and transformation—it guides the reader to new heights of self-awareness and greater outcomes!"

TERRY KRAMER, Faculty Director, Easton Technology Management Center, UCLA Anderson School of Management; former CHRO Vodafone Group Plc and President, Vodafone Americas

www.amplifypublishing.com

Composure: The Art of Executive Presence

This paperback edition was printed in 2022.

For more information, please contact:
Amplify Publishing an imprint of Mascot Books
620 Herndon Parkway, Suite 320
Herndon, VA 20170
info@amplifypublishing.com

Library of Congress Control Number: 2021912110

CPSIA Code: PRV0322A
ISBN-13: 978-1-63755-422-7

Printed in the United States

To my mother, Marilyn Jean Purmal,
who taught me kindness, compassion, and empathy
and nurtured my creative spirit.

COMPOSURE

THE ART OF EXECUTIVE PRESENCE

BY KATE PURMAL

with LEE EPTING & JOSHUA ISAAC SMITH

TABLE OF CONTENTS

PREFACE

Between stimulus and response there is a space.
In that space is our power to choose our response.
In our response lies our growth and our freedom.
· Victor Frankl ·

When I am in need of inspiration, I set out on a walk with my dogs and listen to an episode of the podcast *On Being with Krista Tippett*. To invite serendipity, I hold an intention in my mind, then scroll rapidly down the list of episodes on my phone, tapping to select at random the episode that will bring me the creative spark I desire.

With the intention to come up with a title for this book, I notice my finger has stopped on the podcast with Mary Catherine Bateson, a Professor Emerita at George Mason University and the acclaimed author of the bestselling book *Composing a Life*. A scholar and scientist in her own right, Bateson is also the daughter of the great anthropologists Margaret Mead and Gregory Bateson.

In the interview, Bateson talks about a pivotal point in history. In the early 1970s women who had previously given up higher education or employment outside the home to start families "were going back to school, back into the workplace, trying for the first time to combine family life with an active career and finding it very difficult . . . [they were] talking

about *juggling*, which to me is a terribly anxiety-producing metaphor."

That sentence resonated with me deeply. In our practice, my associates (Lee Epting and Joshua Isaac Smith, both of whom you'll meet later in this book) and I work with ambitious and high-performing women—and men—who feel like they've lost control of their lives. They *struggle* to feel confident and successful as they rise in their career and experience undue stress and anxiety that spills over into their personal lives. Quite often their very existence ends up best described in anxious metaphors that are eerily similar to those that Bateson talks about. *Hmmm. Are we going in the right direction?* I wondered. *Shouldn't the challenge to have both inspiring work and fulfilling lives be getting easier instead of more difficult?*

I was awestruck when, as if she read my mind, Bateson provided a beautiful, poetic, alternative to the struggle: "I like to think of men and women as artists of their own lives, working with what comes to hand through accident or talent to *compose and recompose* a pattern in time that expresses who they are and what they believe in, making meaning even as they are studying and working and raising children, creating and recreating themselves."

And that's when it hit me. *Composure*. Composing is the creative act we bring to our clients. We teach them new solutions and practices to give them greater control of their lives. As a result, they become more resilient, less reactive, and better able to navigate the pressures and challenges at work, leaving them with more energy and time for their families and personal lives.

When our clients get stuck in a demanding work dynamic that feels out of control and leaves them exhausted with no energy for their family and no time for themselves, they're

desperate to "fix" the problems at work to find relief. But rarely do they have the ability to completely control their work environment. They can't magically change the way their boss treats them or reduce the demands on them to perform and do more. Nor can they eliminate the biases and micro-aggressions they experience from coworkers and colleagues. The only real solution (short of leaving, which many do) is to make *internal* shifts so they become less reactive to the stressful, anxiety-producing, energy-draining dynamics that make it difficult to be present in their home lives. In other words, *they need to compose themselves.*

Fortunately, leading people to find relief from unrelenting career pressures is the holy grail of the work that Lee, Joshua, and I do. Composure is the end game. It's the trait that the women (and men) we work with ultimately achieve, which leads them to a greater satisfaction and well-being. But here's the kicker . . . most of the time they don't realize that's what they're actually looking for.

If you look up *composure* in the dictionary, you'll see this:

> com·po·sure | kəm-ˈpō-zhər : a calmness or repose especially of mind, bearing, or appearance : SELF-POSSESSION // *The witness started to break down, then paused and regained her composure.*

The clue to why composure is so important is not in asking what it is, but rather in asking what *it is not.*

That question is best answered by giving you a sneak peek into the Impostor Syndrome, which you'll learn a lot about when you read the rest of this book. I don't want to tip my hand too much right now, so let me just offer you this to make my point: The behaviors associated with Impostor Syndrome are a lack of confidence, rejection sensitivity, perfectionism,

depressed entitlement, and feeling like a fraud. And how are all those annoying traits triggered?

They're triggered when we lack composure. When we are overly reliant on external validation and overly reactive to external pressures—driven by fear of things like judgement, criticism, exclusion, threat, punishment—we lose our composure. And that's not good, because with composure you find grace under pressure . . . without it you're defensive and anxious.

Even though composure may sound like a great idea, most people discover it's not that easily found. Like anything that matters, it takes work. Composure is something that you must *learn* and cultivate by creating strong personal boundaries, building confidence, developing self-awareness, and connecting and aligning with yourself and your values. And that's what we teach our clients.

Yes, some argue, "*Shouldn't company leaders provide a safe and supportive work environment, so we don't feel so stressed, anxious, and out of control?*" Of course that would be the ideal solution, and we're deeply committed to seek change to bring safety, equity, and inclusiveness for all. Yet we know this will take a while. In the meantime, not all of us have the luxury to opt out of a suboptimal workplace. For those, cultivating composure brings relief because it makes even difficult environments more tolerable.

Unfortunately you can't feign composure, just like you can't project confidence or credibility when you don't feel it on the inside. Lee, Joshua, and I do not advocate that women and those in the minority (the *out-groups*) be inauthentic in a desperate attempt to navigate a hostile workplace environment just so they safely fit in with the majority (those in the *in-groups*). Although we cannot control the environment we work in, we can control how we show up in that environment.

With composure, we aspire to empower our clients to remain calm and curious and to feel more confident and grounded as they find ways to experience well-being in spite of their circumstances.

Breaking through the Impostor Syndrome creates greater resilience in *any* environment. Composure challenges you to go within to gain self-awareness, confidence, and appreciation for who you are. It calls on you to connect to what you value and align your actions with what you know to be in the highest and best good for everyone. This not only encourages you to celebrate your unique contributions, but also emboldens you to bring them to the table without restraint.

One of the things we tell our clients is, "You don't get what you deserve; you get what you tolerate." When you are fully authentic and confident and operate as your best self, you no longer tolerate environments that attempt to diminish and stifle you. As you contribute energy and passion to create high value and high impact, you bring change when you challenge those around you to rise to the occasion—and often they do. And when organizations and leaders fail to rise to the occasion, composure gives us the ability to accept the situation as it is and then vote with our feet. In other words, composure creates *agency*.

Everyone's road to composure is unique, but just knowing a road exists is a good start. How you navigate that road is up to you, and I hope this book helps. However, no matter what your journey looks like, I can confidently share with you where I think you'll end up. When you cultivate composure, it will lead you to greater success and happiness.

And really, at the end of the day, isn't that what we *really* desire?

– *Kate Purmal*

CHAPTER 1

THE HIGH ACHIEVER

When Sarah first called me, she sounded confident and upbeat, but I could sense she was struggling as soon as we got the introductory pleasantries out of the way. The reason she reached out eventually became clear when she sheepishly admitted to me, "Honestly, I don't feel like I deserve all the success I've had in my life—is that weird?"

I could tell she felt awkward seeking out coaching in the first place, let alone copping to such a vulnerable confession with someone she'd just met. By her own admission, she had always been a high achiever. Now here she was, questioning if she really deserved any of that achievement.

"I'm terrified," she quietly disclosed.

"And how is that?" I asked.

"I think I've just been lucky . . . you know? I've always been on the fast track in my career, and I've always got whatever I went after. But recently I was passed over for a promotion to vice president, and it's really shaken my confidence. Now I feel stuck, and I don't know what to do or where to go from here."

When she walked into my office a week later for our first session, she appeared smart and interesting, like she had it all together. This made her earlier confession on the phone all the more confounding. At age thirty-four, with her dark curly hair and kind brown eyes, she looked like a slightly more mature and worldly version of the girl next door. Although she carried

herself with confidence, her presence was completely non-threatening, emanating kindness and warmth.

As she shared her story, I could see her inner struggle take shape. Outwardly, Sarah seemed like the kind of woman who could brush off being passed over for a promotion. But inwardly, the rejection hit her like a brick wall. Though she couldn't articulate it yet, I knew all too well where this was heading, which was this: *Sarah's motivation to work hard and succeed was fueled by her relentless fear of failing. And this fear made her insecure and reactive and prevented her from ever internalizing or accepting her own success. With each new hurdle she cleared, her fear of failing at her next challenge grew alongside her fear that she didn't deserve any of it.*

We Look at History to Change the Future

Even though life's issues seem to appear out of nowhere, usually they've been fermenting for quite some time before they evolve into full-fledged problems. I asked Sarah to give me a little history that led her to where she is today, just so I could gain some perspective.

"Well, it's only been lately that I've lost my footing. Up until now my life really hasn't been all that unusual," she began. "I'd say I had a typical childhood. The only thing noteworthy is that my parents divorced when I was twelve, so things got financially tight, but we managed."

"What about high school and college?" I asked.

"Oh, I loved high school," she replied with enthusiasm. "I got involved in everything. So much so that I was able to get scholarships to go to University of California, Davis, where I got a BS in bioengineering. And then I got my dream job after that."

"Really? How did that happen?"

"I got hired right out of college at Illumitex, one of the biggest biotech companies in the world. I was excited to work for Illumitex because they developed innovative therapies and pharmaceuticals that addressed treatments for cystic fibrosis, rheumatoid arthritis, and epilepsy, which runs in my family." Sarah's face lit up with pure joy at the thought of those carefree early years of her budding career. "I bought a nice car, moved into an upscale neighborhood, went out every night with friends, and took fabulous vacations. By age thirty I was debt-free, drove a cute sporty convertible, and owned my own condo. Life was easy."

Sarah's stellar rise up the corporate ladder at Illumitex was rapid. Everyone wanted her working in their department. But instead of deciding which projects she'd personally like to work on, she always went with the high-profile projects that generated a lot of money and visibility for the company . . . and for herself. "Yes, it sometimes meant long hours and lots of business travel," she admitted. "But I always managed to pull it off and make everyone happy. I guess, back then, I truly loved the work. So even if it got hard, at the end of the day, I found my job rewarding."

Soon Sarah's reputation spread, and after eight years at Illumitex, other biotech companies eagerly courted her, including a little, up-and-coming medical device company named GG Group. Better known in the industry simply as GGG, this organization was almost like a Silicon Valley video game start-up, rather than a traditional healthcare company. The young, whip-smart techies at GGG used 3D printers and good old GPS technology to create simulated, presurgery

"operations" (models) that helped surgeons do "practice runs" to determine the least invasive paths for risky surgeries.

The work culture at GGG was more like that of Google or Apple, with an intense, yet fun and collaborative, atmosphere. And they all hung out together outside work, frequenting happy hours and beach barbecues. And since the company made lots of money, the extracurricular activities, such as holiday parties, company picnics, sales retreats, and product launch celebrations, were off-the-hook fancy and fun.

Given Sarah's bioengineering degree and project management success at Illumitex, GGG offered Sarah a position in corporate development, which she found far more interesting than simply pushing to get a product out the door. Plus, every time Sarah put off GGG's recruiter, GGG offered her more money. Finally it got to the point at which it was ridiculous to say no. Sarah jumped ship from Illumitex to GGG and never looked back.

At first Sarah loved being at GGG, mainly because she worked with an amazing team. On top of everything else, she counted herself as fortunate to work for an innovative, cutting-edge company that actually did good things in the world. Plus, as a bonus, she met the man of her dreams at GGG, when she wasn't even looking to date.

Juggling Career and Family

About a year after she was hired, Sarah met Allen while at a GGG corporate retreat in the Bahamas. Allen was a lead engineer she knew casually at the office, but once they were away from the daily grind of work, drinking piña coladas in a tropical paradise, they became *better friends*. Putting work first at the retreat, they decided to meet for drinks after they got

back home. Drinks led to dating, dating led to a proposal, and a year later they were married. "We honeymooned back in the Bahamas where it all started," Sarah added dreamily. "I have to say, it was magical."

Now in her thirties, Sarah had some new decisions to make. "I knew that if Allen and I were to have kids, we needed to get on that bus soon." Within a few years Sarah and Allen were the proud parents of a newborn daughter and an eighteen-month-old son.

At that point, even though Sarah's responsibilities at work were the same as before she had kids, suddenly work seemed more burdensome than ever. "My job was challenging and demanding, to say the least," said Sarah. "It took a lot of energy to maintain the level of productivity and enthusiasm I had established at GGG. I had set that bar high. But now I also had responsibilities at home that were relentless and exhausting. I struggled to be present and enjoy my children, but I always had the burden of work in the back of my mind. And conversely, when I was at work, I worried about my kids. It was really hard. I wasn't sure *what* to do."

When her boss told her they were opening up a VP slot above her and encouraged her to apply for the role, she did so with trepidation. She didn't really feel quite ready for this step up and worried about the toll a promotion could take on her family. Regardless, she put her hat in the ring. "I assumed I'd figure out how to manage it all, and that I had a pretty good chance of getting the job. After all, why would my boss encourage me if I wasn't a strong contender for the role?"

But Sarah didn't get the promotion, and it crushed her. "The CEO told me that because the company was growing so quickly, he and the board decided they needed someone who

was already operating at a VP level," she confessed, her voice heavy with disappointment. "And since he needed to focus on the next round of fundraising, he wouldn't have time to mentor and coach me to bring me up to speed."

Instead, they hired a man Sarah had worked with when she was at Illumitex, and she knew he was totally wrong for the job. "It's not that he was a bad guy," she said. "It's just that I was definitely equally, if not more, qualified. I don't know why they couldn't see that."

"So aside from the title, do you have any idea why he got the job and you didn't?" I asked.

Sarah paused to think for a moment before she continued. "He's composed and has a solid presence. He is very charming and can talk a good game. My guess is that he convinced them that he was some sort of strategic visionary," said Sarah, shaking her head in dismay. "But I had interacted with him plenty of times, so I knew the truth behind the façade. He projects a lot of confidence, but he's all talk, no action, and in over his head."

And now this guy was her boss.

And to make matters worse, the corporate environment at GGG had become more challenging for Sarah due to the company's rapid growth. This additional stress made juggling family life with her career even harder. "The trade-offs with my family were tolerable when I at least enjoyed, and felt successful in, my work. But after being passed over for the VP role, I dreaded coming into the office." Not only was she swamped, her confidence had taken a big hit. Not to mention, she simply could not stomach working for this man. Now that it was him (and not her) who stepped into all the strategic

meetings with the executive team, she no longer had her finger on the pulse of the business.

She quietly put the word out that she was open to new career opportunities, and within a few months, several executive recruiters contacted her. She had a couple of interviews, but they didn't go well. Inside, she worried about how she would find the extra time required to come up to speed in a new job *and* meet the demands of her family. "I think I've lost my mojo," she whispered, holding back tears.

Shaken, Sarah felt if she could just get back in the saddle and ride awhile, she'd be able to settle into a place where she was comfortable once again. But in her situation, the demands of her family and work combined were too much. She traveled a lot, didn't have time to eat as well as she'd like, and almost never had time to exercise, let alone time to read a book. Between her work and her family, she simply had no time for herself.

"If you could wave a magic wand and get exactly what you want out of life right now, what would that look like?" I asked.

"Well, I know I *should* want to find a new challenge, maybe join an emerging company that leads the market with new technology and has a good potential upside in terms of money and stock," she said thoughtfully. She paused before she added, "But now, after what's happened, I just want a new job, *any job*, and to work for a boss I can tolerate, maybe even respect, at a company I like. I just want to settle back in and prove myself once again."

"So you can get your confidence back?"

"Yeah, I guess so. Right now I'm just so burned out. I used to love coming to work every day, and I didn't mind working hard. But since the company passed me over for that

promotion, I feel like I'm always second-guessing myself and that my work isn't valued," she confessed. "That, coupled with my unrelenting workload and the fact that I work for someone I don't respect, it's just too much."

After a pause, she revealed what she really wanted. "There are moments every day where I just feel like giving up, taking a break, going on a retreat, or taking a long sabbatical. I need something, anything, to restore my energy. Unfortunately, as the main breadwinner for my family, I can't afford to take time off. So changing jobs feels like the best option now, even though I know that it will take even more energy for a few months until I settle in."

As Sarah continued to up the ante in her career, she worked harder and harder as the jobs and challenges became bigger and bigger. But now, after working tirelessly for so long, the credibility and confidence that Sarah had spent years cultivating had suddenly disappeared.

Self-Determination Theory

We know from our research that many high performers like Sarah learn from a very early age to breathe oxygen from external validation. Over the course of their lives, they've perfected the art of tailoring their performance to secure praise and avoid criticism (or worse yet, failure) at all costs. They have been the team captains, the class presidents, the honor students, the star employees, the wunderkinds, and the prodigies, and they have rarely experienced being perceived as anything less than exceptional.

So when they falter, it's devastating. Their sense of self comes crashing down. The playbook they've used their whole life suddenly stops working. And it's terrifying.

I knew from my decades of experience coaching women like Sarah that the first and most obvious problem is how her motivational strategy has developed over the course of her life. It's a phenomenon common among high-performing people that's explained beautifully by Self-Determination Theory.

Self-Determination Theory defines the motivation behind how people move themselves or others to act. Self-Determination Theory posits that there are two kinds of motivational strategies: intrinsic (internal) and extrinsic (external). Most people employ a blend of the two. But in examining the extremes, we better understand how these motivational patterns work.

Starting at a very early age, high performers, like Sarah, develop and strengthen a motivational pattern throughout their lives in which they constantly seek rewards from external factors, such as grades, accomplishments, titles, evaluations, and the opinions of others. As this pattern of collecting performance-rewards builds, they become extraordinarily adept at accomplishing things that garner approval and acknowledgment. They rarely fail, and in fact they often avoid trying new things to sidestep failure.

But they're hypersensitive to judgement, and when they are criticized or experience failure, self-blame, guilt, and shame quickly follow. What would be perceived as a minor setback for most becomes devastating for these high performers.

On the other extreme are people who are motivated more from within, by interests, curiosity, passions, and their own intrinsic values. Even when these internal motivations are not rewarded externally, these individuals continue to summon the energy and courage to pursue and sustain their creative interests and passions. These people are willing to try

anything, even at the risk of mistakes and failure, but don't experience self-doubt, shame, or guilt if they should happen to fail. And they rarely cave to societal pressures, nor are they motivated by money, prestige, and accolades.

Although the behaviors associated with external validation (such as lack of confidence, depressed entitlement, and rejection sensitivity) tend to index higher in women than men, the roots of this dynamic go far beyond gender. We see similar patterns for anyone in an underrepresented group in the workplace, whether it be based on race, age, nationality, culture, education, socioeconomic background, sexual appearance, physicality, or just about any human aspect that makes someone unique or different from an environmental herd. In our discussion, we refer to those in the minority as the *out-group*. In its simplest terms, an individual is part of an out-group if they do not identify with the dominant demographic of a workplace. For example, a man who works in a predominantly female environment would be considered in the out-group. Being a female in the traditionally male-dominated club of high-tech engineers, Sarah is definitely in an out-group.

To begin your journey with me in this book, I introduced you to Sarah as a model to explore the way that this early patterning (i.e., having an over reliance on external validation to feel *okay* and avoiding rejection at all cost) creates challenges for people like Sarah throughout their lives. Because once you identify these similarities in yourself, you're on the road to seeing how this may have led to perfectionism, rejection-sensitivity, or a lack of confidence in your own life.

At age thirty-four, with a husband, two kids, and a high-paying leadership role at a high-profile company, Sarah finally met her match. She was spinning so many plates in the

air, her fear of any of them falling became her reason to get up in the morning. What she wanted for herself wasn't just relegated to second, third, or even tenth on her list of priories. *Her wants didn't even make the list.* So what was her solution?

Spin those plates faster.

Exhausting, right? And terrifying. Especially when the plates will eventually fall, as they are destined to do.

Let's see how we can turn that all around for Sarah . . . and for those of you who feel the same.

Download Your FREE Companion Workbook

We have found that thinking through and writing about what you have read enhances your ability to absorb and benefit from the practices and techniques we introduce in this book.

We have created a FREE editable digital Companion Workbook to *Composure: The Art of Executive Presence.* The workbook includes chapter-by-chapter summaries of key takeaways, instructions for the tools and techniques we introduce, and writing exercises. It also contains links to audio and video guided meditations and guided exercises, demonstrations, and other FREE resources.

You can download your FREE Companion Workbook at www.composurethebook.com.

CHAPTER 2

THE IMPOSTOR SYNDROME

After Sarah finished her stories of conflicted success, I reassured her that her feelings are incredibly common. "Have you ever heard of the Impostor Syndrome?" I asked.

"No. But with the word *impostor* in the title, I assume it has something to do with lack of confidence or feeling like I don't deserve my success."

"That's part of it," I said.

"It's odd. I'm actually pretty confident in my day-to-day work, and I'm not afraid of pushing myself to get what I want," Sarah said with sincerity. "But when I was passed over for that promotion, everything changed."

"How so?" I asked.

"I used to feel like I had a bright career ahead of me. Now I worry that I might have plateaued, and I'm not as confident as I was before. Without confidence, I don't know how to move forward. Quite frankly, I feel like I'm in over my head."

I could see how Sarah could think that. But losing confidence in her ability to succeed in a high-pressure situation is just a symptom of a problem that Dr. Pauline Rose Clance and Dr. Suzanne Imes, both noted psychologists at Georgia State University, first studied in 1978. They coined the term "Impostor Phenomenon" after studying hundreds of women in undergraduate college courses, PhD programs, and psychotherapy. In each case, the women they observed were respected

professionals in their fields or students recognized for their academic excellence. Dr. Clance and Dr. Imes noted, however, that despite the women's achievements (i.e., earned degrees, scholastic honors, high achievement, praise, and professional recognition), they did not internally experience the feeling of personal success and, moreover, considered themselves to be impostors when people recognized (and celebrated) their achievements. From this study the Impostor Phenomenon was born. And while the study revealed that the Impostor Phenomenon did occur in men, it occurred with much less frequency and with less intensity than it did in women.

Regardless of the circumstances of success, however, the women they studied found innumerable ways to dispel any belief that they were, in fact, intelligent. And if anyone insisted otherwise, the women believed it was because they had fooled them. Some PhD candidates even went as far as to presume they were mistakenly admitted to graduate school because of an error by the admissions committee. Others believed that their high examination scores were due to dumb luck, being misgraded, or the faulty judgement of their professors.

The female professionals in the study felt their success was the result of being overevaluated by colleagues and administrators, leading one woman to boldly conclude, "Obviously I'm in this position because my abilities have been overestimated." Another, who held two master's degrees, a PhD, and had numerous publications considered herself unqualified to teach remedial college classes in her field.

Drawing heavily on the work of Dr. Clance and Dr. Imes, my consulting partners, Lee Epting and Joshua Isaac Smith, and I use the term *Impostor Syndrome* for our work. Lee is a technology executive, board advisor, and executive coach

who has delivered numerous market-winning products for the largest telecommunications and tech companies in the world. And Joshua is a Leadership Fellow and facilitator at College of St. George, Windsor Castle, and the former assistant director of the EMDR Center London. He's an expert in trauma therapy, which is so helpful in our research.

As you can see, I'm in very good company.

Based on all of our experience, our definition of the Impostor Syndrome goes beyond feeling like a fraud and has more to do with how people perceive their competence relative to others. We define the Impostor Syndrome as when *an individual perceives her or his competence to be less than others perceive it to be, despite evident success*. With that in mind, we developed our Impostor Breakthrough Assessment to determine just how much a person identifies as an "impostor" and developed programs that help our clients overcome and break through the Impostor Syndrome. Our work is unique because we combine our decades of experience in psychology, neuroscience, neurolinguistics, and cognitive and somatic therapeutic techniques with our expertise as corporate executives and executive coaches. In addition to people like Sarah, we work with leaders at all levels, and from all around the world, to move beyond these limiting behaviors so they can finally unlock their full potential in their career and personal life.

What Does Impostor Syndrome Look Like?

As you saw with Sarah, the people who live with Impostor Syndrome are multifaceted, which is how they are able to accomplish so much. Through our studies, however, we've found not one, but five characteristics that are incredibly consistent. The five behaviors that comprise the fingerprint for the Impostor Syndrome are:

- Lack of Confidence
- Rejection Sensitivity
- Depressed Entitlement
- Perfectionism
- Feeling Like a Fraud

Before Sarah and I first met, I had her take the Impostor Breakthrough Assessment; then we discussed in detail each of the five Impostor Behaviors, described below, and how they affected her. (It's important to note that not every "impostor" always shows signs of all five traits, but for the purposes of our discussion we'll go through them all.)

Lack of Confidence

A person with Impostor Syndrome most likely lacks confidence in their ability to do something, which is situational. While they may generally be quite confident, certain situations create anticipatory anxiety and self-doubt. This lack of confidence can be paralyzing, even physically upsetting, especially if they are faced with taking on something new or handling a role or project that tests the limits of their skill and experience. Their lack of belief in themselves shakes them to their very core and often impedes the kind of experimentation and trial and error that leads to faster learning and growth.

As Sarah told us, she considers herself to be a generally confident person. However, when she's under pressure—like in a job interview, or when she makes an important presentation to the executive team—she swings to self-doubt and panics. "I start to sweat, my throat tightens up, and my voice cracks. I'm worried I won't know the answer to a question or that I'll say something that reveals I haven't fully thought it through."

Rejection Sensitivity

Sensitivity to being judged, criticized, or found lacking, even in the most constructive ways, is also a common trait among people living with Impostor Syndrome. As a result, they tend to personalize the reactions of others, internalizing any type of criticism and feedback. When they feel judged, instead of learning from it, they are likely to experience shame. In their hypervigilance to avoid or prevent such rejection, they often find their self-worth through the validation and approval of others, often at the expense of their own needs. While this may make them valuable contributors, the constant people-pleasing and approval-seeking is exhausting, especially when they don't allow what *they* want to be part of the equation.

"Even when I know I've done a good job, I dread receiving feedback," confesses Sarah. "I know the intent is mostly to receive constructive input so I can learn and improve, but just the slightest negative feedback stings, and I get defensive. It fills me with the shame that I didn't perform better. Honestly, my bar for failure is pretty high. In my annual performance reviews, if I don't get a five out of five rating on everything, I feel terrible, and it takes days to shake the disappointment."

Depressed Entitlement

People with Impostor Syndrome feel like part of the out-group and have a persistent fear that they don't measure up to their colleagues. As a result, they constantly feel the need to work harder than others in order to prove themselves. They judge themselves too harshly, and because their self-worth is connected to how they perform, they often undervalue their contributions and feel less deserving of the compensation that's commensurate with their actual worth.

Sarah illustrates this with her own experience. "I've always been the only, or one of few, women in my college classes and in my work, and honestly I'm proud to have made it as a woman in a male-dominated field. But because I'm a woman, I have always felt like there is more pressure on me to prove myself and many people underestimate my abilities. This is particularly an issue for me when the subject of compensation comes up." Sarah took a deep breath before she continued. "Before I got my last job, I asked a trusted male colleague what he thought I should be making in my new role. It turns out the number I had in mind was significantly lower than what he thought. He convinced me to ask for the higher amount, even though it just about killed me to do so. I was shocked when they quickly gave me what I wanted without question, which makes me think I could have asked for more. Even so, sometimes I worry that I'm being paid too much—which puts more pressure on me to work harder and deliver more."

Perfectionism

For people with Impostor Syndrome, failure is not an option, and there is no sense of *good enough*. They strive for flawlessness in everything they do in almost all aspects of their daily lives. This compulsion for perfection drives them to overprepare and over work, long after most people would call it a day. Not only is this physically, emotionally, and spiritually exhausting, but it's often wasted effort that hardly ever leads to the kind of payoff that would make their heroic efforts worthwhile. Impostors rarely experience the satisfaction of accomplishment for whatever accolades, praise, or rewards they receive from the external world. At best, they feel some internal relief when the task is over. And yet they climb right back on the treadmill to prepare for their next herculean

effort. They unwittingly perpetuate the cycle of anxiety, over-work, and fleeting sense of accomplishment followed immediately by the anxiety of the next looming task—which starts the cycle anew.

"When the stakes are high, I tend to over prepare and second-guess my work for fear that it will fall short," said Sarah when we discussed her score. "It depends on the situation, but I can definitely relate to the fear of my work not being good enough, causing me to work harder than necessary. And now that I'm struggling with not having enough time for both work and family, the time I spend doing more than required has become a problem."

Feeling Like a Fraud

Someone with Impostor Syndrome never really feels like they have achieved true success, leaving them feeling as though they don't deserve the rewards of status, prestige, or money that result. Instead, they feel inauthentic and phony. Despite all the striving, effort, and anxiety, little sense of enhanced self-worth comes from any accomplishment, because they don't trust that it was, in fact, their competence that brought success. What's worse, they fear being exposed as a fraud, that people will find out that *it's all a lie*. Naturally, this drives them to strive for more success, leaving them feeling vulnerable and exposed.

This by far was Sarah's worst scoring trait. "I don't feel like my success up to now has been the result of luck," she admits. "However, since being passed over for the VP role at GGG, when I do finally get to the next level, I suspect I'll question if I deserve it, since clearly the executives who hired my boss over me didn't think I was ready or capable. That weighs on me now."

As a senior director at a high-tech company, Sarah was on fertile ground for Impostor Syndrome. Hundreds of men and women from entry-level to C-level have taken our Impostor Syndrome assessment, and we've found that women index higher in lack of confidence, depressed entitlement, and rejection sensitivity than men. However, men and women are roughly equal in perfectionism and feeling like a fraud.

According to a 2020 study released by KPMG LLP, the US audit, tax, and advisory firm, 75 percent of female executives across all industries have experienced Impostor Syndrome at certain points in their careers. The study found that 81 percent of women put more pressure on themselves to not fail than men do, and 56 percent report being afraid that they won't live up to expectations or that people around them won't believe they're capable. Nearly half the female population (47 percent) say their feelings of self-doubt are because they never expected to reach such a high level of success. And sadly 32 percent of the women who identify with Impostor Syndrome claim they didn't know there were others out there like them (either personally or professionally). It's no wonder executive women feel like frauds.

Regardless of the statistics, the Impostor Syndrome takes an emotional, physical, and psychological toll on anyone who suffers from it, limiting their potential and derailing their achievements. And it's not just the self-claimed "impostors" who lose. We suffer at a societal and organizational level from the loss of talent, contribution, leadership, and everything that those things impact. But that's nothing compared to the stress and burnout it creates for those who suffer, leaving them feeling less accomplished and less satisfied in their professional lives than they could and should be.

A Case Study

Eager to test our theories in a closed-work environment, we conducted an "Impostor Breakthrough" workshop in 2019 with twenty-six women and nine men at a medium-sized software firm in San Francisco. This engagement was not unusual except for one big difference: my daughter, Mariah, who was the firm's head of Diversity and Inclusion brought us in. For a mother, that was a moment of real pride and relief. It symbolized the transition to a new generation of women leaders spearheading the charge to level the playing field for women and other underrepresented groups in business. I have hope that this next generation will make huge strides, well beyond the rather disappointing steps my generation has made.

Before we met, we asked each of the participants to complete our Impostor Breakthrough Assessment (the same one Sarah took). The Assessment takes about five minutes to complete and measures the degree to which the participants experience the five Impostor Behaviors by addressing twenty statements like, *"When I receive negative criticism I take it personally."* The participant then rates the statement on a five-point scale from *Not At All True* to *Very True*.

As we compiled the results from Mariah and her colleagues (most in their twenties or early thirties), I recognized how little things have changed for women since my own professional life began more than thirty years ago. The data did not surprise me, but their responses broke my heart: some of the men and almost all the women at my daughter's company scored higher than average across all five impostor behaviors. While not a statistically valid sample size, the data was highly consistent with what we see for entry-level employees and first-level managers, all of whom tend to score significantly

higher across all traits than their older, more experienced executive colleagues.

In addition, the women and men we surveyed showed distinct differences in their Impostor Syndrome tendencies, as is also common across our surveys. As expected, the women were about one-third more likely to feel a lack of self-confidence in their jobs than the men, two-thirds more likely to experience depressed entitlement, and about half more likely to feel rejection sensitivity.

When Sarah took the assessment, she scored high in all Impostor Behaviors, but especially high in Rejection Sensitivity and Depressed Entitlement. After taking the assessment she reflected on her scores. "You know, Kate, I think if I had taken this assessment before having kids, or before I got passed over for the promotion, I may have scored differently. I felt really confident back then, and I did feel like I deserved the success I had earned. But now, after losing that promotion, I'm not so sure. And my high scores clearly reflect that."

What Sarah experienced is common for impostors. Their behaviors remain dormant when things are going well but flare up in high pressure situations like interviews or presentations or when they are triggered by criticism or stung by failure. In other words, the Impostor Syndrome is highly situational. Which means it doesn't only apply to work and academic environments.

Many of the women we work with express the dual challenge of feeling impostor behaviors at work *and* at home when they become mothers and struggle to divide their time and energy between career and family. And unfortunately, home life tends to suffer more. Because for women their homes,

which used to be their refuges from the pressures at work, no longer bring them the same relief and comfort.

As part of the study, we conducted small breakouts to allow the participants to explore and share how the Impostor Behaviors impact them at work and in their lives. What we heard was similar to what we hear from all the groups we work with.

One woman, who had graduated top of her class at a prestigious engineering school, told us she was one of a few women in her department and didn't feel as though she truly belonged. "When I joined the company, it was really intimidating, because it's a hot start-up known for hiring really smart people. I joined a team of mostly male engineers. Not only was I new to the company and to the technology, I was also new to the product, which is really complicated. So I had a lot to learn," she explained. "But I was, and frankly still am, afraid to ask questions. I don't always know how best to solve the problem I'm working on, but I'm afraid to ask for help. I feel like I should already know how to do it, so I just work a lot harder and longer without letting anyone know I'm struggling." She did notice, however, that the men on the team worked more easily together and were more likely to reach out to their colleagues when they needed help.

Even so, men can be just as vulnerable.

A male participant told us that he was still affected from an experience that happened a few months earlier. "I presented a new design idea that I was really excited about to my manager and team. The reaction I got was devastating. My ideas were dismissed in a way that felt really condescending. Now I don't dare put myself out there, so I feel like I'm just going through the motions. I don't want to risk tapping into

my own creativity for fear it'll be shot down again." Since that happened, he had become much more reluctant to speak up in team meetings.

They all to varying degrees struggled with a range of familiar and commonly shared doubts: *Am I competent? Do I belong? Is it okay to make mistakes? Do I deserve to be here?* Triggered by workplace pressures and missing a sense of psychological safety, they reacted to their fears of criticism, judgement, and exclusion using well-practiced Impostor Behaviors. They coped with the constant strain of their self-doubt and fraudulence by doubling down on their anxiety and stress, fueling overwork and perfectionism until they felt completely burned out. And yet it was a relief for most to discover, often for the first time, that others, even those they admired and respected, had similar impostor feelings.

As you can see, such feelings are deep-seated. A first step to counteract Impostor Behaviors is to visualize what life would be like if the behaviors didn't exist. To do this, we ended our session at my daughter's company with what we refer to as a "brain hack" demonstration on a volunteer, in which we have them imagine that their clone is sitting next to them. Their clone is identical to them in every way—has the same life experiences, the same education and experience, the same pressures and dynamics in their personal life. But they differ in one important way—the clone never experiences the fear, self-doubts, and anxiety associated with her Impostor Behaviors. It's like those thoughts and feelings just never occur.

We asked our volunteer, Nikki, to talk about how her clone would prepare and show up differently for an upcoming presentation. Nikki laughed ironically. "She's not all that concerned."

"Oh, really? How is that?"

"Because *she* has enough time to put some real thought into creating and giving a great presentation without any distractions. And on the day of the presentation, she got a great night's sleep the night before. And in the days leading up to the presentation, she didn't have the constant interruptions and over thinking that I constantly have to deal with."

"That sounds lovely, but a tad bit unrealistic. *Given she's your clone,* how would things be different specifically for *her* on the day of the presentation than it would be for you?" I inquired.

"What do you mean? I just told you," replied Nikki.

"Well," I said politely, "what you just described for your clone is a life you fantasize about if your personal circumstances were such that your time was not constrained. But your clone has the exact same life as you: same husband, same kids, same responsibilities, same mindset, same challenges, same everything. With all that in mind, what might she do differently in preparation for a big presentation?"

"Oh. Okay." Nikki took a moment to think and really let this idea sink in. "Well, for one, my clone would make arrangements to go to bed a little earlier the night before. Then the next morning, she'd wake up a little earlier than usual, so she's not rushed. Then she'd do a short meditation and thirty minutes of yoga."

"That sounds perfectly reasonable," I agreed. "What do you usually do on the morning of a presentation?"

Nikki smiled sheepishly, like a kid caught with her hand in the cookie jar. "Wake up tired. Run through my presentation. Check emails. All even before I even leave the house."

"Wow. Would your clone do all that, too?"

Nikki thought carefully before she answered. "No, I don't think so. If my clone started her day differently, I think she'd be way less stressed and nervous walking into that presentation. As a result, I'm sure she'd do a lot better and be more relaxed, more approachable.'"

"But if the Nikki clone didn't have the anxiety and self-doubt," I asked, "would that impact the quality of her presentation or how well she delivered it?"

"Hmmm. That's interesting," Nikki replied. "With that kind of calm state of mind, I'm sure if she got questions she couldn't answer, she wouldn't panic. Instead she'd say something like, 'I don't know, but I'll find out and get back to you.'" Nikki took a moment to picture this in her head, but then quickly added, "However, if I'm being honest, the anxiety and self-doubt make me go the extra mile to ensure my presentation is perfect and that I'm well prepared."

"Yes, but that's *you*," I reminded her. "What about your clone?"

Nikki again took some time before she answered. "I guess my clone doesn't need stress and self-doubt to fuel her to work hard and do well. We both have high standards for our work, but there's one big difference."

"What's that?"

Nikki could see where this was going, which is exactly what I wanted for her. "She knows when enough is enough," she concluded. "And because she is more relaxed and confident going in, she has a lot more composure, and she's more authentic and connects better with her audience. It's kind of like water off a duck's back. Whatever comes at her she just deals with."

When we do this demonstration, it's always inspiring because everyone in the room lights up with a sense of hope. While we all know such a shift is not easy, what Nikki demonstrated is that even though these Impostor Behaviors are within us, they are also within our control, and therefore it *is* possible to free ourselves of them. My daughter and her colleagues were beginning to see how the rewards of eliminating Impostor Behaviors could be life-changing. Each participant then took some time to talk about what that possibility might look like for them by "road testing" an impostor-free version of themselves. This exercise gave them a vision of how they wanted to be.

My Story

I want to take a step back for just a second to reassure you that this work I'm sharing with you is not merely academic for me. Like everyone else, I've made some mistakes and learned huge lessons as a result. So you'll be happy to know that this work is very personal, even as it reflects the experiences of so many people I know and have worked with (especially women and those in underrepresented groups).

Let me tell you my own story to illustrate that.

More than twenty years ago, I was a senior director at a technology company. I had a two-and-half-year-old daughter and had just returned to work after having my second child, a son. At the time, the job market was competitive, and it was almost impossible to hire product people like me. Product experts were in high demand, hard to find, and even harder to keep. In fact, my team had three consultants working under me who were making twice what I was making.

So I decided to step out of the corporate employee world to become a freelance consultant. With my two young kids in mind, I wanted to create more flexibility for my family and myself. When I made this move, I was worried I'd set my career on the slow track, and that if I wanted to go back to being a corporate employee someday, it would be really hard to work my way back up the ladder. But I was exhausted working at a rapidly growing company with two small kids at home, so I decided it was worth the potential career risk.

Fortunately, things turned out better than I had expected. I loved being a hands-on mother, and I found that I could set my own hours as a consultant, while still remaining deeply engaged in my work. I had a steady stream of interesting clients and over time began working more with senior executives and CEOs on highly strategic projects. Within five years, I was hired to launch a new technology company. Three months later, the board of this company asked me to become their CEO, basically formalizing the role I had already been filling.

Immediately, I said, "No."

They asked me again, weeks later, and without hesitation my answer was the same. How could I possibly balance the demands of being a good mom with the demands of running a new company? They asked me a third time, and again I confidently turned them down.

At the time, I thought it was my need to have the flexibility to spend time with my kids that kept me from taking on this new challenge. But I now recognize that I felt like an impostor. I had never imagined becoming a CEO (it was never my goal), and I didn't believe I was capable of fulfilling the requirements of such a job, or that I was even worthy of the position, and therefore didn't deserve it.

Fortunately, fate forced me to recalibrate those views a few months later.

It happened at the Consumer Electronics Show in Las Vegas. If you haven't experienced the unparalleled hellishness of Vegas during an industry trade show, then you probably can't appreciate how little I was thinking about personal potential and a healthier self-esteem. Even so, on one particular morning that week, I had a breakfast meeting with two board members of the tech company that kept trying to hire me as their CEO. It took an hour of long taxi lines and wading through dreary, loud, smoke-filled casinos to finally get to the table of waiting board members. I was only five minutes late, but not exactly in the best mindset. However, I had no idea that my day was about to get much worse.

The board members didn't care that I was late. They had exciting news. They'd finally selected a great candidate to take the CEO position I'd repeatedly turned down.

"That's fantastic," I said, curious and anxious at the same time.

But when they told me the candidate's name, it took every ounce of energy in me not to choke on my coffee. The candidate they had in mind was a former colleague and someone I did not respect very much. Although on the outside he appeared to have a solid grasp of business fundamentals and a sense of vision for where the industry was moving, in reality he completely lacked the ability to execute anything and make that vision happen. Apparently during his interview he had expertly hid the fact that he was very entitled and had an erratic temperament that did not work well in a team environment.

This development shocked me. Suddenly, the bar for the CEO position, which had seemed so far out of reach, plunged to somewhere around my shins. If this is what they expected, I knew I could fill the role better than their chosen candidate, despite all my previous concerns. Compared to him, I could manage the job in my sleep with one hand tied behind my back and two kids in tow.

I left breakfast feeling sick to my stomach with the bitter taste of regret in my mouth. Walking back to my hotel through the casino, I saw my decision to refuse their CEO offer (not once, but three times) in a new and jarring light. I had done to myself what my research now shows women do so often. Given a chance to throw their hat into the ring for an executive role, they demur for complicated and sometimes completely unrelated reasons. And then stand by helplessly afterward, watching someone else *less capable*, usually a man, get the job.

Recall that Sarah relayed a very similar story when she first came into my office filled with confusion, anxiety, and despair. It turns out neither Sarah nor I are anomalies.

Research shows that men will apply for senior managerial promotions when they feel they meet as little as 60 percent of the job criteria. Women, on the other hand, will typically apply for the same positions only if they feel they meet 100 percent of the criteria. In my reluctance to step forward, I had turned myself into another data point, foregoing a potentially life-changing opportunity without even entertaining the possibility of something bigger and better. You can imagine all the regret, self-blame, and judgement I heaped on myself over the next few days.

Then came another twist in the story.

The company couldn't come to an agreement with the candidate regarding his specific role and compensation. And worse, the negotiation process had damaged his relationship with the hiring committee. Suddenly, he didn't seem so stunning anymore. In short order, the board took him out of the running and went back to square one. The job was open again.

I once again had my chance! Did I jump at this new opportunity that was suddenly handed to me on a silver platter?

No! Not even then!

But there was a notable difference this time. Now I knew how I would feel if someone less qualified than I got the position. So I turned to two of my most trusted mentors, Lisa Goldman, a brilliant executive coach who has coached dozens of CEOs in some of the largest companies in America, and Jeff Karan, a former investment banker who had just created his own venture fund to invest in groundbreaking Life Sciences companies, to talk to them about whether I should reconsider taking the CEO job. In our conversations, I realized that while I did have concerns about the commitment level and the demands of the role, what lay hidden below the surface was the real issue. *I was terrified I would fail.* I had never been a CEO before and had never imagined becoming one. I didn't have an MBA or any of the typical prerequisite experience. My anxiety and self-doubt were so consuming that I didn't just worry about failure in this particular job. The *real* reason was that I was afraid my inevitable, spectacular, crash-and-burn catastrophe would destroy my entire career and I would lose all my savings and end up living in a cardboard box.

Extreme and irrational? Of course. I had never failed to that extreme at *anything* before in my life. So why would I now?

But that fear felt very real to me, even though I'd never overtly acknowledged it. Staring at it head-on, and letting myself sit with my emotions, I let Lisa and Jeff talk me off the ledge, and helped me see reason. With their guidance I could see that even if I did fail miserably, a cardboard box was not in my future. In fact, they reminded me that failure as a CEO can be a mark of hard-won experience in Silicon Valley, where second acts are plentiful and many "damaged" CEOs quickly go on to bigger and better things.

So, What Next?

I was convinced that Lisa and Jeff were right, but how could I use this newfound enlightenment to my advantage? I wanted to move beyond my fear, but I honestly didn't know where to start.

However, Lisa gave me this powerful piece of advice, which gave me a new direction: "Turn your list of *'I can't do this because . . .'* excuses into a list of *'I can do this if . . .'* solutions." Her wisdom helped galvanize my thinking when it came to considering the CEO position. Upon careful reflection, I quickly came up with some bullet points that would be must-haves for me if I were to take the position, although I knew they were possible deal breakers for the board. Nevertheless, here is what I listed:

- I wanted a short commute to work.
- At most, I'd have only one international trip per quarter.
- I'd hire a team of four executives to help share the workload.
- I wanted to work from home one day per week when possible.

- The company would provide me with an executive coach.
- I'd earn a salary that would make all the sacrifices worthwhile.

I had a flash of insight after writing down my list—not just thinking about it, *but writing it down*, and then envisioning me sharing it with the board. It was then I realized that none of my demands were deal breakers at all! My list wasn't important to the board. All they wanted was for me to take over the reins, and they'd do whatever it took to make that happen. They were dying for a "yes" from me, so I could get busy producing a plan and a budget they could act on.

Turns out I never did share my list with the board. Instead, I accepted the job and made sure I built my personal requirements (from my list) into the business plan and budget I created. They approved the entire plan, including the salary that Jeff coached me to ask for (gulp!), without hesitation.

That was the start of my journey as an accidental CEO, and it was the single most rewarding career move of my life—and to think, I almost missed it! As my leadership skills and confidence grew, the company grew as well. And when the company was eventually acquired, I took another step up, this time from CEO of a small start-up to senior vice president of a $4 billion tech company where I reported directly to the CEO.

Again, I feared the demands of this even larger role: the commute, the lack of balance with my home life, and (as an introvert) the level of energy required for "being on" all the time in a big company environment with thousands of employees. Even though I'm great at getting things done, I don't thrive in large crowds or big social events. I knew that

being a senior executive at a tech company would be incredibly demanding and exhausting. Even the building environment of the big corporation, with its partial cubicles, lack of windows, and single-floor factory-style layout, sucked my soul. But I did it anyway for one simple reason. While the big corporation was almost 50/50 women and men in the rank-and-file level, at the executive level, women were as rare as white zebras. I felt obligated to be the change I wanted to see happen.

Finally accepting that CEO position at the small start-up and then becoming an executive at the large company was, by every external measure, an incredible experience. I had a front-row seat to witness mobile technology evolve in real time, and I worked with some of the most talented executives in the industry.

And never once along my journey did I spend a single night in a cardboard box.

CHAPTER 3

INTRODUCTION TO EXECUTIVE PRESENCE

A few years ago I was advising a thriving start-up with over a hundred employees. The CEO asked me to help initiate a search for a new CFO. His goal was to hire a woman.

At the time, the executive team at the start-up was composed of three men and one woman. For a new tech company, that's a pretty good ratio, but at the next layer of the hierarchy, the numbers were abysmal. Managers were overwhelmingly male, and thus the CEO was committed to cultivating more gender diversity moving forward.

I asked our recruiter to make a special effort to find qualified female candidates. He was all for that idea but explained the challenge. "There are very few female CFOs in your industry, so I might not be able to find a suitable candidate with the level of experience you're looking for. What I recommend is to include candidates one level below that and consider VPs and senior directors at large companies. That will greatly boost our candidate pool of qualified women."

"Sounds good," I said. "Let's do that."

"Do you want me to present only female candidates?" he asked. "When looking for diversity, some of my clients exclude nondiverse candidates."

After talking it over with the CEO, we decided to consider both male and female candidates. "Regardless," I implored our recruiter, "please go the extra mile in finding qualified women."

And he did just that. After rigorous assessments, our final candidate pool consisted of three women and three men. Each candidate had a stellar background in finance and relevant industry experience with high emotional intelligence. I was satisfied, and I felt positive about our chances of hiring a woman, even after one of the female candidates dropped out at the eleventh hour because of a family crisis. We still had two highly qualified women in the running.

And yet, even after having every intention of hiring a woman for the CFO position, what did we do?

We hired a man.

Why Aren't There More Women Leaders?

Tomas Chamorro-Premuzic is an organizational psychologist and professor of business psychology at University College of London. His groundbreaking research sheds light on why it's so hard for some highly competent people, especially women and those in underrepresented groups, to advance to the top levels of their professions.

Chamorro-Premuzic starts with the basics. Adult women make up around 50 percent of the population. As college students, women outperform men in aggregate. But even though academic success should, in theory, set students up for professional success, that's not how it works for women. Most senior managers are male, and women are remarkably underrepresented in top roles and leadership.

Why is that?

There are three popular explanations for this phenomenon:
1. Women are not capable.
2. Women are not interested.
3. Women are both interested and capable, but unable to break the glass ceiling.

Let's use my story of failing to hire a female CFO to explore this reasoning further. The first assumption can be immediately scratched out. Our candidate pool consisted of highly capable women who were thoroughly vetted for their technical abilities, experience, and know-how.

The second assumption is also demonstrably false. These women took time out from busy professional and family demands to engage in a thorough, time-consuming process and worked hard on the hope, not the guarantee, to be given a unique opportunity.

The third assumption didn't seem right, either. While I can't completely discount unconscious gender bias, I can assure you that the systemic barriers were low for this role, if they existed at all. I witnessed the process firsthand, and I know that the CEO, in his commitment to promote upper-level gender diversity, was extremely eager to hire a female CFO.

I knew a key factor in any type of career advancement was what Chamorro-Premuzic describes as the difference in confidence between men and women. It's a known fact that people in general can't help but misinterpret confidence with competence. To put it succinctly, people assume that a lack of confidence must mean a lack of competence. But according to Chamorro-Premuzic, when we make that assumption *"we are fooled into believing that men are better leaders than women. In other words, when it comes to leadership, the only advantage that men have over women . . . is the fact that the manifestations of hubris—often masked as charisma or charm—are commonly mistaken for leadership potential, and that these occur much more frequently in men than in women."*

The hiring committee for the CFO position consisted of myself, the CEO, and three people on the finance team, all well versed in the requirements of the job. Up to this point, we were the ones doing the first round of interviews. And even before we spoke to any of the candidates, we knew that based on competence, both the women candidates would be outstanding in this role. Both also exhibited higher emotional intelligence than the male candidates. This assured us either female candidate would be able to build and maintain high-performance teams, develop and mentor reports, collaborate effectively with senior executives and across departments, and establish and execute broad strategic goals.

To be clear, assertive confidence was not a requirement for the CFO we were looking for. In fact, I've observed throughout my career that finance people are often quiet and introverted. The most effective CFO I've worked with is someone who didn't say much, but when she did speak, everyone listened. Although soft spoken, she was highly respected by her peers and the executive team. She had an uncanny ability to sense the best time to enter the conversation to make her point. Though shy, her communication style was direct, and when challenged, she remained calm and composed even when the emotional heat in the room rose. And she was really funny, often using her warm sense of humor to deescalate difficult situations. When she was questioned or challenged, she stood her ground. In this way, she exemplified a quiet but powerful presence that people respected.

After we interviewed all the candidates, Dan, the CEO, and I spoke about how they all presented themselves. "In my view, all the candidates are strong. But the women are showing up differently than the men," I explained. "Although I know

they have really relevant experience, they seem reluctant to promote their accomplishments and often attribute their success to their teams, rather than to their leadership. This makes them seem less accomplished than the male candidates."

The final interview team was made up of four people—two board members and two nonfinance executives. I was concerned that these interviews would not go well for the female candidates. "Dan, I'm really worried about this next round of interviews," I admitted. "None of these interviewers have the necessary finance experience to effectively assess CFO competence based on the needs of the role, so I'm concerned they'll choose confidence over competence. In which case, the male candidates will definitely have a leg up, and we won't end up hiring either of the women. That means a final decision probably won't be grounded in ability."

That day, I also reached out to the recruiter to share what I'd witnessed. "Is there any way to offer the female candidates some coaching so they present with greater confidence?" I asked hopefully.

"I see your point, Kate," he replied. "I will do some extra prep with them, but it's too late to hire an outside coach to make enough of an impact with the next round of interviews just days away."

The Confidence Gap

Chamorro-Premuzic cites the confidence gap between men and women as almost universal truth. All over the world, in just about any industry, men overestimate their own intelligence, while women are generally more humble than men. Ironically, Chamorro-Premuzic's research also shows that the best leaders are typically humble, a trait tied to high emotional intelligence, which is more prevalent in women.

But all that aside, the number of women in the top ranks of most organizations substantiates the confidence gap phenomenon. The McKinsey and LeanIn.org "Women in the Workplace 2019" report reveals that female representation falls from around 50 percent in entry level ranks to about 25 percent at the executive level and around 7 percent at the CEO level. In summary, the higher up you go on the corporate ladder, the less you'll find women.

But if Chamorro-Premuzic is right, and confidence is a differentiating factor, how does this play out in practice?

Let's take a look at the people behind the numbers.

In entry-level positions, the ranks of women and men are roughly equal. Not coincidentally, these roles are heavily tactical in nature and require practical abilities that are observable and quantifiable. And although confidence is always a plus at any level, competence ranks very high at this level because it's *visible*. The managers and leaders above these entry-level positions can see who is doing what.

But as people ascend the hierarchy and become managers and leaders, things change rapidly. The tactical proportions of jobs at the upper levels dramatically decrease, while the intangible qualities (i.e., their personal leadership style, strategic planning, risk tolerance, integrity, influence, vision, etc.) assume more importance. Thus, a key to being promoted into the executive ranks lies not just in one's abilities, but also in our *perception* of those abilities.

Self-confidence thus becomes extremely important when considering whom to promote for leadership roles. But confidence alone is not enough to give women an equal shot at the corner office. This is why Executive Presence matters so much as people rise in their careers.

Executive Presence

I met Robin Toft on a panel at Medtech Women, a Silicon Valley based professional organization dedicated to highlighting women leaders in the medical technology industry. At that time Robin, who is the author of *WE CAN: The Executive Woman's Guide to Career Advancement*, ran her own executive recruiting firm where she personally placed women into CEO and board roles. During the Q&A someone asked us, "Why are there so few female CEOs?"

Robin had a great answer. "As a recruiter, I've seen so many women who have the skills and talent to become CEOs, but they lack the composure that boards look for in a top leader. Clearly people in these positions need to display confidence. That's a given. But they also need to be seen as someone willing to make tough decisions with imperfect information, the kind of person you could trust to lead through crises."

Robin was talking about Executive Presence, which is the set of traits required to turn managers into leaders and senior executives. It appears too many women vying for top corporate positions lack it. Specifically, Executive Presence is best described as a mature self-confidence that inspires global confidence in one's own leadership. It's the ability to instill trust, take control of difficult situations, make tough decisions, and hold one's own with talented and strong-willed colleagues— or even foes—all while appearing calm and composed.

We associate five key abilities with Executive Presence, as follows:

- **Confidence**: Project a solid sense of self-esteem that ensures your capacity to deal with challenges.

- **Composure:** Control your emotions, recognize emotion in others, and effectively manage the outcome.
- **Credibility:** Create global trust in your skills and abilities.
- **Clarity:** Communicate clearly and concisely.
- **Connection:** Interact with others easily to instill faith in your leadership.

As you can see, the Impostor Syndrome steadfastly stands in the way of projecting and internalizing Executive Presence. A lack of confidence erodes one's ability to project confidence, which in turn impacts how others perceive one's credibility. Rejection sensitivity makes people more reactive and thus unable to maintain composure in challenging situations. And when people lose their composure, they are often less able to communicate concisely and with clarity. Depressed entitlement and feeling like a fraud make it nearly impossible to show up in a fully authentic way, which inhibits connection.

When Impostor Behaviors get in the way of Executive Presence, it makes it difficult for women to reach executive ranks and the C-suite. What's worse is that it also limits their effectiveness, influence, and the impact of their everyday work.

I introduced Sarah to the concept of Executive Presence in our second session and then asked her, "Looking back, do you think you exhibited Executive Presence during your recent job interviews?"

She shook her head. "I doubt it. Being passed over for the VP role at GGG really shook my confidence. By the time I went into those interviews, I felt way more nervous than I should have, and I'm sure that made me show up differently."

"How so?" I asked.

"At one point, the CEO asked me a hypothetical question about how I'd handle a crisis situation with our product. It took me by surprise as I have never been in that situation, nor have I thought much about it. Instead of taking a moment to give it some thought, I immediately felt flushed and my throat tightened." She fell silent for a second, obviously reliving the ordeal in her head. "Who am I kidding?" she blurted out. "I froze. I did come up with an answer, but I felt like I was rambling. I'm pretty sure he could see that I'd lost my composure and that my answer wasn't as good as it needed it to be."

"Is that the first time something like this has happened to you?"

She thought back on her experiences at GGG. "Some of our acquisition meetings got pretty heated. More than once, when questioned about my due diligence, it felt like they were calling me out on something I'd missed. My first thought was that I must've dropped the ball, and I panicked."

"Do you think that might've hurt you in the long run?" I asked.

"Maybe. Possibly. Probably." She smiled knowingly. "I got defensive and definitely lost my composure and confidence. I'm sure my answers ended up being pretty weak."

It can be intimidating and disheartening to understand that to rise in our careers we need to be less reactive and more composed than we may feel on the inside. Easier said than done, I know. Which is why we've been diligent in our research and have developed our programs to bring about real change on the inside. But rest assured, our method to break through works. "Our empirical evidence reveals that our techniques naturally elevate Executive Presence in our clients," notes Joshua. "In our exit surveys, 89 percent of those who

have completed our programs report *very much* or *extreme* improvement in their confidence. Seventy percent report *very much* or *extreme* improvement in their composure and ability to project credibility. Fifty-six percent report very much or extreme improvement in their ability to connect with others and 44 percent in their communication." We've seen it happen time after time; when people make important internal shifts, they show up differently on the outside, and as a result the benefits appear quickly.

The Rule of Three and the Art of Envisioning

Not everyone has to learn Executive Presence. Some people are born with it, and not just men. My partner Lee Epting is a shining example of someone with a naturally gifted and powerful Executive Presence. I first met Lee in Silicon Valley when she interviewed for a business development role on my team. Lee was hands down the most successful hire I've ever made—and yet it almost didn't happen, because on paper Lee wasn't qualified. But it was her natural Executive Presence that kept her in the running. The role involved cultivating strategic relationships between our small, but quickly growing, tech company and the largest technology companies in the industry. The responsibilities involved setting up meetings and developing collaborations with high-profile CEOs and executives.

But Lee came from a different industry, which meant she lacked the Rolodex of relationships we needed. Plus, she didn't have any business development experience either. Regardless, her interviews with the executive team went really well—they loved her intelligence, confidence, energy, and drive—but they

ultimately gave her the thumbs-down, because she just didn't have enough experience for the job.

However, I saw something in Lee that let me believe otherwise.

It took weeks of my heavy campaigning before Eddy, my boss, finally relented and gave me the green light to make Lee an offer. "She's just not qualified, Kate," Eddy argued. "This is a big role, and her lack of experience in this industry and lack of contacts at key partner organizations is a real impediment."

"I'm aware of that," I countered. "But look at her background. She has a history figuring things out and then quickly becoming a stellar performer. She's absolutely the type of person we want in this company, and I think we should give her a chance. Worse case, if she can't deliver, we'll put her in another role that's in her bailiwick. Please trust me on this."

Eddy finally relented (I wore him down!), and we made her an offer.

True to form, within three months, Lee had become a company MVP and somewhat of a legend. She had set up meetings with CEOs and senior executives at a dozen large potential partner companies, something no one had thought possible. These relationships elevated the company's profile and position within the industry and generated significant new revenue streams.

Lee went on to a stellar career. She ultimately ran a multibillion dollar business unit for Samsung and became one of the highest paid executives in Samsung Europe, which is quite a feat for an American woman working in a Korean technology juggernaut.

After more than a decade of working in Europe for some of the largest technology companies in the world, Lee moved

back to the United States where (I'm happy to say) she joined Joshua and me to found our company. Within our organization, Lee specializes in coaching our clients when they need to significantly up their game.

This was true for Jacqueline, who was promoted to the chief customer officer of a hundred-person start-up, a job which she secured while going through one of our programs. A few months later, Jacqueline was recruited to interview for a role as senior vice president of customer success at a $17 billion multinational company—a significant step up!

After passing an initial phone screening with the internal recruiter, Jacqueline reached out to Lee for guidance, because she didn't feel confident enough to ace the upcoming round of interviews. "I'm worried I don't have the level of experience they need," she confided in Lee. "I manage a team of forty in my current role, and the team assigned to the job I'm interviewing for consists of more than two hundred people. I've never managed that many people before."

Lee knew that Jacqueline needed to boost her Executive Presence in order to nail her interviews. One of the secrets to Jacqueline's success would be to ensure Jacqueline communicate clearly and concisely to promote her accomplishments without coming off as arrogant. Lee coached her on how to position her leadership experience as scalable enough to qualify her for the new role. She also taught her how to use the *Rule of Three* in response to interview questions. "Whenever you're asked a tough question," offered Lee, "take a breath, count backward from three to one, and start your response with, 'Well, Joe, there are three things to consider . . .' You'll certainly have an answer for the first thing, and as you talk you'll come up with the other two."

To practice this technique, Lee asked Jacqueline to think of a tough question she might be asked in the interview.

Jacqueline thought for a second and then answered, "The EVP will probably ask me how I would deal with a problem with a large and strategic customer."

"Okay, using the Rule of Three, let's hear your answer," Lee prompted.

Jacqueline took a breath, silently counted backward from three to one and then began. "There are three things I'd do when I face a challenging customer discussion. The first is to meet with my team to do a deep dive into the client account so I understand the situation. Next, I'd evaluate the client's mix of products and services in the context of our portfolio so I can determine creative ways we might address their problem and look for opportunities to offer new products and services that would improve our relationship with the customer. And finally, I'd set up a meeting with the client, at the most senior level possible, to work through the issue collaboratively. I'd do my best to make them feel like we're both sitting on the same side of the table so we discover a win-win solution for everyone."

After practicing a few more tough questions, Lee had Jacqueline step into the future to envision what it would feel like to actually *have* the job and to give her the opportunity to see herself successfully in the role so that she could gain important insights and build confidence. She asked Jacqueline to imagine herself as the SVP of customer success at the company, having just been told in her six-month performance review by her boss, the EVP, that she was the best hire he'd ever made.

"Now what do you see?" asked Lee.

"I see myself strutting down the hallway in a sharp black suit and Christian Louboutin stilettos," replied Jacqueline smiling. "I'm confident, owning my role and influence in the business. Though it is a big step up, I'm doing a great job, my team is working well together, and we've had several visible wins since I was hired. My presence in this company has contributed significantly to cross-sell and up-sell within our customer base. And now I'm a sought-after speaker in industry groups and events, and I'm becoming known outside the company. Not only is this a big step up for my career, but I'm also building my own personal brand, both internally and externally. Even more importantly, I'm having a big impact on other women at the company as a role model and advocate."

This vision instilled even more excitement and confidence in Jacqueline that she could take with her into her interviews. Not only was she ready, she actually looked forward to the hiring process because it put her one step closer to her vision.

After the interviews, Jacqueline and Lee debriefed the outcome. Jacqueline had felt really confident and prepared. "When I walked in, I could really see myself in my black suit and stilettos walking the halls and talking with my team members. I knew that I have what it takes to lead a larger team. I knew whatever they asked me, I could compose my thoughts, so I could respond in a clear and concise way. And it worked! I used the Rule of Three several times during the interview, and each time I could see they were impressed."

Jacqueline aced the interviews, ultimately making it to the final round of three candidates. Though she didn't get the job, she reflected a few weeks later on what the experience had meant to her.

"This process has changed me," Jacqueline told Lee. "I am so much more confident, and I feel like I'm communicating at a whole new level. It's a relief to know I can overcome my insecurities and be a better leader. Before this, I thought I had plateaued in my career. But now I see my potential. When I step outside my comfort zone, it's an opportunity for personal growth. Now for the first time, I have my sights set on eventually becoming a CEO, and I'd like to work with you to chart a path to get there."

Jacqueline is not the anomaly in situations like this—she's actually the norm. Therefore, as a metaphoric example, Jacqueline's experience shows that anyone, even those who have been afraid to reach for the brass ring in the past, can break through to make lasting, effective changes, resulting in more confidence throughout their lives. The bonus side effect is that when you do this, it leads to experiencing less anxiety, stress, and feeling overwhelmed, and this often spills into other aspects of your life, from family to career to personal passions. Because instead of being reactive, you operate with more composure and take control to actively pursue the outcome you want, instead of hoping your desired outcome finds you.

We're proud to say that proof of the effectiveness of our program lives in our results. I can tell you with certainty that three-quarters report very much or extreme improvement in resolving a lack of confidence and depressed entitlement, 65 percent report very much or extreme improvement in rejection sensitivity, and 61 percent report very much or extreme improvement in not feeling like a fraud. And more impressively, more than half of our graduates are promoted in their careers within six months of completing our programs. These

remarkable results are a testament to the untapped potential that lives within each of us. Our research and results reveal what's possible when you show up with greater confidence and elevated Executive Presence. And that's an opportunity you don't want to miss.

Case in point, more than a decade after I accepted the SVP position with the large high-tech corporation I told you about in chapter 2, I became a Senior Industry Fellow at Georgetown University's McDonough School of Business and had the opportunity to work with Dr. Catherine Tinsley, professor of business management and faculty director of the Georgetown University Women's Leadership Institute. We worked together on a research project to compare the career paths of men and women who become public company CEOs. This research revealed that I had been just *one step* away from having the requisite experience to become the CEO of a large corporation. All I was missing was corporate board service, which would have been possible to secure given my executive position. In other words, if I had stayed on the senior executive track and served on a corporate board, I would've had the necessary credentials to be one of the less than 7 percent of women to hold such a position.

I pushed that potential aside, however, to put all of my focus on my family during a complicated divorce. I had to make difficult decisions to put my children first. I don't regret giving my family my all. In retrospect I regret that I didn't have more insight into my own career potential and what was possible if I could've found a way to stay my course while I worked through the challenging months that followed. At the time, I felt compelled, as a woman and a mother, to make a certain kind of sacrifice—one that favors my family. A man,

in contrast, might have felt compelled to make the opposite choice. It bothers me how much our lives and decisions are shaped by societal and psychological forces that make women more likely than men to put family over career.

To a large degree, that's why I decided to become an executive coach. I loathe the loss of opportunity and the waste of potential that occurs because of deep, often unconscious behavioral patterns that get in the way of success. My passion is to work with people to break through these behavioral patterns, so they can overcome unconscious barriers and free themselves to do their best and become their highest selves.

The evolution brought on by our program consistently increases Executive Presence, which is the X factor people need to succeed, not only productively, but also with *joy*. This allows our graduates to experience more balance and greater fulfillment in all areas of their lives. This is enormously important, because when people elevate their confidence and composure, improve clarity and communication, deepen their connections with others, and boost personal credibility, they are more qualified than ever before to become the next generation of leaders the world needs.

CHAPTER 4

POWERFUL INTENTIONS

"Well, I guess it's pretty clear that I suffer from Impostor Syndrome," said Sarah, almost with a sense of relief. "I must admit, it's comforting to know it's a *thing*. Apparently, I'm not alone in doubting myself and being so sensitive to the opinions of others." She took a moment to let her acceptance sink in. "However, now I *really* feel stuck," she added. "I was hoping that if I found a new job it would be exactly what I needed, but now I'm not so sure. Obviously, I've got some work to do."

I smiled, also feeling a sense of relief that even though Sarah finally recognized the issue, she knew the solution didn't involve a quick fix, magic bullet. "Yes, that's true," I confirmed. "But the good news is if you're ready and willing to do the work, you will get unstuck within days and weeks—not months. And then you'll be in a much better place."

Breaking Through

The journey to break through the Impostor Syndrome involves three phases, *awareness, resolution, and transformation.*

In the first phase, awareness, you discover how Impostor Behaviors impact your work and your life. By exploring these root causes, you see how family and social dynamics throughout your life not only create but also strengthen the Impostor Behaviors. These behaviors are safety patterns your brain puts into place to keep you from taking risks that could possibly

result in failure, judgement, or criticism. As Joshua explains, "You can't 'think away' safety patterns; you can only resolve them by making internal changes so that they're no longer necessary. In essence, you have to update your brain and let it know that the older safety patterns are no longer relevant and may in fact block you in your ability to move forward into a more desirable future."

The second phase is *resolution*. Here we work to shift and resolve your Impostor Behaviors so that you develop greater self-awareness and stronger personal boundaries. Once those are in place, you're able to operate with greater confidence and clarity, which leads you to become more sensitive to your own needs. The payoff is that you're less driven by the interests of others. You become more willing to take risks without experiencing self-doubt, shame, and guilt when you make a mistake. Your stress and anxiety levels come way down, bringing you to a place of greater well-being. As a result, you naturally show up with more composure and greater Executive Presence.

And finally, we have *transformation*. In this phase your motivation shifts inward to focus, often for the first time, on *your own* interests, curiosity, passions, and intrinsic values. Doing so allows you to create a more powerful, aligned sense of self. This is important, because when you factor the *whole you* into your life, your priorities change. Suddenly societal pressures, prestige, accolades, and even your relationship with money are no longer your primary motivators. As you move through your life in congruence with your true self, you can't help but find greater ease and grace. And not by coincidence, flow and serendipity tend to show up for you more often. You'll see that when your emotional energy recalibrates into a positive direction, and you operate in alignment with your

core values, you automatically are guided and supported in unexpected ways.

Although Sarah liked what she was hearing, I could see that she still had a slight sense of trepidation. "This all sounds so interesting . . . and yet still a little scary. All week I've anticipated our coaching session with a mix of excitement and dread. As expected, a lot of things have come up for me, especially when it comes to my reacting—or maybe overreacting—to certain situations. Having even just *that* perspective is helpful."

"I'm so happy to hear that," I replied.

"But now that I'm more aware of my own unhelpful behaviors, I understand how those *old tapes* playing in my head feed my fear and anxiety. That realization is frightening and unsettling. I want to get rid of them, but it seems like that'll be hard to do. I'm hoping this session will help."

"It will," I assured her. "But before we go forward, it's good to establish a strong near-term intention. As you already know, our work together requires you to turn inward to create greater self-awareness and make shifts to resolve your Impostor Behaviors. I want you to identify an intention that will act as your *North Star* to keep you focused and motivated toward your goals. A powerful intention guides you to your greatest impact by ensuring that when we work together you're clear and focused on what's most important."

Intentions are the starting point of every dream, and they fuel motivation and achievement to provide meaningful outcomes. Intentions orient us toward our highest good, whether the goal is professional growth, financial gain, relationship healing, or spiritual awakening. Intentions align our energies, decisions, and abilities to be in service of attaining those goals.

"So how do I create my intention?" asked Sarah.

"This is the fun part!" I reassured her. "Close your eyes and imagine a compelling outcome in the next few weeks or months that is possible only when you make important shifts to free yourself from your most limiting Impostor Behaviors. Let me give you a couple of examples. One of our clients wants to eliminate her rejection sensitivity and fear of failure. Doing so gives her the confidence and courage to pitch her CEO on a new product concept that, if successful, will bring significant new revenue into the company."

Sarah smiled at this thought. I could tell just hearing another person's intention got her thinking about her own. I continued, "As another example, another client has the intention to stop spending so much of her energy trying to be perfect, second-guessing herself, and overpreparing in her day-to-day work so that she can free up time and energy to be more present and joyful with her family."

"I think that might be something I want to consider, as well," said Sarah.

"That's great, but before we get too far, here's the key to setting your intention: *How you formulate your intention determines its effectiveness.* There are three important aspects to a powerful intention. One, your intention must be stated in the positive. Two, it must be solely within *your* control. And three, it must have clear and compelling outcomes."

Stated in the Positive

Imagine someone gets into a taxi and the driver asks, "Where to?" and the passenger says, "Don't take me to the airport." This sounds silly, yet it's how many of us navigate our lives. It's nearly impossible to achieve the outcomes we desire when we haven't been clear or congruent about what it is we would like.

The example above reflects what we refer to as an *Away-from* intention. Away-from intentions encourage you to avoid anything you don't want. The emotions that feed Away-from intentions include anger, fear, and frustration. These emotions are important because they give you the energy to take action and get out of a bad situation. But to get out of the situation in service of what? In the client example above, the desire to end the cycles of perfectionism, rejection sensitivity, and over-preparation is an Away-from intention.

Positive statements, on the other hand, promote *Toward* intentions. They compel you to achieve something you desire, ideally something you would *really* like, by moving toward it. I think we can all agree that it's much more fun and effective to move *toward* something positive than it is to run *away from* something negative.

Toward vs. *Away-from* in Action (a Case Study)

Sam is a management consultant whose practice has consistently grown year after year. "Some months I have more work than I can handle, but other months I have fewer projects, which means not enough revenue. Either way, I live in constant fear, because I know a client might cancel a project at any time, leaving me with a gap in income." Despite the fact that Sam has met and exceeded his annual income objectives every year since he started his practice, he still experiences stress around this uncertainty.

"What would you like instead?" I asked him, knowing his answer would be just the starting point for what we would ultimately craft into a powerful intention statement.

"I want to stop being stressed out about having enough clients and making enough money," he quickly answered.

Although his answer was clear, it was not as powerful as it could be, because it was an Away-from intention. Sam focused on the negative instead of the positive.

The problem with Away-from intentions is that the mind does not effectively process negative statements. And in this case, Sam's intention to "stop being stressed out" does not send a clear and actionable command to the brain. What your subconscious gets stuck on here is the "being stressed out" part. And because it doesn't go any further, your brain ignores the "stop" part. Look at it this way. If I tell you, "Don't think about pink elephants," what happens? Of course, you can't think of anything else but pink elephants. They start dancing around in your head like some sort of weird cotillion. Negative words throw the brain off, and end up causing the opposite focus— in this case it might even generate more stress!

Toward intentions, however, focus the brain on positive, desired outcomes. After I explained this difference to Sam, he decided he'd rather *not* be stressed and worried.

"So when you're no longer stressed about having enough clients and making enough money, what is happening instead? What is the opposite of that?"

At first, he couldn't get off the negative path, and continued to come up with things he didn't want, like, "I wouldn't worry about a gap in income."

But each time, I continued to ask him what he would like instead, until finally he landed on a more positive and powerful desired outcome. "I'd like to feel more confident about my ability to land clients and generate income, so I'm more relaxed about money."

Aha. Now we were getting somewhere.

Stating your intention in the positive allows you to be clear about what you would *really* like and what is helpful and achievable. Sam's first few intention attempts were negative, because they focused on "*not being stressed out,*" while his final intention was positive, because it focused on "*feeling confident and relaxed.*"

When I asked the same questions of Sarah, she thought about her intention. "Okay, I think I get what you're saying, but I'm not sure how to put my intention in a positive light. Right now I'm pretty stuck, which doesn't *feel* positive at all. I don't want to be in my current job. I'm burned out. And after bombing my recent interviews I'm afraid to pursue any new opportunities. So it's pretty clear what I *don't* want. But honestly, I'm not sure that I know what I *do* want."

"That's a great start. It's fine to begin with what you *don't* want," I reassured her. "Let me ask you a few things so we can discover what you *do* want. If you weren't feeling stuck, if you weren't burned out and afraid, what would you be feeling instead?"

"Hmm. I guess I'd be excited about landing a new job that I know I'll love. I'd be hopeful and feel energized." She pondered this for a second. "Ahh. I know. I *really* want to get my mojo back."

Independently Achievable and Sustainable

Creating independently achievable and sustainable outcomes can be challenging for many of us, yet without them, we're not in control of getting from where we are to where we'd like to go.

We often hear our clients say things like, "I want my executive team to listen to my suggestions and appreciate my

work." While this sounds like a noble intention, the problem is that the outcome is in control of the executive team, not the client. Depending on the individuals and culture of the company, some members of the executive team may never listen to suggestions or appreciate work.

So how do we shift this into the control of the client?

We ask questions, starting with, *"Is your intention solely within your control?"* And if it's not, we follow up with, *"What would you like instead that is solely within your control?"* Perhaps the client could focus on doing a good job and presenting ideas that result from that good work, in which case her intention could be, "I will strive to do my best work possible and present my ideas as well as I can." This intention is centered on her. *She* feels confident in her work and how she's presenting her ideas, which, of course, is likely to have a positive impact on the outcome. In other words, instead of wanting someone else to change, she identifies what *she* can change that's within her control in order to create a positive outcome.

As Jacqueline (the customer success executive we met in chapter 3) put it after her first round of interviews, "Well, I don't know if I'll move to the next round. And oddly, I'm not sure it matters. What I do know is that I kicked butt! I'm really proud of how I prepared, how I showed up, and how I maintained my composure when faced with some tough and probing questions. So even if I don't make it to the next round, I feel really great about how I did, and I am grateful for this experience. It's been transformative."

When your desired outcomes can be initiated and sustained by you, you are in control. So I asked Sarah, "What can you do, that's solely within your control, to have the outcome you desire?"

"Well," she began, very thoughtfully, "I do have control over whether I feel excited, confident, and energized. And nothing would make me feel that way faster than to be in a job I love. So if things don't work out for me in my current role, I guess I could always hire an even better recruiter to find the right career move for me. Or possibly go back to the people who saw me as a rising star back in the day. I mean, I worked with a lot of people in the past, and I never burned any bridges, so those bridges are still there, right?"

"Most likely, yes," I assured her. "But even if they were, whether or not those people hired you is beyond your control. So defining success as *getting hired* means that *not getting hired* is failure. And you don't have control over that."

Sarah nodded in agreement, but still didn't have an answer.

"Okay, look at it this way," I offered. "When you didn't get the promotion, it wasn't because of the recruiter you hired, right? How is it that you didn't get the promotion? What happened?"

"I guess I just wasn't as ready as I thought," she answered honestly.

"Okay, fair enough," I agreed. "So what do you have control over that you can do *right now* to achieve the outcome you truly want?"

Sarah took a deep breath. "Well, I do know that I'm solely in charge of whether I get my mojo back and *how* I move forward to do that. Maybe my intention is about the journey of finding a new job and not the reward of the job itself." She let that idea simmer in her head for a moment. "How about this: My intention is to feel excited, confident, and energized as I interview for new opportunities and explore what's next for me."

"Does that feel good to you?" I asked.

"Yeah, it does," she replied with a smile.

"I love that you've included the phrase 'explore what's next for me' as that opens up options beyond finding a new job."

"Yes, *that is* a relief. It takes some of the pressure off. I mistakenly thought that the only way to feel better would be to land a new job. And with the recent setbacks, that's pretty daunting. Now I see that I just need to get to a place where I'm excited and confident about the process. That feels doable."

Defined by Specific, Measurable Experiences and Outcomes

The more specific and granular you are about your intention, the more you'll discover what it is you really want, and the greater the likelihood you'll get it. Once again, this can be a circular process that brings clarity and may, in fact, change your intention to something even more powerful. All you have to do is ask yourself what it is you would really like. What will that look like? And how will you know when you have what you would like?

Getting back to Sam from earlier in the chapter, recall that after much exploration together he came up with the following intention: *"I'd like to feel more confident about my ability to land clients and generate income, so I'm more relaxed about money."* So I asked him, "What will having that do for you?"

He got a perplexed look on his face. "I said it before; I'd be more relaxed about money."

"Yes, and when you feel more *confident* about money and clients, what will having that do for you?" I clarified.

"Oh, I see what you mean. Hmm. I suppose I will feel more secure and in control when I feel *confident* about landing clients and generating income."

I smiled. "Okay, and how will you know when you have that?"

Sam thought long and hard before he answered. "I would need a strong sales pipeline with several potential clients lined up," he said.

"And how might you accomplish that?" I asked, sensing that Sam was getting closer to the answer.

"I guess I need to be in a constant dialogue with clients and prospects, so that I don't have to start from ground zero to secure the next client when projects end. I'd already be talking with the right people."

"Do you ever have a sales pipeline *exactly* as you just described?" I asked.

"Yes, I do!" he answered enthusiastically. "After a few weeks of active networking, I usually have at least two new projects in early sales stages and meetings on the calendar with at least three potential clients."

"Great! So what might you do differently in your day-to-day work in order to have the sales pipeline you desire?" I asked.

"That's an interesting question. Because normally after a project ends, I start out with nothing in my sales pipeline. So it always takes a lot of energy and effort—and stress—to line up meetings that result in projects."

"Right. But if you put that old way aside, what new approach could you try?" I asked. "One that gets what you want, without all the anxiety and stress that usually goes along with finding new business."

Sam took another deep breath and took a minute to fully formulate his thought. "You know . . . if I reached out to even just a couple of clients every week to connect, then my sales pipeline would always be primed when I need it." Sam paused a second before he added, "Now that I think about it, that seems really doable. It would probably take me less than an hour a week, and the payoff would be huge."

Sam hit upon the secret sauce that would give him the security he desired. And the great thing about this is, it's nothing new. It's something he's done before, so he knows he's capable of doing it. Now he has clarity about what he needs to change in his day-to-day work to *make it happen*. But more importantly, he's clear about the benefit so he'll be motivated to make the necessary changes.

By answering these same three questions, Sarah also fine-tuned her intention. After several tries, she came up with, "I will research what I want to do next, and it will be fun and exciting for me to once again be in a learning mode. Within sixty days, I will have identified several new companies and technologies that I'm interested in knowing more about. I will have had several meetings with colleagues and friends in the industry and make connections with people involved in the companies and technologies that interest me most."

"Will you have time for all that?" I asked.

"I think so. Because you know what? What I just described is basically a big part of my job now. The only difference is in my job I focus on companies and technologies that interest my firm. And I'm *really* good at my job! So I'll just use my talent to also focus on companies and technologies that interest me. Wow. Now I'm excited to get going on that!"

As you can see with Sam and Sarah, developing an intention that satisfies the three key criteria—stated in the positive, independently achievable and sustainable, and defined by specific, measurable experiences and outcomes—creates powerful, constructive, and effective motivation to get unstuck and move forward. With clear intentions and actionable goals, you can focus your energy in a direction that significantly increases the likelihood that you'll achieve them.

Acting "As-if"

Recall in chapter 3 that Lee worked with Jacqueline to envision herself a success at her new company. This may seem like just a fun little fantasy exercise, but in reality it's much more than that. When Jacqueline saw herself walking down the halls in a black suit and stiletto heels, Lee had invited Jacqueline's mind to explore the *As-if* frame. The As-if frame enables you to investigate the possibilities of your future outcome internally, without having first achieved the outcome in the physical world. In other words, you trick your brain into experiencing your successes *before* they actually happen.

What's key to the As-if frame is that you pre-suppose two important things. First, that you undoubtedly overcome the internal barriers that stand in your way. And second, that you've already achieved what you hope to achieve—and then go beyond that. This allows your mind to temporarily set aside the burden of your fear and self-doubt for the purpose of discovering alternative possibilities. This process serves to clarify your intention *even more*. It strengthens your motivation and gives your psyche the experience of already having attained your positive (and desired) outcomes. And if your brain thinks you've already reached your goals once, it won't try to talk you

out of reaching them again. Which means that when you actually try for real, it will be easier and more likely that you'll achieve the success you desire.

After Sam discovered his positive intention, I used a short guided meditation to prepare him for the As-if exercise by getting him into a relaxed, yet alert, state. Then I gently brought him into the future, as follows: "Imagine you're several months out. You have made all the changes in your life that you only dreamed about back when you were setting your intention. But now you have the solutions, behaviors, and responses that you desired, even though originally you weren't exactly sure about what you wanted." Then based on Sam's specific circumstances, I asked him a series of questions that helped him fully step into his future experience. I concluded with, "What does your day look like now, Sam?"

"Well, I wake up in the morning, and money is *not* my first thought," he happily admitted.

"Good. What *is* your first thought?"

"To be honest, my first thought is 'I need to check my email,'" he replied sheepishly.

"And do you do that?"

Sam thought for a moment and then firmly stated, "No. No, I don't check my email.

"Good. And did you sleep well the night before?"

"You know, I didn't wake up at 2:00 a.m. worrying about money like I normally do," he replied with gratitude. "In fact, I'm much more well-rested than I used to be."

"Fantastic! Sleep is so important to success. So *now* how do you start your day when get up?"

At this point a big smile spread across his face. "I do a short meditation before I head to the kitchen to get my coffee."

I could tell that he had finally tapped into what he needed to see. "I'm excited to reach out to the people in my network, because it's really fun and rewarding for me to reconnect with people I've worked with in the past."

"You mean the Old Sam didn't do that?" I asked jokingly.

Sam laughed. "No, he didn't! But he should have, because when I do that now, it's one of the most enjoyable parts of my day. Plus, I notice how great it feels to have several new and exciting possible projects in the works. I know I get to choose what I want to work on versus taking on projects that are not a good fit just because I need the income. I actually wonder if I might have to turn some business away. Or hire colleagues to get it all done!"

"Good. That's a beautiful picture of your future. How does all that make you feel about yourself personally?"

Sam smiled even bigger. "Proud for having done such a good job at keeping my business going, all while completing my existing projects."

"And does that lead to anything unexpected?" I inquired.

Sam didn't answer right away. After sitting with the question for a moment, he blurted out, "Yes! I feel more generous with my time and money, because now I have more of both! Go figure! Now I can donate to charities I care about. And I look forward to exercising or taking a walk without feeling guilty. I often end my workday early enough to make dinner for my family instead of picking up takeout. And dinner isn't rushed. In fact, I'm much more present when we sit down to eat, because I'm not consumed by worries about money and work."

As you can see, taking your future self for a "test drive" reveals details about the benefits and joys of your desired

outcome, details that you may not have otherwise discovered. This is the motivational fuel you need to make your outcomes happen *for real*.

Sarah's experience test-driving her future self led to similar revelations. When I asked her how her average day looked in the future, when she was pursuing what's next with excitement and curiosity, here's what she said: "Every day I either meet with someone in my network or I learn about new technologies in my field."

"And how is that working out for you?" I asked.

"Very well . . . I think," she concluded thoughtfully.

"You sound a little tentative."

"I have several companies on my radar to explore. And even though it may seem like extra work to look into these companies, I have to admit, I get kind of excited thinking about them."

"Really? How is that?"

"That's a good question. I think it's because in the past I would've said I don't have time to do this kind of research. Instead I always waited passively for opportunities to come to me. But now that I'm actively researching opportunities on my own, I find that I'm passionate about the options I'm discovering. It's made me realize that I don't have to accept what finds me, *unless* it aligns with what I want."

"That is such an empowering thought! So now when you go into an interview in the future, what does that look like?" I asked.

Sarah pictured the scenario in her head. "I'm way more confident than I was in the past. Because now, before I even get in the room, I've already done my homework about the technology, company, and the CEO." Sarah reflected a bit

longer before she continued. "As I look back on those bad interviews, I see that I was just going through the motions. I was burned out. I wasn't all that interested in the companies or their technologies. Obviously my goal was to get out of a bad situation at work rather than truly be excited about a new opportunity. I see now that my heart wasn't in it. No wonder things didn't go well."

The power of the As-if frame is that your brain and body can't readily distinguish the difference between having an actual experience versus having an experience in your mind. Athletes know this, for example. When they prepare for competition, or when they're sidelined by an injury, they often integrate visualization as a training technique to rehearse the outcomes they desire for an upcoming event. For example, a basketball player might visualize successfully completing free throws over and over again. Visualization has been proven to increase performance and enhance the rehabilitation process for injured athletes in a variety of sports.

Similarly, if you draw on your own senses to visualize outcomes for yourself, your system logs the experience as real, which in turn eases and expedites your ability to actually achieve the outcome in the physical world. When you successfully visualize a compelling future, you're drawn to bring it to fruition. It seems possible, because your sub-conscious "remembers" having the experience, despite the fact that it hasn't actually happened yet.

The Magic of the Visionary

More than a decade ago, I learned about the power of developing a compelling vision for the future when I did research on visionaries. My goal was to discover what makes them tick

and how they're different from the rest of us. Vision plays a vital role for entrepreneurs or anyone developing new products, medical treatments, or innovative ideas or creating new services.

I developed an appreciation for the power of vision by working for many years in the technology industry with well-known product visionaries, especially when I joined Palm, Inc., as an early employee and member of the management team. Jeff Hawkins, the founder of Palm, Inc., invented the PalmPilot long before smartphones and tablets existed. Like many innovators, Jeff developed a clear vision of what he wanted to create, and his passion and clarity for his vision fueled his success.

To make his vision come alive, Jeff spent one weekend carving a balsa-wood mock-up of his mental image of the PalmPilot and carefully crafted the stylus from a bamboo chopstick. He came in on Monday and gathered us all around, excited to share his new product. He carried the wooden prototype everywhere, pulling it out during our meetings with partners and customers, interacting with his balsa-wood model as if it were an actual working prototype. At times this made him look a bit nuts, as we would reassure our customers and partners that, yes, he did, in fact, realize the wooden model did not actually work. But instead it was his way to gather important insights that he would later feed into the product design process.

Jeff's wooden model didn't only guide him; it also guided the product team I led, as well as the engineering teams when it came time to make key product decisions and trade-offs. It served to clarify what was essential for a small, handheld

computer with a small screen and kept us focused on the ideal user experience.

The PalmPilot went on to become one of the fastest growing consumer electronics products in history and launched two critical new industry segments: smartphones and tablets. Jeff's wooden model served as a powerful physical manifestation of his vision, inspiring us all to stay the course as we navigated the challenges and roadblocks we faced bringing a breakthrough product to market.

In my research on visionaries, I discovered that natural visionaries are a rarity. They represent somewhere between 4 to 8 percent of the population. What sets them apart from everyone else is that visionaries spend an inordinate amount of time imagining future experiences that, to them, are very real. These visceral, multisensory imaginary experiences guide visionaries in all they do. And in the end, these experiences lodge in their bodies as memories of events that haven't happened yet.

As a result, when visionaries literally move from the present to the future, they do so opposite of how most nonvisionaries would move forward. For example, nonvisionaries set goals in the future, and then plan the sequential steps that will get them to where they want to be. In contrast, visionaries use their visceral, preimagined experiences of the future as a completed fact, which pulls them from the present into the future, often nonlinearly. Sometimes they even confidently skip steps that might have emerged from the more traditional process. Visionaries are highly motivated, often obsessed and compelled, to act. Because once they've seen and experienced the future (in their mind's eye), they become intolerant of the

present, and thus are excited and compelled to get there as quickly as possible.

Like visionaries, when we work with our clients using the As-if frame, it gives the client the experience of having already achieved success. In other words, the client's brain is convinced that the work *is done*, which proves that the work *can be* done without being overwhelming or tiresome. This insight creates a drive to move forward quickly and opens up the possibility that it's possible to get to that compelling future with more ease, grace, and confidence than they ever thought possible.

As Sarah put it, "Now I'm excited to conduct my own research and create new connections with industry colleagues. This positivity sparks new ideas and fuels my passion for my work. It's a powerful, vital feeling throughout my body, one that I haven't experienced in a long time." Sarah abruptly stopped and her eyes welled up a little.

"What's wrong?" I asked, concerned.

"That's my mojo," she answered quietly. "I thought I'd lost it, but what I really lost was my curiosity. I wasn't using my creative energy at all. What a relief it is to have it return!"

"When you look back from that future place, was it easier or harder than you thought to get there?" I asked.

Sarah smiled as she spoke. "Wow, that's so interesting. Even though it did involve extra work, I was driven by my own curiosity and genuine interest and not by a desire to get a new job. So it feels like it was more natural and effortless."

Did Sarah feel better? Absolutely. Did anything external change for Sarah? Not really. Because her change mostly came *from within*.

While I was excited for Sarah to start her journey, there was still work to do. We had clarified her intention, and even

though she was excited to get started, I knew that below the surface what remained was the self-doubt and fear of rejection that had taken root in her childhood and been reactivated and amplified as a result of being passed over for the promotion. I knew that Sarah's perfectionism would still drive her to overwork and overprepare in her current job. There was no doubt in my mind that it would be difficult for Sarah to balance the demands and pressures of her work and home life, as she explored what's next.

And yet, what we know to be true is that once people connect with their passions, they find a path that reveals a powerful vision of the future. And when that happens, both mind and body reset into a more positive and energetic state. It's so rewarding to watch and listen to a client's relief and joy once they take their first step on that path and move toward their fullest potential, so they can reconnect with their highest and best good.

This excitement builds unstoppable momentum, which is way more important than you might think. Being left unexamined and unresolved, outdated and unnecessary Impostor Behaviors are certain to stand in the way and derail us from achieving our most inspiring visions of who we can become.

Just think of the tragic loss of potential and possibility when we let that happen.

CHAPTER 5

THE ROOT CAUSE

With Sarah's compelling and positive intention in place, it was time to examine the dynamics that operate beneath the surface to create and sustain her unwanted Impostor Behaviors. Though she finally did find an intention that focused on the positive, I wanted to check to see how it was going. At our next session, I asked her, "When we met last, you had identified a powerful, positive intention that felt compelling. I'm curious how you feel about it now?"

"To be honest . . . sometimes a little frustrated," she replied sheepishly.

"Oh, really? How so?"

"When I left your office last time, I was genuinely surprised by how different I felt. And it was all due to shifting from feeling like I needed to start interviewing for a new job to realizing that I simply needed to explore new companies and technologies *at my own pace*. At the time, *that's* what took the pressure off."

"So what's changed?"

"It's what hasn't changed. My work is still just as demanding as ever. I'm struggling to find the time I need for exploration and, at the same time, work and take care of my family. I have noticed that I'm probably working harder than necessary on some things.

"Can you give me an example?"

Sarah thought for a moment before she told me a quick story. "Last week I had to send a sensitive email, and I spent hours writing, rewriting, rereading, and revising it before I finally hit Send. I just wanted to make sure I was crystal clear. After I sent it, I didn't hear back from the guy for a couple days. Well, that just put me in a tailspin. I went back and reread and reread *and reread* what I had sent, worried that I may not have hit upon the right tone."

"Then what happened?" I asked.

"That's the ridiculous part! It turned out he was just away from the office for a few days. When he finally got back to me, he was fine. Delightful, in fact. His response couldn't have been more positive. I spent all that time worrying for nothing!"

Sarah's experience got to the heart of what I wanted to talk about with her, which was her over reliance on external validation and what causes it. This behavior is common among perfectionists who worry unnecessarily about the quality of their work. In Sarah's case, for example, instead of just being patient, she assumed she had done something wrong when she didn't get an immediate reply, even though there was no reason to make such an assumption. Until Sarah can become more aware of her sensitivity to rejection and reliance on external validation, as well as the impact it has on her life and work, history is doomed to repeat itself every time she worries about her efforts or performance.

"I hear what you're saying," Sarah said after I explained all this to her. "But being keenly aware of what other people want me to say and do, so I can please them, has been my superpower."

"What do you mean?" I inquired.

"I've relied on people-pleasing my whole life to achieve success in things like job interviews, sales meetings, and even family dynamics."

"And how's that working out for you *personally*? How does that make you feel?"

Sarah scrunched up her face, deep in thought. "Honestly? Exhausting. It takes a big toll on me and makes me overly sensitive and vulnerable to what others think, which can sometimes be paralyzing. I watch colleagues who aren't afraid to speak up, and who take critical feedback and challenges in stride, and I'm envious."

With this insight into her deep, personal challenges, along with a powerful intention to inspire and guide her, she was ready to explore the root causes of her Impostor Behaviors. And with my coaching and guidance, she would learn to do so with curiosity and compassion. While a successful breakthrough involves resolving and transforming unwanted behaviors, the biggest shifts come when we shine light on the unconscious dynamics that rule our behavior.

Impostor Behaviors arise from an overreliance on external validation, resulting in a weak and underdeveloped sense of self. This dynamic most often emerges from childhood and can be the result of several things, including family dynamics and childhood experiences, trauma, limiting societal norms, and even being a gifted child.

Family Dynamics and Childhood Experiences

Difficult childhood experiences often result in an acute awareness of external authority. And when that happens, children such as this grow into adults who ignore their own personal instincts and instead seek approval outside themselves. This

is especially true for children who felt they had something to prove while growing up or those who overcame challenges in school, family dynamics, or both. What kind of challenges? Some of the more common ones we've seen include:

- Children who struggle with learning difficulties
- Families in which children were caretakers for their parents or siblings
- Families that don't allow children to embrace their intelligence and shine

For example, Max is a successful corporate lawyer with a steady client base of mostly small to midsize companies. But her success has been hard earned. Her older brother was a gifted child with many talents, and he was the apple of his mother's eye. Max, on the other hand, struggled early on in school with a learning disorder, which was made worse by the fact that her mother doted on her brilliant brother. He was clearly her favorite. As a result, Mom was painfully critical and disapproving of Max, no matter how hard she tried.

Max explains further in her own words. "With extra support in elementary school, I was able to compensate for, and sometimes even overcome, my learning differences. I worked so hard that by high school I excelled and ultimately earned a scholarship to the University of Michigan and then attended Stanford Law School. After that I became a corporate lawyer."

Despite her academic success, she still carried the lingering sting of her mother's favoritism from her childhood. "My brother, Tom, was expected to be a doctor or a lawyer, because he was *the smart one*. My parents always reminded me of that. They were very traditional. In their view, college and jobs for women were just stepping-stones to getting married, settling down, and becoming a full-time, stay-at-home mom. In fact,

they actually discouraged me from going to college because it would just get in the way of the inevitable outcome of being a wife and mother. But that wasn't in the cards for me, so I spent most of my life trying to prove myself to my parents."

The scars of shame Max felt as a child struggling to read and write were at odds with her own unexpected academic success. "From the day I walked on to the Stanford campus, I didn't really feel entitled to be there. I was terrified everyone would realize that it was all a mistake. Or worse, that I'd eventually flunk out." Max took a deep breath before she continued. "This is going to sound crazy, and I hate to even admit it, but I actually turned my first law school assignment in late, not because it wasn't done, but because I was terrified that when the professor read it, he'd instantly know I was a fraud and kick me out of school. It took me three agonizing days to summon the courage to turn in that paper. I know now that's totally ridiculous. But at the time, it felt so real."

Ultimately, Max graduated from Stanford Law with honors, and after a stint at a large law firm, she started her own practice specializing in corporate law.

A few weeks before Max and I first met, one of her favorite clients moved to a large company and then hired her as outside counsel to draft an agreement for a big business merger. "It was a coup for me to land such a large client. And the work was right up my alley. I've done dozens of these types of deals over the years," Max tells me. "I know the potholes to avoid and the strings to pull." Then she added with a droll smile. "This is something I'm really good at."

But the night before it was due, Max woke up in a cold sweat, panicked. "I was terrified that the agreement I drafted wouldn't hit the mark, that I'd be fired and then summarily

disbarred due to my egregious negligence." At two in the morning, wide awake, her body coursing with anxiety, she came to this conclusion: "I decided to call the client first thing in the morning and beg for an extension, so I could bring in a more experienced attorney to help me."

"Wow, that sounds like a miserable night. What happened next?" I asked, totally engaged in her story.

"The next morning, I still worried that the agreement I wrote was bad enough that I shouldn't even show it to a colleague, let alone my client. I was trying to avoid the shame of taking my work public, even though it might mean delivering the agreement weeks late."

Max reached out to me to get some help with this pattern, that in the light of day she realized was an overreaction driven by her deep-seated insecurity and fear of failure. She no longer wanted to suffer from the crippling anxiety created by these behaviors.

In our first coaching session, I asked Max to look for the positive intention behind her middle-of-the-night bout of panic, knowing that a critical first step to resolving an unwanted behavior is to acknowledge its positive intention.

"Positive? Are you serious?" she asked incredulously. "There is nothing positive about having a complete existential meltdown at 2:00 a.m."

"I know it's inconceivable that the stress and panic could serve a positive purpose," I replied. "But human beings always and only choose the best item on our menu of behavioral choices at any given moment. And these choices lean toward what keeps us safe. In that context, let's explore the good things your system might have been intending by jolting you awake. Even though it's unpleasant, close your eyes and take

yourself back to that moment at 2:00 a.m. and notice what's happening in your body."

As Max felt into that moment, I could see her shoulders tense up. "My chest is constricting, I feel a big lump in my throat, and my shoulders are tight. A rush of heat moves up my chest and neck. It's pretty intense."

"Thank you, Max. I know this is uncomfortable, but trust me on this. Now tell me, is this a familiar sensation?"

"Actually, it is. It's the same feeling I had in elementary school when I struggled academically. When all the other kids finished their work, I instantly got overwhelmed because I wasn't done. I'd be so far behind that I'd start to panic." Max spoke rapidly after that. "I *just knew* I wouldn't finish or that I'd do it wrong. Either way, I totally expected to fail the assignment, and then the other kids would make fun of me. This happened over and over in school."

"As you sit with this feeling, let's assume for a moment that it's a pattern your system learned in childhood as a way to keep you safe. What might its positive intention have been?"

"Hmm. I suppose it's trying to encourage me to take action, to work harder so that I get the assignment done on time," she replied.

"Good. Thank you." Even though she was uncomfortable with this, I could see her body relax a bit. "So this reaction is actually designed to protect you. How has this kind of reaction possibly benefited you throughout your life?"

"Well, it certainly made me a good student. Before I overcame my learning difficulties, my fear of looking stupid made me work twice as hard as everyone else. I guess from that I developed an incredible work ethic that still serves me well. So I think it makes me do really good work." Max thought

about this for a second but then shook her head in disbelief. "But Kate, I can't keep this up. It's one thing to double down on practicing my spelling words in the third grade, but now this routine creates serious anxiety that disrupts my sleep and takes a toll on my health. I'm exhausted."

"I can imagine," I empathized. "But recognizing the good your brain tries to do for you when it gives you anxiety and panic is the first and most important step in resolving that behavior."

What Max and many others who experience similar behaviors don't realize is that only when you develop an *awareness* of a deeply entrenched behavioral pattern and eliminate the resistance to it can you do anything about it. Because once you recognize that it's there, then when it rears its ugly self, instead of reacting to it, you can step back and observe it with curiosity and compassion. It's not nearly as scary when you know it's designed to protect you and keep you safe. When you observe it objectively and compassionately, then you can ask yourself whether it's really needed or if it's just an old response that's running on autopilot.

"Just float back in time to the past two or three times this happened," I advised Max. "Was the intense reaction you had necessary?"

"Well, the last time was the 2:00 a.m. sweat episode, and no, it wasn't. However, when I woke up in the morning, I did call one of my colleagues to review my agreement. She said it was great and had only minor suggestions."

"How about the time before that?" I probed.

Max had to think back before she could answer. "Something similar happened a couple of months ago when I prepared a brief for a court appearance. Again, I panicked in

the middle of the night, and then I had a colleague review the brief the next morning before I went into court. I was really nervous, but that also turned out fine."

"It's great that you can see this. It provides you with perspective. Now just stop and breathe; feel the weight of your body in your chair and notice your breath going in and out. If you want, cross your arms across your chest and lightly tap your hands on each upper arm while you breathe. Does that help calm your system?"

"Yes, that feels so much better. It's almost like I'm reminding my system that I'm okay and I don't need to react negatively," she observed.

"Now whenever your body kicks into high gear panic, drop your awareness into your body and breathe. We call this *finding your butt*."

It may sound silly, but when anxiety and panic take over, we stop breathing and our bodies tense up so much that if you sit, for example, your full weight isn't in the chair. It's actually *you* physically supporting yourself, not the chair. But if you can stop, take deep breaths, and become aware of feeling the weight of your butt in the chair, you can consciously release your weight, so that you relax and start to calm your breath.

Once that happens, observe the changes in your body with curiosity and compassion. Then take a moment to consider, *"Is what I'm feeling right now helpful? Is it needed? Or is it just an overreaction?"*

And don't forget to BREATHE.

Giftedness

Not all Impostor Behaviors are rooted in family dynamics and childhood experiences. Another reason for seeking external

validation is giftedness. While it might seem inconceivable that a child prodigy would suffer from Impostor Behaviors, we see a high correlation between high performers who are gifted at something and the Impostor Syndrome.

Gifted children have the capability to perform at higher levels in one or more domains compared to others of the same age, experience level, and environment. Giftedness is found within all racial, ethnic, and cultural populations, as well as economic strata. It's an equal opportunity phenomenon.

Research on giftedness sheds some light on this. Gifted children are, by definition, kids who perform exceptionally well intellectually, academically, creatively, and artistically. They generally gravitate toward leadership, in addition to their other natural talents.

Joshua explains why this is true. "Neuroscience research reveals that gifted children have greater intellectual processing capacity. The neurons in the brain of the gifted child seem to be biochemically more abundant and thus are able to process more complex thoughts. They also demonstrate greater pre-frontal cortex activity in the brain, which indicates a capacity for more insightful and intuitive thinking and curiosity. They also demonstrate more alpha wave activity, which allows for more relaxed and focused learning. This leads to greater memory retention and integration."

But as great as all that sounds, there can be a downside to being gifted, as Joshua explains further. "Research also indicates that gifted individuals tend to be emotionally sensitive and empathic, making normal environments more stressful. They often feel as if they're held to higher standards than their peers. And as a result, they can be anxious and find it difficult to accept criticism, as any effort viewed as less than perfect can

feel like rejection, and this experience is emotionally painful. Furthermore, gifted children may find it harder to develop a sense of belonging and may often feel as if they simply don't fit in. Their emotional sensitivity and overly advanced intellect make them different from their peers, leading them to often feeling isolated and misunderstood as children and as adults."

As a child, most things came easy for Sarah. When she was only three or four, her advanced vocabulary and high intelligence made for an impressively articulate young girl. But there was a catch for this gifted child, as she was tiny for her age, looking at least a year or two younger than her pre-school peers. So when people overheard her speak to her mom in public, they commented on "*how extraordinary*" this toddler (barely out of infancy, surely) was that she could express herself so well.

So it was a surprise to her parents when Sarah struggled with reading and comprehension in elementary school. They hired an after-school tutor, and with the extra support, Sarah learned that if she worked hard, she could keep up. Over time, she realized that when she did the things she excelled at, like playing the piano and doing above-grade-level math, she got a rush of attention from the adults around her, especially her parents. "As a shy kid, I was naturally sensitive, timid, and self-conscious, so I really tried to hide my struggle with reading. This glowing attention made me feel more secure."

"I remember one time in the second grade, my teacher chastised me for talking in class," Sarah reminisced. "Instead of letting it go, I panicked, playing the rebuke over and over in my mind for days. I was terrified that at some point the teacher would call my mom to tell her about my behavior and

that my mom would be disappointed in me for *failing*. As if talking out of turn in class was a failure."

Her experience with giftedness contributes strongly to her need to seek external approval by outperforming her peers in those areas. Like many gifted children, Sarah was also a highly sensitive child.

"I loathe conflict," confided Sarah. "I got so upset as a kid when my parents fought, and I would do whatever I could to try to diffuse the situation so it would stop. I have also always needed a lot of personal space and downtime, and if I don't get it, I become really stressed."

Joshua also explains how giftedness related to this childhood experience, "Sensitive children are often introverted and can find noise very distracting and chaotic situations intolerable."

"What's more," he continued, "gifted children are able to read people easily as they have a highly developed ability for interpreting the thoughts of others. This makes them highly attuned if not hypersensitive to the reactions of others, and this can cause underlying anxiety and overfunctioning behavior. They have a radar for tuning into subtle approval or disapproval signals—real or imagined—which they can sometimes take very personally."

Gifted children like Sarah learn to use their gift of being highly externally attuned in order to feel control over, or at least minimize, the threat posed by the chaos around them. This high degree of external focus protects them from the things that can trigger their sensitivity but can also be experienced as emotionally painful and mentally exhausting.

After our discussion of this, Sarah shared her observation: "I can definitely see how this pattern emerged for me as I

tried to manage my environment. I always ingratiated myself to my teachers so that I could have special privileges to go to the library or stay in the classroom during recess. For most kids recess was their favorite part of the school day, but for me it was a nightmare. I would dread the noise and chaos and couldn't wait for the bell to ring to go in where it was quiet and orderly."

Trauma

There is a running joke in coaching and therapeutic circles that when a client is dealing with a deep-seated challenge, the first question you ask is, "Mom or Dad?" Almost all our unwanted behaviors and experiences can be traced back to family dynamics or trauma we endured at the hands of loving, but often flawed, parents or primary caregivers.

Exploring how your early childhood impacts your adult life is not an indictment of you or your parents or how you were raised. It is instead a way to forge a deeper understanding about yourself and the unconscious patterns that arose as a result of childhood experiences that underpin much of your behavior and belief system today. Once you have that perspective, it makes it easier to explore what works and what you'd like to revise in your behavioral patterns. This awareness gives you the freedom to make better choices, especially in response to challenging situations and environments where you don't feel psychologically safe.

"Humans require the longest period of care of any mammal. It takes another eight or nine years after birth for us to catch up to the level of functioning that other mammals have available on day one," explains Joshua. "In our early years, our very survival depends on the physical and emotional care we

receive from our parents (or adults in a parental position). In early childhood, consistently feeling loved, valued, supported, and accepted for who we are by our parents and caregivers leads to strong emotional health and well-being in adulthood. In order to thrive we need a continuous flow of experiences where we feel safe, secure, and nurtured through the unconditional love we receive from the parental figures in our lives.

"As young children, if we should happen to experience our parents' anger, depression, abandonment, or even death, we can't help but feel that love has been withheld and that the parental bond has been broken. This often leads to experiences of shame that make us feel unlovable and unsafe."

To understand how feeling unlovable shapes our behavior and beliefs, we need to understand the world as experienced through the eyes of a child under the age of seven. Children in this age group take the word of their parents as gospel. This is the period of childhood *before* we make individual choices and before our brains have developed sufficiently to have an intellect that can contextualize and mediate our experiences.

Once again, Joshua explains this dynamic. "Children are egocentric, and that means a child takes everything personally. A child's brain is wired to need her parents to survive as she cannot fend for herself. So when a parent is not present, physically or mentally, the child feels as though she is worth less than her parents' time, attention, or direction. When her parent or caregiver has somehow turned away from her, chastised her or neglected her even for a few hours, she concludes that *'it's because of me'* and that *'something is wrong with me, otherwise my parents would want to be with me.'* This is how we all carry shame from our childhoods, as we make decisions about ourselves being 'bad' or 'not good enough' from these

experiences rather than see how it's really a result of the situation that was happening at the time for the parent or caregiver.

"There are a wide range of factors in a child's environment that can produce anxiety and insecurity," Joshua continues. "These include a lack of emotional warmth and safe touch, inconsistent and erratic behavior, punitive and punishing caregiving, broken promises, overnurturing and overprotective caregiving, a lack of patience, a lack of tolerance and respect for the child's needs, a lack of encouragement to try new things, too much admiration for achievements and not enough acknowledgment of effort, having to take sides in parental disagreements, too much or too little responsibility, shame and isolation, and racial, gender, or cultural injustice and discrimination."

As I reflect on my parenting during my daughter's early childhood, I'm alarmed when I read this list, as I can think of numerous circumstances in which I exhibited some of those parental reactions, especially during those times I worked from my home office. Back then I tried to juggle being a parent with being responsive to the demands of my work—a condition all too common for working parents, especially mothers who are forced to endure an unexpected crisis such as the mandatory quarantine imposed during the COVID-19 pandemic.

Parentification

One common thread we find among highly functional and high performing people is they were thrust into an undue burden of family responsibility at an early age. This is known as parentification. As Joshua describes it, "Parentification is the process of role reversal between parent and child in which the child is required to act as a parent to their parent or siblings. In

some cases, the child fills the void of an absent, incapacitated, or estranged spouse to support the other parent's emotional life."

A great example of this is Marie, the second oldest of nine children in a Catholic family. Her mother had the first five children within seven years. After a break of four years, when Marie was ten, her mother was pregnant again, and within rapid succession she had three more children.

Just after the birth of the seventh child, Marie's dad lost his job, and the family struggled to make ends meet, resulting in the entire family living in a five-room apartment. While they were in these less-than-perfect conditions, her mother became pregnant again. By the time Marie was twelve, her mother's physical health was in decline, and her emotional health was tenuous. "Right before going into the hospital to deliver my brother Jon (child number eight), my mom pulled me out of school and told me that she was worried that she might not survive the birth. She told me that if that happened, I was to take over as mother of the family and care for the rest of the kids. As I say this, I know it sounds terrifying, but at the time, it was just so shocking that she'd tell me something like that. I just went numb and continued about my day, going through the motions."

But fortunately for Marie, her mother pulled through. "Three days after Jon was born, I learned that my mother had survived the delivery, which honestly was a shock. I was sure she had died. But when she came home, she wasn't functional. I now know she had postpartum depression. Since I had taken on the role of mom while she was in the hospital, and immediately after she came home, I just continued beyond that. I'd get up at 6:45 a.m. every day, wake up the kids, get them

dressed, make breakfast, and get them off to school, all before I got myself ready and out the door. I usually missed the bus, so I'd have to run to school. I would almost always be late, racking up demerit after demerit. Of course, the school had no idea what was going on at my house. No one did."

The routine wasn't much better for Marie at the end of the day. "After school I'd come home and change the baby's diaper, get snacks for the kids, help Mom make dinner, clean up the dishes, help the kids with homework, and then put them all to bed. Then I'd finally be able to start my own homework. In between I'd try to fit in doing piles of laundry."

You'd think that this kind of schedule would take its toll on Marie and that her academics would suffer. After all, there are adults who try to go college while raising a family, and many of them just can't do it. But not Marie. "Somehow throughout all this, I remained a straight-A student. My dad would come in the kitchen and see me falling asleep at the table and tell me to go to bed, but I couldn't because my homework wasn't done. This went on for almost three years. And even after it was over, I still carried a weight of responsibility to keep the family going."

"Wow, that is such a remarkable story," I told Marie. "Can you see from this how amazing you were? Can you imagine any twelve-year-old girl stepping up to this kind of responsibility and actually pulling it off like you did?"

"No. It kind of breaks my heart to think of it that way."

"Yes, it is heartbreaking," I agreed. "Your childhood was completely interrupted while you took on responsibilities that weren't yours to take on and that were way too much for a young child. What's worse is that you had to keep it a secret, so you couldn't ask for help. That must have been so difficult.

I'm so sorry that you had to struggle through all that alone and that you didn't have the freedom to just be a kid."

Marie's childhood has dramatically shaped her adult life. Not surprisingly, she decided not to have children of her own. She became an advocate for children, creating an institute that supports and mentors children experiencing neglect to help them succeed in school and set their sights on higher education.

When Marie came to me for coaching, she was overwhelmed, struggling to do it all herself. She grappled with feeling like a fraud, perfectionism, and fear of failure. It's no wonder, because as a child if she didn't do it, it meant neglect for her siblings.

Marie finds it difficult to ask for help and to delegate. She is very private about her business and struggles to manage her workload, which includes raising funds to run the organization. "What would happen if you did ask for help?" I inquired.

"I'm worried that if I do, people will think I'm not capable," she answered, "and that it would put too much burden on my team. I also worry they won't perform up to my standard, and I'll have to do it over again anyway."

Marie is in her sixties and would like to ratchet back on work so she can travel and enjoy more time with her husband. "My dream is to get away for weeks or months at a time. I would love to find someone else to run the nonprofit, but we don't have the funds to hire an executive director. And I worry about my team. I feel obligated to continue raising funds to keep them employed." This is a long road to navigate, as Marie uses her own funds to keep the operation afloat and pays herself last, and often there are no funds left for her.

Notice the parallel with her childhood.

When I shared this with Joshua, he explained how the child and adult situation are isomorphic. "We see this so often with parentification. Isomorphism is a psychological concept in which we set up situations in our adult lives that mirror the almost impossible situations we survived as children. Freud referred to this as 'repetition compulsion' to describe our unconscious drive to recreate the very difficulties in childhood we're trying to avoid as adults. Because we were adaptive and survived difficulties in childhood, our brains wired to continue these same behaviors to drive us forward to successfully manage future challenges and adversities. The payoff is we survive and we're confident we can weather future storms. The cost is we stay stuck in an often destructive unconscious pattern and continue to recreate adversities and challenges that remind us of our childhood challenges. It's a bit like the Myth of Sisyphus, where we keep rolling a boulder up a hill and watch it roll back down, or like the movie *Groundhog Day*, where we wake up and it's the same time, the same day, and the same events that we're dealing with."

These situational patterns and beliefs that we developed in childhood to survive are not really needed in our adult lives. And yet these patterns operate unconsciously below the surface, keeping us trapped in conditions that we may not really want.

Limiting Societal Norms

Another aspect that contributes significantly to Impostor Behaviors is societal norms. These norms fuel much of the inequity that out-groups experience in their academic and work lives. Nowhere is this more pronounced than in how

people advance in their careers and in how they are compensated for their work.

A 2001 research study on entitlement by Brett W. Pelham at the State University of New York, Buffalo, and John Hetts of Ohio State University reveals the enormous impact of societal norms on gender pay equity. Here's how the study went. Imagine you're asked to take part in an exercise for a small cash prize. The requirements are simple: you're given five minutes to solve a set of twenty anagrams.

After those five minutes, you're asked to fill out a ten-item self-esteem questionnaire. Then you're asked to estimate the number of anagrams you solved correctly as compared with others in the study. And finally, you're asked to pay yourself an amount of money (from $0 to $2.50) you honestly think you deserve for your performance of the task.

A typical anagram in the study looks like this:

INTHK

That one is straightforward enough, right? Unfortunately, what you don't know is that most of the anagrams aren't nearly as simple as the one above. In fact, fifteen of the twenty in the set are *extremely* difficult. They look like something closer to this:

LITLCAME

So after likely struggling through the anagrams, the study invites you to ask yourself: "How did I do?" What the researchers found is that how you estimate your performance and what you decide to pay yourself actually have a lot to do with your gender.

[*Solution: THINK*] [*Solution: METALLIC*]

The Results

In the study, participants solved an average of 3.24 anagrams, with women solving slightly more than men. In the self-assessment of performance, both men and women believed they performed worse than their peers. But here's the catch: the women paid themselves just *half* of what the men did, with an average of just under $1.00 for the women as compared to almost $2.00 for the men.

Pelham and Hetts found that the women's self-pay was based on how they perceived their own performance. The better women felt about their performances, the more they paid themselves. However, perceived performance did not predict what the men paid themselves. Instead, it was their feelings of self-esteem that had the biggest impact. Men who scored higher in self-esteem after taking the test paid themselves significantly more for their work.

This finding has major implications for how we think about gender equality in pay and advancement.

When I shared these results with one of my clients, a CEO of a 150-employee technology start-up in San Francisco, he stared at me in disbelief. "How could these women pay themselves so differently from the men?" he wondered. And what could he, a CEO committed to creating gender equity in his company, actually *do* in light of this finding?

The Entitlement Gap

Self-pay is a measure of what people believe they deserve for their work. In other words, it's what people feel *entitled* to. And what we're entitled to is dictated by societal norms. Viewed through this lens, the anagram study is essentially a lesson on entitlement's impact on self-pay.

In our culture, entitlement has a negative connotation, but we haven't always felt this way. In the 1960s the word "entitlement" became associated with government benefits such as Medicaid and food stamps, which effectively shifted our society's sentiments, associations, and definitions of the concept, relating entitlement to *a handout*. Prior to these programs, entitlement simply meant to have a *rightful claim* to a possession, privilege, designation, or mode of treatment.

In our work, we support the notion of "healthy" entitlement. Studies like the one above demonstrate that women suffer from a depressed sense of entitlement as compared to men. Elevating entitlement to a healthy level for both genders would go far to improve gender equity in the workplace.

The anagram study measures what each individual perceives as their rightful claim to compensation. What it found was that societal norms create a clear distinction between genders on the basis of a "rightful claim." The men based their rightful claim on their feelings of self-esteem, whereas the women based their rightful claim on their perceived performance.

The men in the study felt an elevated sense of entitlement by virtue of their gender and stature in society. So of course they felt rightfully deserving to pay themselves more. The women, on the other hand, felt a depressed sense of entitlement, based on their perceived performance, which resulted in paying themselves less.

Entitlement Impacts Advancement

According to an oft-cited Hewlett Packard internal report, men apply for a job when they meet 60 percent of the qualifications, but women apply only if they meet 100 percent. Men

thus feel more entitled than women to pursue advancement or promotion, even when they feel (or even if *they are*) less qualified.

Women's depressed sense of entitlement is rooted in the idea that they have been socialized to base their entitlement to advance on *past* performance, whereas men tend not to believe this about themselves at all. For most men, the past is the past. It's all about the future. *Can I do this job? I think so. Therefore, I will.*

But here's the big catch for women. When it comes down to it, it's impossible to feel qualified to meet a position's requirements based on past performance, given that advancement itself requires new skills and responsibilities. *So how do you know if you're good at something new if you've never done it?* These feelings of entitlement to promotion help provide context for why we see so few women, and so many men, in positions of power. To achieve gender equity in promotion and advancement, we need to find ways to elevate women to healthy levels of entitlement, similar to those of their male peers.

But how do we achieve this?

The same concept of transparency used to close the gender pay gap could also be applied to closing the advancement gap. A recent study conducted by PayScale found that (in most industries) when people agree or strongly agree that their organization is transparent in how pay is determined, then the gender pay gap closes at all levels. To put it another way, when compensation is openly discussed in a company, everyone can achieve equal pay for equal work, regardless of gender.

What this idea boils down to is rather simple: When men and women ask themselves "What do I deserve?" based on the

experiences of how they're treated in society, their answers are quite different from each other. Unless there's transparency in the process, it's highly unlikely that women will tell themselves they deserve a pay bump or a promotion.

Transparency in this case might call for opening a dialogue between men and women to help women understand how men assess their readiness for promotion and advancement. In this way, men become agents of external validation for pay equity and advancement for women, as well as for individuals in underrepresented groups. We might also call upon men to advocate for high-performing female colleagues when they're ready to step up in their careers. When men tell others that a woman should be promoted, they send a strong signal to everyone (and most importantly, the woman) that she is ready to move up, even if she doesn't feel entitled to the promotion.

I have personally benefited from several instances of these very circumstances in my own professional life. When I look back on my career, I advanced most when my male colleagues advocated for me, especially when I didn't feel qualified. By offering me their unconditional support, these men helped give me permission to learn on the job and ditch the notion that I had to meet 100 percent of the job qualifications before taking on more responsibility. They also had me advocate for the compensation I deserved—which was often much more than I expected.

When we open the dialogue, increase transparency, and destigmatize the concept of healthy entitlement, we invite everyone to participate in the process of helping women overcome the societal norms that stand in the way of achieving their highest potential. In doing so, we offer a proactive way to change the criteria by which women judge their own

deservedness. This is well worth the effort, because when we elevate women to a healthy sense of entitlement, we level the playing field.

Childhood Trauma

One's sense of entitlement can also be rooted in trauma and childhood experience, as it is for Joshua. "It was a few days before my eighth birthday, and I was living in a neighborhood that had a man-made lake in its center. I was an only child, and one hot, summer day while my parents were working, they had my cousin come over to babysit me. They told me in no uncertain terms that I was not to swim in the lake while they were at work, but of course the moment they left, I snuck out with my friends, and we took off on our bikes to the lake.

"But unbeknown to me, there was good reason for my parents to have concern. Despite being so young, I was a strong swimmer. But the lake had a powerful drain in its center, and as I swam near it, it pulled me down and held me there. I struggled, and I knew that if I didn't break free of the suction I would drown.

"I remember as I was being pulled down to the bottom of the lake, I said to myself 'I'm going to die' and felt the temperature get colder and colder as I descended deeper into the darkness at the bottom. I immediately thought of my grandmother, who had died just a few years before. I saw her face and remembered touching her ice-cold skin when I kissed her forehead as she lay in the casket.

"Suddenly something switched inside me. I said 'no' and somehow I summoned the strength to fight. I kicked and was able to swim hard enough to make it back up to the surface. My friends helped me to the shore just as my cousin pulled me

up out of the water. I begged my cousin not to tell my parents what happened. But he did. And they summarily cancelled my eighth birthday.

"So I nearly die and somehow survive, which is traumatizing enough, and what happens next? No presents. No party. No celebration whatsoever. And I was grounded so I couldn't see my friends. But some of my friends snuck presents by and gave them to me through my bedroom window. Regardless, it was miserable. I felt terrible for having violated my parents' rules, and so sad that the birthday I was so looking forward to had been cancelled.

"Two years ago, as my birthday approached, my friends were asking me what I was going to do to celebrate. I told them I wasn't into birthday celebrations, and that I'd do what I always did—work. But this time a dear friend asked why I didn't like celebrating my birthday. And it hit me like lightning."

After Joshua's parents found out about him defying their rules and nearly drowning, his childhood brain concluded that he must be a bad person. And that as a bad person, he didn't deserve to celebrate his birthday. He concluded at the young age of eight that he wasn't entitled to birthday celebrations. And so he unconsciously came up with excuses to avoid celebrating his birthday for the rest of his life.

"I realized that the shame and guilt of defying my parents, combined with the imprint of that near death experience had led me to believe I wasn't worthy of a birthday celebration," he told me one day over coffee. "This was an odd realization, because despite being black, I've always had a pretty strong sense of entitlement in business. My father was a very successful businessman and served as the chair of Minority Business

Development under President George H. W. Bush. I believed I could do anything I wanted in life. Except, apparently, celebrate my birthday."

Feeling Like a Fraud

There are so many dynamics in our early lives that lead us to develop Impostor Behaviors, it's no wonder so many of us experience them. These behaviors fuel our need to hide our true selves in order to avoid shame and gain external validation. And with that we feel like a fraud. But given that we are hiding our true selves, and withholding our authentic expression in the world, the irony here is that we *really are* being fraudulent. When we seek the approval of others over trusting in a solid sense of our intrinsic, autonomous value as individuals, we abandon our true selves. We don't feel deserving and entitled to success, which limits our potential. When we can't stand fully in our personal truth and uphold our intrinsic value, we live lives that are less fulfilling than we deserve.

A year later, for Joshua's forty-sixth birthday, he went big. He hosted a party for himself and invited all of his close friends, and the evening included great food and wine, music and dancing, and yes, even presents. Going forward he plans on celebrating many more birthdays to come.

Proving that it's never too late to experience a breakthrough.

CHAPTER 6

BADASS BOUNDARIES

"I'm so frustrated, Kate." Sarah was back in my office for the start of our next session, and up to this point we had made some great progress.

"Really? Last time we met you were so excited to explore what's next for you."

"I am. That's the problem. Now that I have some direction, I'm frustrated because I don't have time to take on anything new. I'm already struggling with balancing work and family," continued Sarah. "There are only so many hours in a day, and there's never any time left over to do what I want."

"I know it seems that way," I reassured Sarah, "but in reality, how you use your time is a reflection of your priorities, and you are in control of your priorities more than you think! Imagine if every time you told yourself '*I don't have time to do that thing*,' you instead rephrased it to '*That thing is not a priority*.'"

"You mean that instead of saying, '*I don't have time to explore what's next*,' what I'm really saying is, '*Exploring what's next is not a priority*'?" asked Sarah incredulously.

"You got it. How does that feel?"

"Awful! I want to explore what's next! But too many things get in the way. And I can't just drop them."

"Of course you can't," I agreed. "But we can explore how you set your priorities, as well as how your perfectionism and

other Impostor Behaviors can negatively impact the way you use your time and energy, both at home and work."

Sarah's right. We can't do everything. But we can make choices to determine what we *will do* given our finite amount of time and energy. These choices are our priorities. And our priorities become more manageable when we establish personal boundaries.

Personal boundaries are the limits (or parameters) that we establish in our relationships with people and can help us assess what actions we take. They reflect what we feel we're entitled to. But equally important, they determine what we're willing to give (or tolerate) without compromising our physical, emotional, and spiritual well-being. As Joshua explains, "Our boundaries are actually somatic, meaning they live in our bodies. As such, boundaries are felt more than seen. It's that *felt sense* that indicates where we end and others begin. Your personal boundary creates a protected, sacred space around you, in which *you and only you* get to decide what gets in and what stays out."

That's not to say that a boundary is always exclusionary. Boundaries work both ways, as Joshua further clarifies. "Boundaries are badass when they allow us to say '*No*' or '*Back off*' to things we don't want. However, they're equally as badass when they encourage us to say '*Yes*' or '*I can*' to what we really, really want! It's your ability to know and assert your boundaries that reflects a healthy sense of self-worth, ensuring that you're not subject to other people's judgement, expectations, and needs."

As I talked with Sarah about boundaries, I suggested, "If you're curious where you may lack robust personal boundaries, simply consider areas of your life where you wish others would treat you differently."

"Like what kind of areas?" she asked.

"Well, a lot of our clients say, for example, they wish their managers would be more aware of their workload before assigning them new projects or loading on additional work. Or they wish their spouses equally shared in childcare duties or helped out more around the house. Any of that resonate?" I asked rhetorically.

"Yes. Please! All of the above!"

Triggers

Personal boundaries are critical to alleviate Impostor Behaviors because they shield us from being overly reactive to negative things (or the things we perceive as negative). But when our mental and emotional boundaries are not sufficiently strong, we instantly and unconsciously internalize things we don't want to deal with. These things include unwelcome requests, judgement, criticism, problems, unexpected feelings, or the overwhelming emotions of others—which, in turn, triggers our Impostor Behaviors.

As an example, let's consider Jana, a senior product manager at Amazon. She describes her role as both stimulating and challenging, because the caliber of talent across her department is high. But so are the expectations and pressure to perform. Jana and I first met just after she and her team had presented their annual plan to the VP in charge of her department. His response to her presentation was great, but he felt she could "think bigger."

When Jana took the Impostor Breakthrough assessment, she scored high in Rejection Sensitivity. So it was no surprise that her immediate reaction to her VP's feedback caused her to take his input as searing criticism (even though he most

likely meant for his comments to be constructive). This triggered deep and unconscious feelings of shame, which caused her to shut down. She ended the meeting abruptly and quickly left the room. But it didn't stop there. The VP's remarks stayed with Jana for weeks, causing her to question whether she was really qualified and deserving of her position at the company.

Even though all that sounds extreme, her reaction is completely natural, as Joshua tells us: "When Jana's boss told her to *think bigger*, she experienced this as a threat. As a result, her fight-flight-freeze response took over. Fight or flight is a primitive survival instinct that results in instant hormonal and physiological changes. These changes are designed to get you to act quickly to protect yourself. Your heart rate goes up, which increases the oxygen flow to your major muscles so you can take quick action. Your pain perception drops, and your hearing sharpens due to the adrenalin that courses through your veins."

This may sound like your body is getting ready for a fight. And back when we were hunter-gatherers, that was probably true. But now that we've evolved from caves to boardrooms, shouldn't our brains know the difference between a real threat and a perceived threat?

Not necessarily.

Even though you've evolved, there is still a reptilian part of your brain that spontaneously responds to certain stresses as if your life were threatened by a predator. At that point, a bodily process older than humankind takes over.

"When your body perceives fear, it releases the stress hormones adrenaline and cortisol to get you away from a perceived threat and into safety. This reaction is biologically timed to last around thirty seconds, just enough time to get you out

of danger. However, the fear doesn't go away that quickly, and the body can still perceive that a threat lingers out there in the future. As a result, the parasympathetic nervous system can counterbalance the physical effects of stress," says Joshua, "by slowing down your heart rate and your breathing, often to the point of holding your breath, as if your body freezes in a motionless state of protection against a future threat. This is why the first thing we teach people to do when they're triggered is to BREATHE so they can reset their nervous systems away from fear and freeze and into feeling safe again."

Jana's reaction to the VP's feedback in the meeting was first flight, then freeze. When she created the *exit* she needed ("Meeting adjourned!"), she went into flight mode and immediately left the room. Then after that she went into a paralyzing freeze mode by never meeting with the VP, thus missing out on the potential benefits and valuable insights his feedback could provide.

Triggers Are Reactions to Boundary Violations

When your boundaries are breached, your body experiences it as a threat to your personal safety. Instantly and unconsciously, this perceived threat triggers your fight-flight-freeze responses. Strengthening your personal boundaries can greatly reduce your tendency to be triggered into fight–flight–freeze mode.

Upon sharing this with Sarah, she decided that her boundaries were fragile when it came to how she negotiated her workload, whether it was at home or at the office. As a result, there was never any personal time for anything that mattered to Sarah. "Okay, so let's continue from there," I offered. "Tell me about the things that infringe upon the time you allocate for yourself, especially the ones that tend to trigger you."

"I guess what triggers me the most is when my boss adds work to my plate when I'm already overwhelmed. I'll go into a project review meeting with him, and somehow during the meeting he'll add three more things to my already way-too-long to-do list. It's all too much! When he does that, it overwhelms me, so I go on autopilot and just write it down and don't object. But then I get back to my desk, and I feel terrible. I'm so tired of having to get up early before my family wakes up *and* stay up late after everyone goes to bed at night, just to keep my head above water."

It should come as no surprise that it's incredibly common for our clients to struggle with saying no to what they don't want. Consequently, these same clients struggle to establish boundaries so they can set limits for what they take on, including when and how they work. Because when they overemphasize external feedback, seek approval, and avoid criticism, they quite often end up taking on more than they're actually comfortable doing. Unfortunately, this tendency spills into all areas of their lives, which creates anxiety and leads to burnout. It's simply not sustainable.

The good news is that when we work with clients to develop and strengthen their personal boundaries, our clients reduce their triggers and quickly shift these troubling dynamics in their lives.

Strengthening Your Personal Boundaries

Triggers are emotional reactions that are out of proportion to the situation. They arise instantly and unconsciously, making it difficult to manage your emotions. The first step in resolving those triggers is to become less reactive, and to do that you must develop strong personal boundaries.

Now that Sarah had identified one of her triggers (her boss adding work to her already overflowing plate), it was time to do some somatic work to strengthen her personal boundary. Once again, Joshua puts it all into perspective for us. "When you create somatic awareness, you tune into your *felt sense*, which tells you what feels *right* and what feels *off*. Your *felt sense* is a physical body awareness, not a mental experience. When you bring your awareness into your body and slow down, you make it easier to notice the energetic, emotional, and sensory landscape. This frees you up to focus on sensation, movement, and feeling, with the goal of going inward. From here your awareness naturally shifts from external to internal and gives you a sense of greater calm and control."

Your somatic perception of where you end and where others begin forms your personal boundaries. Thus your *felt sense* is a key tool to becoming aware of what feels right to you and what feels off. By trusting your body to tell you this, you can transform your boundaries so that they better serve you.

I had Sarah take a couple of balancing breaths by breathing in through her nose as she raised her outstretched arms toward the ceiling (with palms facing up), and then exhaling through her mouth as she lowered her arms (with palms down). "Like leaves falling off of trees in autumn," as Joshua says. After that I invited Sarah to explore her personal boundary. "Put both arms out in front of you," I instructed, "with palms facing forward and fingers pointing up, as if you're pushing something away.

Sarah did so, and I could tell that she was already getting increasingly comfortable in this exercise.

"Great," I acknowledged. "Now look at the back of your hands and imagine that the space between you and the back of

your hands is your own sacred, safe space. Nothing gets in that space unless *you* allow it in. *You*, and only you, decide what you bring in and what stays outside."

A big smile spread across Sarah's face.

"Okay, good. Now take a deep breath and really feel into that space." I paused to let her take in the moment. "Tell me what you notice."

Sarah closed her eyes, took a few more deep breaths, opened her eyes, then focused on the space in front of her between her and the palms of her hands before she replied, "I get a sense of calm, like I have a protective buffer around me that is all mine."

"How is that helpful?" I asked

Sarah thought for a second and then said, "I feel like I can relax a little bit, and I notice that my breathing is more even."

"That's great," I replied. "Now slowly move the backs of your hands closer to your body, coming near your chest and shoulders. When you do this, you decrease the space between you and the back of your hands. Once again look at the back of your hands now that they're closer to you and notice how that feels."

Sarah complied and was visibly surprised. "Wow, that's so strange. When I move my hands closer to my body, it somehow feels constrained. My chest tightens, my throat constricts, and my breathing becomes quicker and more shallow. Honestly, I feel a little panicky."

"Nicely noticed!" I congratulated her. "Now slowly move your hands away from your body again, all the way out, beyond where they were before, and notice how that feels."

"Whew, I can breathe again, really breathe," she said with excitement. "It feels good, spacious and way more relaxed. I have a sense of freedom and expansiveness here!"

Finally, I had Sarah move her hands to where she thinks her personal boundary was when she met with her boss. "Yikes. It's way too close. The back of my hands are about six inches away from my chest!"

"Okay, then move your hands farther away. Find a more comfortable place for the space between you and your boss."

Sarah moved her hands about a foot and a half away from her. "Ah. That feels better. Not all the way out, as I do need to be open to what he has to say. But not so close, either."

"Now just focus on the back of your hands and imagine that you're meeting with him. But this time with this amount of sacred, safe, personal space around you. You let in only what *you* decide to allow in. Just settle into that space and breathe. How does that feel?"

"I'm much more calm and grounded—and confident. Like I can push back if I need to, rather than just taking everything in."

"I'm so happy to hear that. Now breathe and integrate that feeling into your system, so that your system will remember *how this feels* the next time you meet with your boss."

Butterfly Tapping

Sarah was making such great progress, and I wanted to be sure she would deeply integrate what she was learning into her system. "Cross your arms around your chest area and rest each of your palms lightly on the opposite upper arm. Imagine you're giving yourself a warm hug. Does that feel comfortable for you?"

"Yes, it does."

"Very slowly, alternately tap each hand on each opposite arm. Tap one hand on one arm, then the other hand on the

other arm. You might do this to the rhythm of your heartbeat. And breathe as you do it. Notice what you feel."

"Ahhh. It's really relaxing and soothing. I like this."

"I know. I agree! This is called butterfly tapping. It's a technique used to calm your body. It allows you to be present with the work you're doing. You can even butterfly tap in meetings by resting the palm of each hand on the same-side thigh, then alternate light tapping on each thigh. Or you can alternate tap your feet on the floor. This is an amazing technique to use when you feel yourself tensing up or becoming stressed or anxious."

Joshua explains how it works. "Alternating butterfly tapping stimulates both sides of the brain. For example, we use butterfly tapping in Eye Movement Desensitization and Reprocessing (EMDR) therapy to help clients find a resourceful place in their bodies so they can safely process fears or worries of future problems, as well as traumatic memories." Joshua is an expert in EMDR, a technique he utilizes when he works with clients with PTSD, including the United Kingdom military. "But butterfly tapping can also be used in day-to-day situations to calm and ground yourself," explains Joshua. "It works because both imagining the future and recalling the past are triggered in overlapping regions of the brain. Bilateral stimulation, which is what we are doing with butterfly tapping, can reconcile the two. This process awakens the whole brain and is believed to facilitate the refiling of memories into useful places in the brain and body."

The effectiveness of this process can be best illustrated by once again looking at how it's used with EMDR therapy. "We store active information in what is known as *working memory*," reveals Joshua. "In EMDR therapy, when we activate a

disturbing memory or thought of something worrisome that might happen in the future, we bring it into working memory. Bilateral stimulation opens the lines of communication between the brain hemispheres to engage the whole brain so it can process what's in working memory. When we experience emotionally charged memories and thoughts, we do so with just one brain hemisphere activated. The other hemisphere shuts down so the mind can focus on acting quickly in a fight-flight situation. When we butterfly tap, however, we activate both sides of the brain while relaxing the body. This decreases the intensity and vividness of the disturbing memories and worrisome thoughts so they can be refiled with less emotional charge."

Why is this helpful to us? Joshua clarifies, "By reducing the emotional charge on the thoughts and recollections held in working memory, we actually alter older memories with a newly updated experience through bilateral stimulation. We can be more objective and process the past without feeling upset—because the emotionally charged thoughts no longer consume our thinking. When original stressful memories are replaced with more positive ones, when we look to the past as a guide, we experience a more positive outlook about the future."

That all sounds great, but at this point you might be asking yourself how can simply rhythmically (and alternately) tapping your body possibly calm down a nervous reaction that takes a lifetime to develop? "The secret to butterfly tapping is a psychological effect called reciprocal inhibition," explains Joshua. "Reciprocal inhibition involves tensing one muscle group while relaxing an opposite one. For example, to reach out and grab your cup of coffee using your right hand, your

right bicep relaxes and your right tricep has to engage. If you look at your right arm, you'll see these larger muscles are opposite each other.

"The same concept applies to butterfly tapping. To relax your brain, you have to activate your left and right hemispheres alternately. Tapping the left hand on the right arm activates the left brain hemisphere (which controls feeling on the right side of the body), and tapping the right hand on the left arm alternatively activates the right brain hemisphere (which controls feeling on the left side of the body). This allows you to use both sides of your brain to help your mind and body relax quickly."

Boundary Violations

We first learn about our boundaries as the result of how our parents or caregivers relate to us as infants and children. All infants have natural rhythms for desired connection and disconnection. It gives an infant or child a sense of safety and well-being when a parent or caregiver is responsive and honors their cues for connection and disconnection.

Yet no parent is perfect.

It's easy to misunderstand a child's cues, which can rupture a child's sense of personal boundary. Ruptures are a normal part of parenting and can strengthen a child's resilience and stress tolerance so long as the caregiver successfully repairs the injury to reestablish safety and reconnection.

Infants coo or smile to express a desire for connection. On the other hand, they avert their gaze or turn their head to the side when they need to disconnect, according to research by Dr. Ed Tronick, a parent-infant mental health specialist. Tronick also observed that depressed mothers, like Maria's

(from chapter 5), were less likely to be attuned to a child's cues for connection or disconnection and therefore were more likely to violate boundaries.

Having poor boundaries, and the resulting propensity to be easily triggered, can emerge as a result of the boundary violations we experienced as children. Jack Rosenberg and Marjorie Rand, somatic psychologists, identify three common patterns of boundary violations in childhood.

Invasion: An invasion boundary violation is the result of a caregiver who consistently misreads signals for disconnection. The parent or caregiver simply does not recognize the child's need for space. Or the parent may use connection with their child or infant to fuel her own need to feel loved. In some cases an invasion violation arises as the result of abuse. Those who felt invaded as children have a tendency to develop a rigid boundary style. In this case, their boundary serves to protect their most vulnerable feelings. As adults, these individuals can become isolated and develop extreme independence, feeling as though they can rely only on themselves to take care of things.

Abandonment: Contrary to an invasion boundary violation, an abandonment boundary violation results when a caregiver is not responsive to signals for connection. With abandonment violations, children learn to override their own natural need for connection and disconnection. To survive, they instead develop an instinct to seek connection at any cost. These individuals tend to overly adapt to the needs of others, and feel hesitant to set limits with others for fear of rejection. They also have a tendency to become enmeshed, losing their sense of self for the sake

of a relationship, or taking care of others at the expense of their own needs, which can result in resentment and anger.

Combined Invasion and Abandonment: This combined boundary violation results when a caregiver alternates erratically between being invasive and unresponsive. Children who experience this combination cannot develop a reliable strategy to meet their needs. Thus they develop a pattern in which they alternate between longing for connection and a desire for disconnection.

When I explained these boundary violations to Sarah, she reflected on her present-day boundary patterns, along with the dynamics in her childhood. "I think my boundary violations were mostly invasion. I have always felt loved and supported by my parents, but I remember, from a very early age, strife and conflict between them constantly. I'm sure this affected their ability to be consistently aware of what I needed and when I needed it." Sarah stopped and then added as an afterthought, "I really relate to being fiercely independent and feeling like if I want something, I have to make it happen myself."

It's not too big a leap to connect Sarah's tendency to take on more work than she can handle with the invasion violations of Sarah's childhood. The independent nature that resulted from those violations has led her to believe that if something needs to be done (and done right), she must do it herself. It's this realization, however, that opens the door for Sarah to revise her boundary. It's up to her to create other options that better serve her and give her more of what she would like, which is to eliminate her tendency to overcommit and overwork, thus freeing up more time for herself.

Strengthening the Sense of Self

Now that we're up to speed on boundaries, let's get back to Jana, our Amazon executive who was told (very publicly in a meeting) to *think bigger* by her VP. After taking Jana through the same somatic boundary exercise as I did with Sarah, we were ready to expand her boundary to better protect her from external-input triggers. "And we'll strengthen your sense of self," I also told her, "so that you can evaluate input intentionally and consciously, rather than react to it reflexively and unconsciously. What's the name of the executive who told you to 'think bigger'?" I asked pointedly.

"Terry."

"Let's go back to that moment when Terry challenged you in the meeting to 'think bigger,' but this time with your personal boundary in place." Just as I had done with Sarah, I instructed Jana to "Put your hands out and show the safety buffer you would've needed in that meeting."

Jana moved her upturned hands forward and backward in front of her until she settled on the right place. "Here. I'd say about a foot and a half in front of my chest. This feels good."

"All right, now we're going to step into that same uncomfortable meeting moment, but this time with your boundary in place. Then we'll work through Terry's comment in slow motion, stopping where we need to investigate and repair. Are you ready?"

"I guess so. I'm surprised by how nervous I am now just thinking about it," she confessed.

"That's completely normal. Just breathe, and we'll take it slow," I reassured her. "We can stop any time and regroup if needed. Now with your boundary in place, step me through what happened right before Terry spoke."

It was clear from her expression that Jana took herself back to that meeting, even though the memory was tough on her. "I had just finished my presentation, and we were doing the Q&A. I felt confident because I thought the presentation went well, and the questions I got showed that others liked what they heard and were supportive. Then I looked at Terry, and I could tell he wanted to say something."

"Okay, stop right there," I interrupted. "Step into that moment and show me where your boundary was right then."

Jana again moved her hands forward and back. "Wow. I'm feeling really exposed, because I can't read Terry's expression. So I think my boundary was about here." She positioned her hands a mere six inches in front of her. "I feel my chest and throat tightening, and I'm holding my breath!"

"I know this is hard, but stay with me," I encouraged her. "Take a few breaths, notice the weight of your body, and then *feel your butt* in the chair. Allow the chair to hold you. Now push back your boundary to where it's more comfortable."

Jana moved her hands out about a foot. "Ah, this feels a lot better," she said. "It's much easier to breathe with my hands here."

"Okay, now restart the memory, but this time when Terry speaks, keep his comment on the other side of you palms, outside your boundary."

"All right," Jana replied quietly. I could tell that Jana worked hard to imagine the scene with her boundary in place. "The Q&A is done. It's silent," she reflected. "I looked at Terry, and he said, 'This is great, but I don't think you're thinking big enough.'"

"Stop there," I interrupt again. "Tell me what you feel and the emotions that accompany that feeling."

"It's kind of like a gut punch," Jana admitted. "My stomach feels like it's cramping up, and my shoulders just got really tight. I can feel my face turning red. It's like I'm under attack and need to protect myself." Jana's voice dropped to almost a whisper. "I'm devastated. I feel like I've let my team down."

"All of what you feel is because Terry's comment bypassed your boundary and you internalized it immediately," I informed her. "It triggered you. So now let's move it out. Go ahead and bring your hands to your chest like you're scooping up his comment, and with a strong exhale push it out forcefully with both hands, far away, and say '*Back off!*'"

I asked Jana to do this three times. Each time I could tell she said it with a little more confidence. After the third time I asked her, "Is Terry's comment completely outside your safe space?"

"Yes," she answered with relief. "It did take a few times of pushing it away. But now it's safely far from me. That feels so much better."

"That's because you're not triggered—you pushed his comment out from where it landed in your body after automatically internalizing it."

Now that Jana knew how to send Terry's negative input far away (to somewhere *out there*, beyond her boundary), I wanted her to step into this new perspective. "When you consider his comment from a safe distance, well beyond your personal boundary, what do you notice?"

"Honestly, it feels a lot less charged," she said casually. "I'm actually curious about what he means. My team worked really hard to push ourselves to think big. So I'm a bit surprised by how he doesn't see that. We thought our proposed plan was pretty bold."

"That's great. Notice how much more resourceful you are when you feel curious, as opposed to when you're triggered," I offered. "Also notice that when you're not triggered, you can be more objective. For example, what do you know to be true in the moment Terry made his comment?"

Jana smiled at her revelation. "That my team and I worked hard and did a great job. We pushed ourselves to think big. I'm proud of the plan we presented." And then she added thoughtfully, "Maybe Terry had something specific in mind when he said we could think bigger. Regardless, my plan was a solid start."

I was proud that Jana could own up to the value and quality of her work. "Can you see how when you internalized Terry's comment, you didn't take into account what you knew to be true—which was how hard you worked, how proud you were, and that you did, in fact, think big?"

"Yes. I feel stronger and more confident now that I realize that."

Jana had come a long way, but I wanted to make sure she knew she deserved an honest outcome. "With your boundary in place, and Terry's comment waiting outside for you to process, what do you think you're entitled to in this situation?"

"I deserved to have my plan evaluated fairly," she responded with confidence. "And to have Terry respect and acknowledge the work we did, even if he sees room for improvement."

"Yes," I confirmed.

"You know the weird thing, Kate? When I view Terry's comment from a distance, I have the confidence to see that Terry actually *does* respect and acknowledge our plan. He's not attacking it. If anything he's endorsing it by indicating he's interested in investing in our idea to make it bigger." Jana

comfortably leaned back in her chair. "Wow, that's crazy. I couldn't see that before, but now it's so obvious."

Since Jana was so responsive in our session, I wanted to make sure that I could get her as far as possible. "Let's try the exercise again, but this time I want you to verbally respond to Terry's comment from this place of composure and curiosity and not from your triggered place."

Jana reran the memory in her head, and then after about a minute, she said, "With my untriggered mindset, I would've replied, 'Your comment surprises me, Terry. I'm curious what you meant, because I worked really hard with the team to push us to think big. And I feel our plan reflects that. Tell me what you think is missing.'"

I smiled at Jana after her triumphant revision.

"Wow. What a missed opportunity that was," she concluded. "Kind of tragic, really. Rather than having enough composure to be curious about what Terry had to say, I shut down. He clarified his point after that, but honestly, I was so offline at that point I couldn't absorb it."

"What about after the meeting?" I asked.

"I never followed up," she replied. "I was so ashamed for having missed the mark. It was right after that I decided to quit, not ever knowing what Terry meant. But it wasn't just that meeting that made me feel like quitting; I was worn out from feeling pressure to perform. Terry's comment was just the straw that broke the camel's back."

"Yes, it was definitely a learning opportunity," I assured her. "And fortunately it still is. Now that you've replayed this experience with your boundary in place, what do you think would've been in the highest and best good for you, your team, Terry, and the company?"

Jana pondered my question considerably before she answered. "Well, I can see how being triggered prevented me from processing Terry's input with curiosity and exploring it further. I could've shown my team that grace under pressure comes with composure, as well as what it means to be open and receptive to feedback and to do so with integrity. Not to mention I probably could've leveraged Terry's insights to create a more impactful plan." She then added ruefully, "I might've even been able to ask for more funding and resources if I had listened to what he had to say. And honestly, I probably wouldn't have felt like quitting. I know my company paid a big fee to recruit me, and they've invested a lot in training me. If I had stayed, the company wouldn't have lost the big investment they made in me."

"That is such amazing insight," I congratulated her. "Now I want you to imagine the next presentation you give in which *any executive*, not just Terry, but *anyone* gives you critical feedback. Tell me how that plays out with your boundary in place. And I forgot a key tip. If you start to feel triggered, count to three backward before you respond at all!"

Jana was definitely more relaxed this time around. "Before I attend any meeting, I'll spend a minute or two getting my boundary in place. After that, I'll feel so much more grounded and confident. Now that I'm aware of how I can slow things down in the moment if I get critical feedback, I'll just breathe and *find my butt* in my seat and count to three backward if that happens.

"I'm also aware that whoever I'm presenting to actually wants me to succeed as much as I do, because we're all on the same team."

"Do you think you'll be able to do all that on your own?"

Jana was silent for a moment, deep in reflection. "When the time comes, I'm not sure that I can actually be this calm and composed," she confessed, "but I'm hopeful. I see how having a strong boundary allows me to be even more bold and take greater risks, which has always been the secret of my success . . . until the stakes got too high. But I must admit, this is definitely a game changer for me."

In most cases, when someone challenges you to think big, or when you receive critical feedback, it's intended to improve and amplify your work. But if you feel threatened, you can feel your butt in the seat and count to three backward as you breathe. This gives you the time you need to compose yourself and take a broader view of the situation by giving yourself a safe distance with your boundary. Doing so allows you the space to ask, *What's in the highest and best good for everyone involved?* Assuming everyone has positive intentions, you can look at *all input* as an invitation to elevate your contribution and presence within the company.

Buying Time

Your boundary isn't just about demanding the respect you deserve for the work you've done, even if that work could be better, as was the case with Jana. It can also be about setting the limits for the work you *haven't done* (or don't want to do). The currency for work isn't just the salary you receive for doing it; more importantly it's your time. Often setting a boundary means protecting your time by saying *no* to more work.

Once again, let's revisit Sarah and her dilemma of how to balance family and career. Due to her new somatic experience, we had her boundary in place. So the time had come

to strengthen her internal sense of self and work with her to redesign the dynamics with her boss.

I wanted her to experience her triggering moment the way Jana did but with a different outcome. "Let's step back into that meeting with your boss, this time with your personal boundary in place. Replay the memory starting right before he gives you more work, and let's see what happens."

Sarah's hands were outstretched in front of her to physically establish her boundary. "Well, for one thing, I feel a lot more calm even being in the room with him. Before I had my personal boundary, I got anxious before I'd meet with him. But now I feel a lot less vulnerable and exposed."

"And how would he add more work to your load?" I asked.

"He'd say something like, 'Hey, I need you to pull together a presentation about the Infinity project so I can present it to the executive team on Monday.' Normally, that would trigger me big time, because it's already Thursday and I'm trying to get enough work done so I can actually take the weekend off to spend time with my family." Sarah paused to really allow the memory to resonate. "I can feel that sinking feeling in my chest and my jaws clench."

"Nicely noticed," I observed. "Now pause the memory. Let's push his request outside your personal boundary. We know it snuck inside because of your physiological reaction to his request. Cup your hands and scoop out that request; forcefully push it as you exhale through your mouth and say, *Back off!*" I had Sarah do this three times. And as I saw with Jana, I could see relief enter her body as her shoulders dropped and her face relaxed. She actually formed a slight smile.

"What do you notice now?" I followed up.

"I like having his request *way out there*, away from me. From there, I can actually separate it from everything else on my plate. Kind of like when I was a kid and I made sure the vegetables didn't touch any of the other food on my plate." With that image in mind, she giggled. "Okay, so now I get to decide if I am going to eat my peas, I guess."

"That's right. With your boundary in place, *you* get to decide what enters your safe space to consume your time and energy. Knowing that, how might you respond to his request now?"

Sarah took a deep breath before she answered. "Well, I'll take a second to decide how committed I am to not working over the weekend. And I'm pretty committed to that! I've been working nonstop, and I notice in just thinking about this that I really do need a break. So I might say something like, 'I'd be happy to do that. But here's the challenge. The briefing on the company we've acquired is scheduled for Monday morning. And it's more than a full day of work to complete that. I had already booked all day Friday to work on it.'" Sarah was about to continue, but I asked her to hold up once again.

"Okay, stop there," I quickly interjected. "You've done a great job at keeping his request outside your boundary—you haven't accepted it. At this point, if you just let your comment sit in silence, you force your boss to come up with solutions. Instead of automatically taking on his request and trying to solve it yourself, you can be silent so you leave it with him to suggest *how* to manage your conflict. How do you think your boss will respond?"

Sarah smiled. "He knows how hard I work, so I can't imagine he'd have the audacity to ask me to work on his project over the weekend. So I think he'd either say he'd take care

of it himself, or maybe he'd ask for a short phone call to get the information he needs for the presentation."

"Well then, problem solved." I concluded. "And you didn't have to do any of the solving! Sitting in that moment, aware of your weekend plans and your full workload, what do you deserve and what are you entitled to?"

"I deserve time off on the weekends! I deserve to spend time with my family," she blurted out triumphantly. "Kate, I work really hard, and I deserve to be able to negotiate my workload and deadlines in such a way that I don't kill myself."

"I'd take it one step further," I added. "Yes, you're entitled to spend time with your family. But in general, you're entitled to get enough sleep and to have evenings free without having to finish up your work. What do you think your boss thinks you deserve?"

"Well, actually, I do think he thinks I deserve all that," Sarah reasoned. "He often comments on how much I work and expresses concern that I'll burn out. So maybe if I take the time to meet with him to discuss my workload, we can come up with a better solution together."

"Yes. And that brings us to a very important question. What is in the highest and best good for you, your boss, and your company when it comes to managing your workload?"

"Clearly they want me to stay," Sarah said confidently. "I'm a high performer and have been recognized several times with awards within the company. They need me to be creative and productive, and I can't do that if I'm struggling with burnout. I used to love working more, but with my family and work pressure, it's really hard now. If we could relieve some of the pressure, I think I could come to love my work again, and that's in everyone's best interest."

"Great. Can you imagine using this in the future when work becomes too much?" I inquired.

"Yes. In fact, I'm going to create a list of everything I'm working on and bring it to my boss tomorrow so we can prioritize together," she said with a new sense of relief.

"That's a great idea," I agreed. "And when you do, I suggest you make it your personal goal to take at least three things off the list or at least push out their due dates. More important than saying yes is saying no to things that are not urgent and important so that you can free up time to take care of immediate needs."

"I can't wait to do this. If he responds like I think he will, it will also go a long way to improving our work dynamic. And that is also in the highest good for everyone."

Sarah was making great progress. But even so, there was still one more thing we needed to discuss, and that was her tendency toward perfectionism. I suspected she spent a lot of time and energy trying to make things unnecessarily perfect. So I drew an analogy for her. "Think of that part of you that's prone to perfectionism as an internal boss. You can use these same boundary principles to negotiate your workload when it comes to perfectionism."

"But I don't *feel* like my investment in high quality work is negotiable. It's who I am."

"Okay, then let's pretend that the *perfectionism part* of you is a demanding boss, and then let's put that boss outside your boundary. And then the part of you that is committed to balance in your life stays inside your boundary. Can you think of an example when your *perfectionism part* pushes you to work longer and harder than the *balanced part*?"

Sarah snorted. "Only about a thousand of them! That's my everyday state. For example, I was recently preparing to present the acquisition-due-diligence report to the executive team, and I finished it a day early. But of course I continued to tweak and revise and rehearse, going over and over my presentation for the rest of the evening and the next morning before the meeting. I'm exhausted just thinking about it."

"That's a great example! So now let's put your *perfectionism part*, and its demands, outside your boundary. What do you notice?"

Sarah sat for a moment, imagining what life was like with her perfectionism at a safe distance. "Wow, just like with my real boss, I notice that *my need to redo* is actually negotiable. My *perfectionism part* is really bossy and overbearing. But when I put her outside my boundary, I can actually feel the part of me that craves balance, wants to rest, and enjoy my family. Usually her needs are drowned out and overrun by the bossy one."

I laughed at Sarah's personification of her characteristics. "Just to be fair, I suspect the one you call *bossy* has actually been really important to you throughout your life. Let's just appreciate her for a moment and reassure her that you aren't trying to silence her or take her job away," I said with a wry smile.

Sarah laughed. "Yes, I have to admit, she's brought me all my success. She's made it possible for me to take risks and try new things. And she keeps me from crashing and burning when the stakes are high."

"Well done. So in light of that, tell me this: Is the pressure from *the balance part* of you helpful when the stakes are high? And by the way, what do high stakes look like for you?"

"Well, they're only high when I want to be thorough or make sure I know the answers to any question that might arise," she said. And then she paused before adding, "It's not like I have to worry about things like being publicly humiliated or getting fired."

"So *the bossy part* of you doesn't even factor in whether the stakes are high or not, let alone question the need to continue to work well beyond your limits. Can you see that?"

"I can now. I guess that's pretty important to consider."

"It is," I concurred.

When we're struggling with perfectionism, the question we always ask ourselves is, *Have I done enough?* And with our perfectionism driving the car, the answer is almost always *no.* "So Sarah, let's get back to when you completed that first draft," I continued. "With your *perfectionism part* on the outside of your boundary, and your *balance part* on the inside, let's ask *both* parts to answer the question, '*Have I done enough?*'"

"Of course the bossy one says '*No! Do more! You might've made a mistake!*'" laughed Sarah. "But the *balance part* of me says, '*Hmm, let's put this in context. If there is a mistake, and if you don't deliver your presentation perfectly, how bad could it be?*'"

"Sounds like she's a voice of reason," I said.

"She is. And now that the two of them are talking, they're actually coming to a compromise, believe it or not! I'm shocked, but they have agreed to do one full run-through of the presentation, then put it away," Sarah said playfully. "The bossy one sees that maybe it's not as high stakes as she thought."

I decided to continue in this playful mode with Sarah, since she was obviously open to it. "Now let's fast forward and imagine what happens if you do just one full run-through of

your presentation and then put it away. How does it feel going into the meeting?"

"For one, I'm rested and have a lot more energy than I usually do. I see myself actually making jokes and laughing before the meeting starts."

"And if someone asks a tough question or challenges your diligence, what then?"

"I know I've done good work and that I've done as much as I was realistically able to do, given the constraints of my time and energy," she replied confidently. "So I just answer the question and, if I don't know the answer, I say I'll get back to them. It doesn't feel like such a big deal."

With that, Sarah leaned back in her chair, sat in silence, and closed her eyes. I could see the wheels spinning in her head. I quietly asked her to butterfly tap so that this important new awareness could integrate into her system and eventually make its way into her cells.

After a long moment of silence she opened her eyes. "That's it, Kate. Enough. I have never had the luxury of feeling like I've done enough. Or hell, even like *I am* enough. I've always looked outside myself to figure that out. I've been waiting my whole life for someone to tell me that I've done enough—or give me permission to stop and rest. And now I see that it's *me* who makes that call. *I'm the one* who decides what is enough. I'm the one who gives myself permission. I am entitled to do just enough. What a colossal relief that is!"

And with that, Sarah left my office ready and excited to say *no!* when necessary. From then on, she began perfecting the art of knowing when enough was enough and how to create the time she needs for herself, and her family and to explore what's next.

CHAPTER 7

DEALING WITH CONFLICT

When most of us think of conflict, we imagine an uncomfortable or difficult situation with another person or group of people. It's the kind of conflict that anyone with ears and eyes can see, because quite often it involves a lot of loud talking and cross facial expressions. Because this type of conflict is on display for all to witness, we refer to this as *external* conflict. Dealing effectively with external conflict is critical when exhibiting Executive Presence. Being able to maintain composure and connection while disagreeing with others is part of the foundation of good leadership.

Yet there is another type of conflict that plays just as important a role in how we handle disagreements and opposition, and that's *internal* conflict. Internal conflict comes from within when we have conflicting beliefs or needs. And like its counterpart, internal conflict keeps us *stuck* and prevents us from having the outcomes we desire. What's more, internal conflict can shake our composure.

Let's take a look at both, starting on the inside and working our way out.

Internal Conflict

To explore (and resolve) internal conflict, it's helpful to think of conflicting beliefs and needs as different aspects of one's personality, like Sarah did in chapter 6 with the bossy and

balanced parts of herself. These subpersonalities influence how we feel, perceive, and behave, and they shape our core beliefs and identity.

One of these subpersonalities is called the *inner critic*. The inner critic is that annoying narrative of nagging thoughts that runs rampantly through your head, casting doubts on your self-worth. It loves to point out all your flaws and mistakes and is a master at undermining your accomplishments, no matter how great they are. The inner critic hates to be ignored, so it can get loud—so loud that it can have an oversized negative impact on your behavior and shape how you live your life. Without intervention, the inner critic conflicts with your curiosity and willingness to take risks. But worse, it prevents you from trying new things, because it likes to focus on the possibility of failure, instead of success. When left unchecked, the inner critic thwarts your motivation to learn and grow, leaving you stagnant and paralyzed from moving in any direction—but particularly from moving forward.

The Marshmallow Test

The Marshmallow Test is a fascinating study of inner conflict: in this case immediate versus delayed gratification. It was conducted by Walter Mischel of Stanford University in 1972. In the experiment, four-year-old participants are left alone in a room, each with their own scrumptious marshmallow temptingly placed on a plate in front of them. Before leaving the room the facilitator offers them an agonizing choice: "You can eat this one marshmallow as soon as I leave, and that's all you get. But if you save your marshmallow until I return in ten minutes, I'll give you another one, and then you'll have two marshmallows. But only if you wait until I get back." You can

search online for "The Marshmallow Test" to watch the video of these four-year-old participants fighting delayed gratification. It's hilarious!

The kids used ingenious tactics as they attempted to hold their diminishing willpower in check. Some sat on their hands, some looked away, others brought their marshmallows to their noses, inhaling the fragrant smell deeply and then quickly putting them back on their plates. And then there were those who couldn't wait. Some ate their marshmallows before the facilitator even left the room!

The Marshmallow Test is the classic setup for an inner conflict of competing desires or motivations, which arise from conflicting beliefs or needs. In the field of psychology, inner conflict is often referred to as *cognitive dissonance*, a term that refers to conflicting and inconsistent thoughts, beliefs, and attitudes. While the inner conflict in the Marshmallow Test is obvious (the desire to eat one marshmallow immediately versus waiting to eat two marshmallows later), many inner conflicts are far less apparent. Quite often, in our grown-up world, it turns out that one side of a conflict can exist on an unconscious level, while the other side is a conscious thought or belief. Such cases are confusing, because you may not understand why you feel conflicted about an issue or situation in which the solution should be obvious.

Interestingly enough, the results of Mischel's study were exactly opposite what was originally predicted. Researchers posited that having the reward right in front of them would incentivize the participants to delay gratification. Waiting a mere ten minutes sounds pretty easy to do to get a second marshmallow, right? But instead, the rewards themselves served to increase the children's frustration and ultimately

thwart their ability to delay gratification, even at the risk of losing a second treat.

What does this mean?

Surprisingly, the results indicate that *not* thinking about a reward (as opposed to focusing on it) enhances the ability to delay gratification.

Feeling Stuck

Unconscious internal conflict often shows up when we feel *stuck*. In these situations we know what we would like to do, or should do, but we can't seem to make ourselves do it.

One of our clients, Alexis, creates TED style talks and presentations for thought leaders. Years ago, she reached out to us for coaching because she wanted to take her business to the next level. She had come up with a list of high-profile thought leaders who could benefit from her services and whom she'd like to have as clients. She tells us in her own words, "It wasn't that hard to come up with twenty people I'd love to work with. These are authors and business leaders that I admire."

To prepare to reach out to these target prospects, Alexis scoured her network to find multiple people who could provide her with an introduction or referral. She revamped her website and crafted brilliant introductory emails that highlighted her work and her unique and compelling process.

But she kept procrastinating on the final step—reaching out to make contact with her prospects. She couldn't get herself to do it. "I am really motivated and excited to grow my business with these amazing people," she admitted, "but honestly I'm terrified they won't respond." This fear was, of course, related to Alexis's rejection sensitivity and lack of confidence; two Impostor Behaviors that emerged as problematic when she took the assessment.

To work through the conflict, we'd need to explore the unconscious half of the conflict that kept Alexis stuck. Once we identified both the conscious and unconscious personalities in conflict, we could curiously explore the intentions of each, and *appreciate* the powerful good of both.

"I'd like you to tell me about your inner struggle when you think about making those calls and sending those emails," I requested. "Tell me about each subpart of you that's involved."

Alexis thought for a minute. "One part of me is really excited and eager to reach out, because I know it will bring me challenging and inspiring work. It'll be joyous to collaborate with these extraordinary people and their ideas." Then she paused before she added, "Plus, I know it will bring me a lot of confidence and financial reward."

"And that's all good, right?" I reassured her. "So what about the other side?"

Alexis smiled shyly. "Well . . . another part of me is terrified to attempt contact, because I'm kind of in awe of those people. They feel bigger than life. And I know I'll be devastated if they don't return my calls and emails. I mean, they're very successful. I'm sure they're busy and have a ton of people reaching out to them. Why would they talk to me?"

Alexis knew what she needed to do, and she had a solid plan that we both knew *should* yield results. And yet with two powerful and opposing motivations keeping her stuck, the question was, *How do we get her unstuck?*

On the One Hand, On the Other Hand

"I love the way you've so clearly articulated your competing internal dynamics," I said. "Now let's boil that inner conflict down to a single sentence, using the phrase, '*On the one hand, on the other hand.*'"

"Okay, I'll try," agreed Alexis. She paused to collect her thoughts and then started with, "On the one hand I want to reach out to exciting new clients so I can grow my business. But on the other hand, I can't bring myself to contact them, because I'm terrified they won't respond and then I'll feel disappointed . . . even hopeless."

"So what I'm hearing is that on the one hand, you want to grow your business with exciting new clients," I recapped, "but on the other hand you want to avoid potential rejection and failure and disappointment. Did I get that right?"

"Yes, exactly!" Alexis replied enthusiastically.

"Great. Now let's boil down your internal conflict into two words. What two words represent these conflicting desires?"

"Let me think . . ." she began. I could almost see the wheels turning in her head. "Success—no, that's not it. *Ambition*. Yes. Ambition represents my desire to reach out to exciting new prospects."

"And the other side of your conflict?" I prompted.

"Hmm . . . fear. No. Wait. How about *safety*? Yes. Safety would be a good word to choose for my desire to stay *safe* by not making the calls so I can avoid potential rejection."

"Great. So on the one hand you want to be *ambitious*, and on the other hand you want to be *safe*, and those two things are in conflict and keeping you stuck."

"That's it!"

Disassociation

In our work we often use the concept of disassociation to work with challenging or emotionally difficult topics. Disassociation, in this context, comes into play in situations in which we encounter resistance to envisioning and exploring alternatives to current circumstances.

When we associate ourselves with a situation internally, we see the situation through our own eyes as if we were actually living and breathing it, even if it's never actually happened! In other words, being associated means that we experience an imagined situation or dynamic with a similar level of emotional intensity, as if we were actually experiencing it in real life.

When we are disassociated, however, we see the same imagined situation from afar, as if we were looking down on it, disembodied from ourselves. This separation distances us from the emotions of the situation, which makes us less triggered, more curious, and in the end, pleasantly resourceful.

One powerful way to shift a situation from associated to disassociated is to use metaphor. The *"on the one hand, on the other hand"* technique I introduced to Alexis is designed to do just that. By looking at both sides of her conflict, Alexis can distance herself from the actual fear and anxiety she experiences with regard to reaching out to her target prospects. With emotional distance from fear and anxiety, she could be more curious and come up with creative solutions. Once we have the kind of perspective distance offers, we're able to explore tension by using metaphorical concepts and objects.

"Alexis, please turn your palms upward and hold them out in front of you," I instructed, "cupping your palms as if holding a small object. Now place your words in your hands, one word per hand."

Alexis put the word *ambitious* in her left palm, and the word *safe* in her right.

"Now, please imagine an object that best represents the concept behind each word. It's usually best to choose the first thing that comes to mind, no matter how strange or silly."

"Hmmm. That's hard," she admitted. "Oh, how about this. A lightning bolt for *ambitious*. And this is kind of silly, but how about a warm blanket for *safe*."

"Those are great objects! They both pack a lot of meaning and embody the energy of those meanings within the object. Nicely done. Now let's appreciate and acknowledge both sides of the conflict as important and positive. Appreciating and empathizing with the intentions behind both sides is the first step in resolving any conflict."

Alexis smiled as she embraced the thought of both objects.

"Now tell me about the good each object wants to bring you. What are their positive intentions?"

"Well, the lightning bolt is easy," she replied with a smile. "It's trying to create financial well-being, while giving me challenging and inspiring work."

"And the warm blanket?" I followed up.

"That's a little harder. It feels like . . . it's keeping me stuck and hiding."

"That makes sense. But I assume it's keeping you stuck and hiding *for a good reason*. What good things come to you when you're under a warm blanket?"

Alexis giggled at the irony of being *stuck* under a warm blanket. "I'm comfortable! And I feel safe."

"Perfect. Now let's appreciate the objects in each hand and their importance even more. Can you please tell me what *ambitious* and *safe* have meant to you throughout your life?" I inquired. "And how have those characteristics shaped you as the person you are today?"

"Sure. The lightning bolt's ambition has brought me a lot of success. It's led me to a career that I love. I've met amazing people and learned fascinating things from their ideas. It's allowed me to push the envelope of my creativity as I work to

bring their ideas to life visually and with words." Alexis took a deep breath, quite satisfied with her answer.

"I can see your lightning bolt lives very strongly in you today," I responded, "and has been vital to your success. It's nice to appreciate that. Now tell me about the warm blanket."

Alexis suddenly got serious. "Well, who doesn't love a warm blanket?" she replied rhetorically. "The part of me that is the warm blanket keeps me safe from criticism and judgement. I grew up in Oakland, California. I was one of a small minority of white students in my high school. I had long blonde hair, and I couldn't have stood out more. Worse, I was a cheerleader and a dancer, which brought me more attention. Although I did get along well with the other girls on the cheer squad—and frankly with most kids at school—I wasn't always *that* well-received by some of the students and fans in the bleachers on game night. On *really bad* game nights in which I was ridiculed, I went home and crawled into bed with my childhood blanket. That brought me a lot of comfort and made me feel safe." Alexis sat for a moment to let her memory sink in. "I think that experience was pretty traumatic. It definitely led me to be more cautious about standing out and to not do things that might invite rejection."

"Wow, that must have been so difficult because you were doing something you loved, and yet it caused you to suffer. I'm so sorry you had to experience that."

"Thank you. I guess that experience really impacted my willingness to take risks. But it also made me more compassionate and aware of racism in our country," she concluded. "That's why I strive for a diverse client base, which I'm proud to say I've achieved. Black and brown voices should be heard. My work helps unlock their genius and gets them onstage at

conferences like TED. It's super rewarding when I help make that happen."

"It sounds fantastic," I lauded. "Now can you think of a character name for each object? It helps to personify them so they can find ways to work together."

"Well, the lightning bolt is easy. He's Usain, the sprinter," she laughed. "And the warm blanket? Hmm. It's definitely a girl. How about Hannah?"

"I love it. Now we're ready to see if we can find a way to have the two conflicting parts of you work together. Are you ready?" I asked. "More importantly, are *they* ready?"

"Well, *I* certainly am. And Usain (lightning) bolt can't wait. But Hannah is really reluctant. She's worried that Usain will get what he wants but in the process will leave me exposed and unsafe."

"Okay, that's fair. So how about this?" I negotiated. "Let Hannah know that whatever we come up with, if she doesn't think it will keep you safe, she can veto the whole thing and we can go back to how things are now. Will that work for her?"

"Yeah, I guess so," Alexis agreed. "Hannah does want me to have what I want, so she's willing to try. But she is fully prepared to use her veto power if needed."

"Great. So now let's see what each of them want for you, if they could solely be in charge. Let's start with Hannah."

"All right. As I've said before, Hannah wants three things: to keep me safe, protect me from rejection, and protect me from failure," Alexis listed. "When I'm warm and safe with Hannah, I feel calm and happy. And feeling warm, safe, and calm gives me a sense of well-being. And that brings me happiness and *peace*."

"Wow, that's pretty powerful. No wonder Hannah has such a strong influence on you! What about Usain?"

"He wants me to have a rich and rewarding professional life," she replied with a wry smile. "He knows it's super fun to collaborate with extraordinary people. My work brings me so much joy, and Usain knows that when I'm working with interesting and successful people, life is fun and satisfying." Alexis suddenly got pensive when she added, "I know I'll be proud and really happy when I land a few of these high-end clients and bring their ideas to life. But right now it seems like I'm always on a treadmill. There's always more for me to do professionally. If I can do this, however, I know I can relax a bit."

"And what will that do for you?"

"It will bring me a sense of peace and well-being, knowing that I'm working at my highest potential."

"Isn't that interesting?" I questioned. "So both Usain and Hannah actually want pretty much the same thing. They just have very different strategies for getting it!"

"Wow, yes, I see that. Interesting."

Once Alexis fully appreciated both sides of her internal conflict, acknowledged the good they both intended for her, and became aware that they wanted the same thing, she was ready to start a somatic exercise. Designed to help these conflicting internal parts work together creatively and collaboratively, the somatic exercise attempts to bring together Alexis's conflicting parts to create new and better ways for each to help her achieve her best interests.

"Okay Alexis, since Usain and Hannah both want to provide you with happiness, peace, and well-being, do you think they're ready to work together to come to a common, positive outcome?" I asked.

"Yep, they are," she replied confidently.

"Great. Now with each object held in your hands, and with your hands in front of you, turn your palms to face each

other, and slowly bring them together until you enclose the two objects in your palms with both hands," I instructed. "You will notice that sometimes you will actually feel resistance, like two repelling magnets. That's normal. When that happens, don't force it; just stop and breathe, and when the resistance fades continue to move your palms closer together."

Slowly Alexis's palms came together, with three stops along the way where she closed her eyes and breathed until the resistance faded.

"How does that feel?" I gently inquired.

"Well, it feels super calm and much less *heavy*."

"Great. Just keep breathing while holding your hands together. Now tell me, did the objects change in any way when they came together in your palms?"

Alexis closed her eyes to reflect for a moment and took a deep breath. When she opened them, she verbally painted a lovely image. "I imagined the lightning bolt as a sparkly bright light floating into the blanket. The blanket then wrapped up the lightning bolt to keep it safe and warm . . . and to recharge, so it can come back as even more powerful the next time I need it."

"How might that metaphor apply to real life?" I asked. "So that these two powerful parts could work as a team?"

"I'll start with baby steps," she replied thoughtfully. "I'll reach out via email and by phone to only a few of the easier target prospects. Then when needed, I'll *retreat* to my warm blanket to recharge and weather the fear and uncertainty while I wait for responses."

"That sounds like a fantastic plan," I reassured her.

Alexis then told me about three lower-profile target prospects for which she had strong introductions and referrals. She felt these were her best chances of getting replies.

"Great!" I encouraged her. "But rather than define a lack of response as *failure*, let's look at those results as *experimental data* that teaches you how to tweak your approach. So that your next outreach is *even better*."

Alexis left my office energized and excited to put her grand experiment into practice. Of course, the experiment worked better than expected, and two of the three prospects she contacted responded immediately and agreed to a meeting. The third never responded. Alexis followed up twice but with no results. She felt like she had done everything she could, so she let it go . . . and felt fine with the outcome.

The *"on the one hand, on the other hand"* exercise works because it provides three steps as important tools that can help you overcome internal conflict. These steps are:

1. Identify and name both sides of the conflict.

2. Appreciate the positive intentions of both sides of the conflict (often they are two different approaches to the same or similar outcomes).

3. Determine a solution that satisfies the needs of both sides of the conflict.

In the first year we worked together, Alexis's business tripled. She continued to refine her strategy to approach new high-profile clients. Today she works with more than a dozen best-selling authors, professional speakers, and corporate executives.

Work-Life Balance

One of the most common inner conflicts we see in our clients is attempting to balance work and home life. Trying to accommodate the conflicting desires of investing time and energy in work but still somehow carve out enough time and energy for

a personal and family life seems nearly impossible. In the last chapter, Sarah experienced this exact conflicting imbalance. Her desire for perfectionism led her to overwork and overprepare, which was in direct conflict with her desire to have more time to pursue what's next and for herself and her family.

Using the same exercise I did with Alexis, Sarah referred to her conflicts as *success* and *home*. "I am very ambitious," Sarah reasoned. "I always have been. And I derive a lot of joy and satisfaction out of working hard and being successful. But this is often at the expense of my personal life. So when I get home, I'm mentally exhausted. I can barely make it through the evening family rituals before falling asleep." She thought back to when it was just her and her husband. "Before we had kids, I'd exercise in the morning, but now I'm too tired to get up early, so that's fallen to the wayside. This imbalance is really taking a toll."

I had Sarah hold out her palms and choose two objects to represent each side of her conflict. "For *success* I'll choose one of my favorite things," she declared, "a crystal suncatcher that sits on my dresser and reflects rainbows around the room when the sunlight hits it. For *home* I'm imagining a miniature version of the cozy chair I sit in when I read to my kids." Sarah personified *success* and *home* by naming them *Sunny* (the suncatcher) and *Cozy* (the chair).

When I asked Sara to appreciate the positive intentions of the objects in her hands, she first talked about how important Sunny has been throughout her life. "Sunny has always motivated me to succeed and take on new challenges, and that's driven me to work tirelessly. From this I've had so many interesting and rewarding opportunities. Plus, it's made us financially comfortable and secure. Sunny wants me to find joy and satisfaction in what I do every day."

"And what about Cozy?" I asked.

"Cozy calls on me to relax and spend time with my husband, kids, and close friends and family," Sarah replied gently. "She invites me to cook and read and take walks and be outside in the fresh air. Cozy wants me to feel connected and healthy and find joy in my family and in doing the things I love to do."

As Sarah brought her hands together, she experienced a lot of resistance. It took several minutes of stopping and breathing for her to finally cup the two objects together in both her hands. "Wow, that felt so weird," she confessed. "They were two incompatible energies swirling, trying to blend. But they couldn't because they were like oil and water. My hands actually resisted coming together. But when I stopped and breathed through it, the resistances faded. After that it felt like the swirling energies mixed together inside me. I almost feel light-headed now. How strange."

"Very nicely done!" I praised. "That means that your system has made some important internal shifts, creating new ways for you to find balance. Did the objects in your hands change in any way?"

"Yes!" she replied excitedly. "My cozy chair became iridescent and now reflects light. So now when I sit in it, I'm enveloped in a glowing, warm, colorful light that helps restore my energy. But it goes beyond that. In my mind's eye, I now see that I can sit in the cozy, bright chair at home *and at work,* which makes me more focused and productive in either place. I like that combination of cozy and vibrant light energy. It calms me so that I don't feel so much anxiety and gives me a better internal sense of when I've done enough."

"That sounds great!" I extolled. "So now when you think about the tension between *success* and *home*, how does that feel?"

"Much better," she admitted. "Next week I have to work on a big presentation. I envision blocking out the last two hours of the day, turning off my email and cell phone, and taking my laptop to this sunny, quiet sitting area at the office. I see myself with my headphones on, cranking out the presentation in record time, because I'm completely focused and present. After that I close my laptop, knowing that I'm done for the day. I head home with lots of energy, feeling really happy. I don't even check my email that evening. I just leave it to the morning. And maybe I'll even get up early the next morning and do some yoga. Wow, that feels fantastic!"

"It sounds delightful. But what about the things that come up while you work on the presentation?" I asked cautiously.

"I picture myself scanning my phone and emails when I'm done to make sure nothing urgent came up," she confessed. "But then I just let it go. Oddly, in this state of mind, the things I miss don't seem like a big deal."

"How are they not a big deal, when they were such a big deal before?" I asked.

"I'm not sure. But I think my hypervigilance to read and be responsive to emails and messages was how I dealt with anxiety. But now with my new comfy chair I feel like my baseline level of anxiety is much lower, mainly because I'm rested and recharged. So I don't feel the need to respond to everything out of a compulsion to *do something*." Sarah thought about her revelation for a moment and then added, "Kate, I really hope I can keep this up. This feels like it could be a big breakthrough for me. Do you think it will actually work?"

"Yes, I do. And it will get better over time," I reassured her. "Occasionally, I'm sure you'll still experience the anxiety and compulsion to over-work, but I also believe your system has some new tricks up its sleeve to better regulate and restore your energy. As you reap the rewards of this new way of working, and you realize that nothing terrible happens when you *turn off*, your system will readjust to a positive, reinforcing cycle. And over the weeks and months ahead, I suspect you will fundamentally shift your work pattern. So that in the future, when you look back at how you used to work versus how you work now, you'll see a huge, positive difference."

Resistance

The *on the one hand, on the other hand* exercise is a favorite with our clients. And yet there are times when internal resistance is so great that it prevents the objects in each hand from coming together. However, this alternative outcome is completely fine and can actually provide its own insights and discernments. Resistance can result when the desired resolution to the conflict threatens safety and well-being, whether it's perceived or real.

This dichotomy became abundantly apparent when we worked with our client, Lonny. Lonny had a stable government job. But he was also an entrepreneur with a big vision who spent his evenings and weekends working to get his start-up going on the side. Although Lonny had faith that his new business venture would eventually take off, he *was* the primary breadwinner in his family and therefore greatly valued the stability his government job provided *now*.

Lonny's conflict was, *on the one hand*, to remain in his stable job and, *on the other hand*, to leave the security of his job

so that he could focus full-time on getting his passion project off the ground. In the exercise he chose a piggy bank in one hand to represent stability and a star in the other hand to represent a full-time focus on his entrepreneurial endeavor. As he turned his hands to bring the objects together, he experienced a great deal of resistance. "Kate, it's not working," he admitted with disappointment. "It feels like I'm squeezing a rock."

"That's interesting," I acknowledged. "Turn your palms upward once again, and let's explore that resistance. Does it feel like the resistance is from one hand or both?"

"It's definitely coming more from the piggy bank, but not exclusively. I feel it from both sides."

"Let's get a little more insight," I suggested. "If the objects could each speak about their own resistance, what might they say?"

Lonny thought for a moment. "Well, the piggy bank says it's his job is to keep food on the table and the bills paid. He's deeply committed to that and worries that the star is trying to steamroll him into backing down from this important obligation to me and my family," he explained.

"Wow. And what does the star have to say about that?"

"The star insists that it wouldn't take long before the business excels and provides *much more* family income, if only I would take a leap of faith and give it my full focus. The star worries that the piggy bank will drain my energy and that I'll give up on my dream. Clearly they've reached an impasse."

When the resistance is insurmountable, like it was for Lonny, we often ask for a third highly creative object to join the fray as a mediator to see if it can collaborate with the two conflicting objects to find creative solutions and move beyond the impasse. Lonny thought for a minute and then brought his favorite creative childhood toy—a set of LEGOs—into

the conversation. With the assistance of the LEGOs as mediator, Lonny was able to find some middle ground. "The piggy bank agrees to allow me to give up my government job and move forward with my business under three conditions," he reasoned. "First, before I leave my job, I must save up a minimum of six months living expenses; second, I need to have my first paying customer in my new business lined up; and third, at least two additional prospective customers must be in the sales funnel, with a more than a 60 percent chance of them closing on a deal. Oh, and the piggy bank has the right to determine the probability of the deals closing."

With this agreement in place, Lonny tried once again to bring the objects in his hands together. The resistance released a bit, but not completely. And the objects remained separate and intact with one exception. The piggy bank was now painted with stars. With the starry piggy bank as inspiration, Lonny found a creative way to move forward, thus getting him unstuck from where he was.

External Conflict

As I said at the beginning of this chapter, external conflict is what we think of when we envision conflict in general. It's our go-to idea of conflict. When external conflict makes itself known, we can physically see and hear it. Therefore, by the time we are adults, most likely we've dealt with external conflict in some form or another more than once. As a result, we tend to have more experience in dealing with external conflict than internal conflict.

This is helpful, because based on experience, we know that certain situations are prime breeding grounds for external conflict. But here's the good news—if you get ahead of

external conflict, sometimes you can minimize it or even prevent it from happening altogether.

When Chris first came to see me, he had been a senior director in a small technology firm for almost five years. Three months earlier, his boss, Frank, the VP of Finance, left the company, and upon his departure, Chris was asked to serve in an interim role to manage the finance team. "This was definitely a step up for me," revealed Chris. "I had never been a top-level executive before. But I knew enough to know that to be an effective leader, I had to get the support of my team."

The first thing Chris did was meet one on one with each of the team members to learn more about their roles, their aspirations, and how he could best support them. "While not all of them were thrilled to have me as an interim leader," he admitted, "over the months that followed, I built a solid working relationship with everyone. And we've performed really well, even putting a couple of new systems in place. Plus, we managed to complete the month-end closes on time, which I had previously worried wouldn't be possible."

Chris reached out to me because a close friend on the executive team encouraged him to push to be promoted into the VP of Finance role permanently. "If not," his friend counseled Chris, "the executive team will launch a wide search to externally look for a replacement. You're doing such a great job, the executive team should at least consider you."

For Chris to make such a bold move, he felt the need to be coached first, which is why he came to me. "I know there are areas of finance in which I'm not an expert," he confided, "but I'm doing a really good job in the day-to-day. I just need to figure out how I can convince Kelly, the CEO, to make me the permanent VP of Finance."

I had Chris work with Lee to develop a plan. To start, Lee had him meet with a few members of the executive team to identify the finance support they needed and where the gaps were. During these meetings, Chris also asked what they each thought Kelly (the CEO) would be specifically looking for in the next VP of Finance.

Well-armed with this valuable data, Chris created a plan to show how he would fill the gaps the executive team members had shared with him. He then worked with Lee to up-level his communication so he could begin to operate with more Executive Presence. Starting immediately, Lee also advised Chris to create a concise weekly report for Kelly using this specific format:

1. Identify three breakthroughs from the previous week.
2. Identify three risks or challenges and what Chris is doing to address them.
3. Make requests of Kelly for more resources or support as needed.

The next time Chris met with Kelly was a week after he submitted his first report. At the end of the meeting, Chris asked Kelly about his report format. "Kelly told me the report was great," Chris said. "And two weeks later she even shared it with the other executives as an example of the kind of weekly reporting she'd like from them." Chris knew the report was effective because in their weekly executive staff meetings, Kelly often mentioned one of the breakthroughs from his report. Occasionally she brought up a risk or challenge for broader discussion with the group.

Within thirty days, Chris created a plan to address the gaps identified by the other leaders in the company and a few weeks later presented it to the executive staff to gain

their endorsement. "Lee suggested I get input from each of the executives about my proposal and to make sure they were aligned with it," said Chris. "That turned out to be the best advice ever, because when I finally presented my proposal at the next executive staff meeting, all the other company executives chimed in with their support."

Chris's plan was a success. He secured his proposed budget increase to hire consultants to fill two spots for the more critical initiatives. As a follow up, Chris also met with Kelly to gain insights into any gaps he could address to be more effective. After that, Chris met with Lee to discuss how best to address those gaps in light of his intention to approach Kelly later about being promoted.

At this point, Lee and I met to discuss the best way for her to coach Chris for his upcoming meeting with Kelly. "Kelly will probably need more time to get comfortable with the idea that Chris has the skills required to be a VP of Finance," Lee told me. "But at the same time, she really needs Chris to stay in that role, at least for now." We decided that if the CEO wasn't ready to promote Chris, he would ideally secure a commitment from her to hold off on launching an executive search for a period of three months. In that time Chris could prove himself by executing the plan he crafted with Lee to overcome his inexperience and skill gaps. "This conversation will be delicate," I shared with Lee, "because it's likely to put Kelly in the hot seat. He'll need to make her feel at ease while he pleads his case." To address this, Lee taught Chris the *"on the one hand, on the other hand"* technique that I introduced earlier in this chapter. In addition to dealing with internal conflict, this technique is also useful when dealing with difficult conversations that involve interpersonal conflict.

Even with all his coaching, Chris admitted that he was dreading this conversation. "I'm really nervous. This feels difficult, and there's a lot at stake. What if she says no? I'll be devastated."

"If she is going to say no, then you might as well know now so that you can make decisions and have more control of your future," Lee told him. "That would be much better than being surprised one day when you learn Kelly has initiated an executive search. But remember, our immediate goal is not to get the promotion—though if that happens it would be great. Our goal is to buy you some time to prove yourself before Kelly takes action to find someone from outside the company to fill the VP of Finance role."

Lee suggested Chris jot down what he could say to put Kelly at ease (*on the one hand*), but also include key arguments that powerfully advocate his promotion into the VP of Finance role (*on the other hand*). After several minutes, Chris was ready to practice his opening salvo. A few tweaks and suggestions later, he came up with this as the gateway into their discussion:

"Thank you for meeting with me, Kelly. I'd like to discuss a possible way to make my interim role as VP of Finance a permanent position by way of an official promotion. First off, I want you to know how committed I am to the company and my team and how grateful I am that you've given me this opportunity to prove and challenge myself. Thank you. *On the one hand*, I know you need to have a permanent VP of Finance in place soon. And although I've done well in the position temporarily, I know you're considering searching outside the company to find Frank's permanent replacement. *On the other hand*, I also know there are a few gaps in my skills and experience. But I've really come through and delivered since I took

on the interim role. The team has completed the monthly closes on time, and nothing serious has fallen through the cracks on my watch. Beyond that, we have new initiatives in place to provide the other executives with better insights into the business. I really want to make this my permanent role, and I'd like to share with you my proposal to overcome my skill gaps and explore what would be required to make that happen."

Perceptual Positions

Now it was time to road test Chris's opening pitch to assess how it would land. To do so, we look at the conflict situation from three different angles:

1. From his own self-interest (associate into himself)
2. From the other person's interest (dissociate from himself and associate into Kelly)
3. From a *higher authority* (disassociate from himself and associate into a neutral third party)

The higher authority holds the interests of both sides without judgement and operates in the highest and best good of all. This is called *Perceptual Positions* and is a powerful cognitive and somatic technique that is best facilitated using three chairs.

Lee set up two chairs facing each other and a third off to the side and then had Chris sit in one of the facing chairs. After that, she asked him to close his eyes and drop into that moment in Kelly's office where he would have *the conversation*. Once he was ready, fully embodied in himself, he gave his opening as if Kelly sat across from him.

"What do you notice?" asked Lee after he was finished.

"I was really nervous starting," he admitted, "but it did help to thank Kelly and acknowledge her for giving me a chance to take this on. But honestly I don't really have a good sense of how she'll react."

"Okay, so now let's put you in her chair, as if you're Kelly, and have you drop into her, to see if you can get insights into how she feels about your meeting," instructed Lee.

Lee had Chris stand up, shake out his arms and hands, and recite his phone number backward to clear his mind. Then she asked him to sit down in Kelly's chair and imagine that he's her, sitting in her office, with Chris sitting across from her. "Picture yourself breathing through her lungs, and looking out through her eyes," requested Lee. "When you're ready, give your opening, but react to it as if you're Kelly sitting across from Chris."

Chris did so, but after a couple of minutes, he got a strange look on his face. "I have to tell you . . . I'm all tensed up," he said. "Almost panicked. I'm nervous about what Chris is saying, even though I can tell he's not trying to be threatening." As Chris felt into it more, he added, "She feels bound by . . . something? Like she wants to work with me on this promotion, but something is in the way." After a bit more silence, he got it. "Maybe it's the board? It feels like she wants to promote me, but she's not sure she can. I think she's worried about how she'll convince the board."

"Great insights!" Lee exclaimed. "So now let's shake that off, and sit in the third chair. This chair is for a neutral third party that has in mind the best interests of you, Kelly, the board of directors, and the company. Let's see what you can discover from this position."

Chris sat in the third chair and once again replayed his opening, watching both chairs and imagining what it would

be like to see the scene played out from this neutral, but higher, perspective. "It's clear that Chris is nervous," he laughed, playfully referring to himself in the third person. "And Kelly's nervous. It feels like she doesn't want to tell Chris about her concerns with the board. I also feel like she really does want to give Chris a chance, but she's not sure how to promote him when she's not clear on how she'll get the board to agree."

"That's great. And as this higher third party, what advice would you give Chris and Kelly?"

Chris gave his answer a lot of thought before he spoke. "I think Chris needs to acknowledge in his opening that he knows it's not just her decision, but also the decision of the board of directors," he concluded. "It will relieve her to know that he's aware that the final decision is not entirely in her control. And I think once he does that, she'll agree to work with him on the promotion. She needs to know that *he knows* it might not work out as he hopes, and therefore she can't promise anything. But she supports him and is willing to try."

"So now, from this perspective, what is in the highest and best good?"

"I honestly do believe that it's in the highest and best good to give me a few months to prove myself while Kelly works with the board to relieve their concerns—and for her to give me exposure to the board, maybe include me in a meeting or two, so they can get to know me. It's not clear to me from this position whether that will work, but that does seem to be in everyone's best interest. Because if it does work, it's a lot better on many levels than recruiting from the outside for a new VP of Finance."

Lee asked Chris to modify his opening with all this in mind. Then he went through it again, sitting in each chair.

By the end of this second round, he confirmed that this felt much better. "I was way more comfortable this time, and so was Kelly."

"How so?" Lee asked.

"We talked about the elephants in the room this time," he replied. "And I understood that she felt less stuck, because she realized she could work with the board to accept me while I proved myself. We both know that all I want is a fair shot at the position. But if I can't prove myself to the board after a couple of months, then that's on me. And I can live with that."

With these insights Chris's actual meeting with Kelly went very well. Together they identified the things he'd need to do to come up to speed before he could be permanently promoted to VP of Finance. At the same time, they came up with strategic ways to give Chris more exposure to the board of directors.

But before they adjourned, Kelly made a point to comment on the composure Chris had demonstrated in their meeting. "I'm so impressed by the way you approached this discussion with me," she commended. "I thought the topic of your promotion might come up, and I was worried you'd demand I make a decision immediately, or worse, threaten to leave the company! But you didn't. Seeing how maturely you handled our discussion today definitely brings you one step closer to moving up."

And then she added as Chris was leaving, "I really value working with you."

CHAPTER 8
REVISE LIMITING BELIEFS

It had been more than six months since I last saw Sarah, and when she came into my office, she looked different, more rested and healthy. She had a rosy glow to her skin, and the darkness under her eyes had faded.

"Wow, you look great!" I congratulated her. "I can't wait to hear how things have been. From the looks of it, you found a better balance between work and your personal life."

"I have indeed!" she replied enthusiastically. "I felt a huge shift after our last session. It was like the anxiety and stress that drove me to overwork receded. I've been much more calm at work—I'd even say unflappable. I just don't get wound up like I used to."

"And how are things going with your boss?" I asked, eager to hear more.

"So much better since our last session. Jack and I now meet weekly to align my priorities," she boasted. "I'm really proud of how well I've managed my workload. I actually say no and push back on things when it's too much. Now when I go home, I truly can shut off. I rarely work after the kids go to bed or on the weekends. This has been a wonderful change for our family and for my own health. I started running again, and even have the energy to get myself to hot yoga two or three days a week."

"That's wonderful news! I'm so delighted you've created more time for *you*." I waited to hear more, but when Sarah didn't continue, I asked, "With everything going so well, what brings you to my office today?"

"You may remember that when we first started meeting, I was at a crossroads in my career. I wanted to explore what's next because I wasn't happy at work," she responded cautiously. "With coaching, I've learned to manage my priorities and workload, and I've been able to carve out time and energy to explore. And at the same time my boss, Jack, asked me to work on a very high-profile project that meant more interaction with the executive team. It's been a rewarding challenge for me. I feel like I'm once again part of the pulse of the business—like I have my mojo back.

"Which was your goal," I interjected.

"Yes! Back when we first met, I thought I'd have to leave GGG to find it. But now it's back and I'm happy. So I haven't felt compelled to spend much time looking for my next big thing."

"That's fine! Happy is good. So what's the issue?"

"A few weeks ago I got a call from a recruiter about running the product team at a new company. I'd be a chief product officer. On the one hand it's an amazing opportunity and incredibly exciting. It's a huge step up, and the product is in the early stages, so I'd have the opportunity to really flesh out the concept and build a team to bring the product to market. My role would be vital to the success of the company."

"Sounds perfect! So what's the problem?" I asked.

"*But on the other hand*," Sarah replied with a knowing smile, "I've found a nice groove that elegantly combines my work, family, and personal life. I'm not sure I have the energy

for a start-up. It's pretty risky, too. The success or failure of the company would rest on my ability to create a new product and make it a success. That's a lot of pressure, and it feels really overwhelming. I guess I'm not sure if I'm the right person for the job."

"What does the new company think about you?"

"Oh, they think I'm a perfect fit," Sarah replied nonchalantly. "But I'm worried that I don't have what it takes to pull it off. I'm hoping you can help me sort this out. I don't know if my Impostor Behaviors are flaring up again, or if my instincts and intuition are putting on the brakes for a good reason. I'm really at a loss on this one."

Sarah's unexpected opportunity clearly pushed the limits of what she thought she was capable of and what she feels she deserves—which is a reflection of her beliefs about herself and her identity. Each of us has a unique system of beliefs and convictions that significantly influence our motivations, performance, decision-making, and sense of self. Combined, they determine what we feel we are entitled to. Beliefs shape our ability to deal with stress, as well as the development and design of our plans, goals, and needs. They shape the perceptions of who we are and what we deserve.

Depending on the nature of our beliefs, this process can positively or negatively shape the reality we create for ourselves. When we harbor a firm belief within ourselves, even massive information to the contrary will not sway us. We ignore negativity, and filter it out in favor of more optimistic, self-affirming information. Conversely, the reverse is true for the negative beliefs we embrace, which is why they are so damaging.

What Are Beliefs?

Beliefs are energy-saving shortcuts we use to predict our environment. They are mental representations of how we expect things in our environment to be, so we can navigate and make sense of our complex world. More simply put, they are the patterns our brain expects.

The brain is an energy-demanding organ that essentially acts as a constant "prediction machine." To conserve energy, it takes shortcuts by looking for patterns within the vast amounts of information it processes in real-time. And that's where beliefs come in. Your beliefs allow your brain to distill complex information, by quickly categorizing and evaluating that information.

In jumping to these conclusions, our brains prefer familiarity. Unfortunately, this shorthand makes our brains prone to error. In its eagerness for economy and efficiency, sometimes our brains see patterns that don't really exist. By default it tends to fit new information into existing frameworks of understanding, rather than reconstruct new ones from scratch. This often comes at the expense of accuracy, simply because accuracy would require reconstruction, and that takes work.

Much of our belief system is developed in childhood as a means of keeping us safe, a process referred to as Safety Patterning. Safety Patterning beliefs are typically seared into our brains when we experience severe fear, trauma, or shame. These beliefs then operate unconsciously and can go largely unexamined, even over a lifetime.

Changing Beliefs

People often consider the process of changing beliefs to be difficult and taxing. Yet people naturally and spontaneously

change dozens, if not hundreds, of beliefs throughout their lives. Often beliefs change when a new experience emerges that destabilizes an existing belief. While it may seem as though beliefs are fixed and immutable, the truth is we frequently cycle through our beliefs in three conscious phases:

- What we want to believe
- What we actually believe
- What we used to believe

The cycle of beliefs can be likened to the changing of seasons. A new belief planted in the spring grows into the summer, where it matures and takes root. In the fall the belief begins to feel outdated. Finally in the winter, the unwanted (or unneeded) of the belief are released and fade away.

For example, let's revisit Alexis from chapter 7. Recall that Alexis creates presentations for thought leaders, particularly for high-profile events such as TED Talks. Alexis developed a plan to reach out to a well-vetted list of potential clients that were perfect for her services. Although she had everything in place to start contacting her twenty prospective thought leaders, she struggled to make her first call.

What were the limiting beliefs Alexis most likely had that kept her from making that first call?

Alexis worried that after she reached out to her prospects, they wouldn't reply. By default she would interpret their lack of response as rejection. As we explored her fear further, however, recall that she revealed this: "These people are important, they're busy, and they won't be willing to take time to talk with me or learn about how my services might benefit them. Honestly, Kate, I'm not even sure I can deliver on my promise of what I offer. They have already achieved so much success."

Alexis's experience lives in stark contrast to Lee's time working overseas. Recall that Lee transcended the gender and cultural divide to become the head of a multibillion-dollar business at Samsung. Korean business culture is not known to be particularly female-friendly. Women are a rarity at Korea's top 500 corporations, representing just 3 percent of all executives in 2018. At that time, among the 500 companies, almost two-thirds had no women executives. Lee not only excelled in that culture to secure a plum executive role, but she also became one of the highest-paid executives, male or female, in Samsung's European divisions, earning more than many of the male presidents under whom she worked.

When it comes to limiting beliefs, unconscious patterns hold us back and get in the way of what we'd like to accomplish. Lee is the counterexample of that. That's because Lee's inherent positive beliefs and healthy sense of entitlement have fueled her success throughout her career.

Developed in Childhood

To deconstruct how Lee was able to achieve such success without the requisite contacts or experience, we took a deep dive into her belief structures. Lee never hesitates to pick up the phone to call anyone. That fearlessness was key to her success at Palm when she built relationships between our small start-up and more than a dozen top Silicon Valley C-level executives.

The seed for success was planted in Lee's childhood, during which her parents made her believe she could do anything she set her mind to, *even as a girl*. Lee's father was a very successful New York City ad executive—a Mad Man. Her mother was a nurse and a socially savvy woman. "Throughout

my childhood, I was exposed to hundreds of powerful, successful people," recalled Lee. "My parents entertained frequently in our home. At their parties I was comfortable and eager to approach people and engage with them. I suppose as a kid I didn't really know who these people were. But I did know some were incredibly wealthy, that there were the politicians and business executives present. I was definitely aware of their power and influence in the community."

When I asked Lee what she believes about herself that makes it easy for her to reach out to high-profile people. Her response was straightforward: "I have always believed that what I have to say is interesting and important." Digging down even further, we uncovered a core belief that was instilled, not only by the powerful people who frequented Lee's childhood home, but also by the close relationships she forged at the other end of the spectrum—the domestic workers and their families with whom she became close in her formative years.

"I guess I just believe that you're no better than me, and I'm no better than you," Lee surmised. This belief made her unabashed about making calls to set up meetings with the Silicon Valley elite.

Whereas Lee's beliefs propelled her career, Alexis's kept her paralyzed. Unwilling to email or pick up the phone to reach out to her handpicked prospects, she explained her reticence as follows: "These are luminaries and thought leaders. They're way more successful than I am. I assume what I have to say is not important to them."

As we explored the origin of her belief system, Alexis revealed that she grew up with a father and older sibling who both have neurological and developmental disorders that cause them to be emotionally detached, disengaged, and distant. She

grew up in an environment where what she had to say felt unimportant to two of the people closest to her. As a result, it is no wonder that she grew up with the belief that what she has to say is not important to important people.

The Belief-Experience Cycle

Many beliefs are unconscious, so they can be difficult to identify. But when beliefs linger below the surface, they become reinforced unconsciously through confirmation bias. In confirmation bias, people tend to favor information or experiences that confirm their beliefs. In other words, they gather or recall information selectively, or they interpret it in a biased way. That means when confirmation bias exists, people might interpret ambiguous or neutral data as evidence that supports their existing position, whether it's true or not. With this in mind, you can see how feedback and the *interpretation* of that feedback reinforces limiting beliefs.

An important first step in shift limiting beliefs is to bring them out of hiding, from the unconscious into the conscious. From there, we can build conscious awareness of the experiences we have that either reinforce or counter that belief. When we have sufficient evidence to the contrary of a limiting belief, we destabilize it so it can be replaced with a more positive belief.

Alexis's prospecting experiment served to destabilize her limiting belief that important people are not interested in what she has to say. When two out of three of her target prospects responded positively and expressed interest in her offer, she logged this consciously as evidence that at least some important people are, in fact, interested in what she has to offer. "It was a big surprise," Alexis revealed. "When I hit the

send button and retreated to my warm blanket, I was pretty sure that I wouldn't get any responses. And that would be demoralizing. But when the first, and quickly thereafter the second, prospect returned my emails and scheduled a phone meeting, I was shocked. And then after that, I didn't really believe they'd show up for their phone meetings. But they did! And I landed a project with one of them. This really shifted my perspective."

The next few prospects Alexis contacted proved critical to shift her belief. "I kind of thought the results of the first three were a fluke. After all, I had cherry-picked some of the easier and lower-profile prospects on my list," she confessed. "So I decided to run the experiment again, but this time with five prospects, two of which were high profile and more challenging."

"Were you as anxious and unsettled as the first time?" I asked.

"A little, but not as much. I convinced myself that even if none of them responded, at least two from the first three did," Alexis concluded. "So it would not be a total failure. I also tried to view this effort as an experiment in which there is no failure, only new information that I could integrate and act on to get better results. But my second outreach was way better than I had expected. Three of the five responded this time, though the third came almost two weeks after my initial email."

"Did you learn anything in your phone calls with the prospects whom you met with?"

"Yes. During our calls I asked what made them curious to connect with me. They all said that it was my email and how I talked about distilling the essence of their ideas into a

compelling narrative in order to bring them to life. That was something they all really wanted—to have their ideas brought to life. And yet not one of them felt they could do that on their own. I learned that my outbound messaging hit a nerve. That knowledge gave me even more confidence to continue to reach out."

What emerged was a new belief. Alexis now believed that she provided something valuable and unique to the people she'd most like to work with. And she felt confident that her formula would work on at least half of those she contacted, maybe more. She could now assume with some certainty that when she reached out to the twenty prospects on her list, even being conservative, she would likely receive a positive response from at least half. Such an outcome would be enough to bring her a few new interesting and lucrative clients.

As a result, Alexis couldn't have been happier. "This experience has been amazing, because now I actually believe I'm good at selling, even when it includes prospecting for new clients, which has always been difficult for me. Before this experience, I thought I sucked at that and wasn't willing to try. But now I know it's a numbers game, and I have a proven approach, so now I can practically predict the results."

Notice the number of new beliefs Alexis formed. *That her formula works. That it's a numbers game. That at least half of her prospects will respond.* She also retired a few, old limiting beliefs. *That people wouldn't want to hear what she has to say. That they wouldn't return her calls and emails.* Alexis even formed a new identity, that of a successful salesperson who excels at prospecting for new clients. As a result, her self-worth grew. She now believes she's worthy of working with important people who believe she has something valuable to offer.

Freewriting

I knew Sarah's current conundrum would also be perfect for us to explore some of the persistent, unconscious limiting beliefs that were getting in her way. I handed Sarah a piece of paper and a pen and said, "Sarah, I'd like you to make a list of things you believe to be true about your situation right now, both good and bad. I'm going to set a timer for five minutes, and in that time please jot down as many as you can. But here's the key. Don't stop writing, and don't edit yourself. Even if you don't know what to write, just keep going. Write down something—anything! For example, if your mind goes blank, write *'thinking . . . don't know what to write . . . still thinking.'"*

This technique is called freewriting, and it's the topic of my friend Mark Levy's book *Accidental Genius*. As Mark explains, "Freewriting is a fast way of thinking on paper. It enables you to reach a level of thinking that's often difficult to attain during the course of a normal business day. This technique helps you understand the world, spot opportunities and options, solve problems, create ideas, and make decisions."

The secret to freewriting is to write fast and continuously. Mark asserts that "fast, continuous writing improves thought by relaxing you." How fast? "I'd say about as fast as your hand moves when you scribble a note to your best office buddy that says something completely neutral like, *'Couldn't wait for you anymore, went to lunch at Giuseppe's.'* That fast. By writing fast, your mind can operate close to the pace of normal thought."

But why *continuous*? Why not write a little bit, take a break, and then write some more? What's the big deal about making it one long writing session, as opposed to lots of little ones? As Mark explains, "By writing continuously, you force the edit-crazy part of your mind into a subordinate position,

so the idea-producing part can just keep spitting out words."
When you take a break from writing, your brain instinctively
wants to go back and edit what you just wrote *to make it bet-
ter*. But if you don't give your brain that opportunity, then the
organic thoughts just keep flowing!

When the five-minute timer rang, Sarah had composed
quite a list! Here are some of the thoughts that Sarah captured
in her freewriting:

Positive Beliefs

- I have a solid track record and deep experience in my
 industry.
- I know how to develop products.
- I'm good at building teams, and people enjoy working
 with me.

Negative Beliefs

- I am not yet qualified to be a C-level executive.
- I don't know how to run a full product team.
- I'm not experienced enough to head up a product for
 a start-up.
- I'm not executive material.
- It will take too many hours and be too much work.
- The stress will be too great.
- I'll have to sacrifice too much if I take this on.
- I don't do well in high pressure interviews.

We certainly had a lot to work with! "When you look at
what you've listed, what do you notice?" I asked Sarah.

"I definitely have a lot more negative beliefs than positive
ones," she answered thoughtfully. "And I'm kind of surprised
by some of them. I thought I had more confidence than this,

especially now that things are going better at GGG. When I read my negative beliefs, it feels like those same experiences of being passed over for the VP role and flubbing interviews are still chipping away at my confidence."

I could tell Sarah was disappointed that these old issues were still influencing her in unexpected ways. "Are you ready to explore some of these negative beliefs to see if we can transform them into more positive beliefs?"

Sarah nodded.

"Okay, so which of these negative beliefs is most troubling for you?" I prompted.

"I think it's actually a combination of two: *'I'm not qualified to be a C-level executive'* and *'I'm not executive material.'*"

When attempting to change your beliefs, it rarely works to repress them by telling yourself *they're not true* or by fighting with them. Repression is an obvious inhibitor, but bullying your beliefs into submission can be just as damaging, even if your goal is simply tough love. When you try to convince yourself that all you have to do is *"fake it till I make it,"* or *"lean into it,"* you won't feel confident or safe. It doesn't work. According to the theory of self-organization, the only way you can change a belief is by way of a natural cycle in which you destabilize your belief using the part(s) of your system that hold the belief in place. For example, if you amass enough experiences that are counter to a belief, it can no longer be deemed true by the part of your system that stabilizes that belief.

This is the approach I decided to take with Sarah. I asked her to "think of an old belief you no longer have. Anything."

It took a while for Sarah to come up with one. But she finally smiled and said, "This is going to sound silly, but I used

to believe I had bad parking karma. But now I believe I have what my husband and I refer to as '*princess parking charm.*' Whenever I look for a parking space, one just magically appears. I'm not kidding. It's kind of uncanny."

"That's a great example!" I exuded. "And maybe as we work on this, your princess parking charm will rub off on me! How did that belief change for you? What happened?"

"That's kind of a funny story," laughed Sarah, obviously excited to tell it. "A couple of years ago, I went to a mall with my best friend, Julie, a few days before Christmas. The parking lot was a hot mess. As we pulled up, I said, 'Ugh, we'll never find a parking place. We might as well leave.' Julie laughed, and said, 'Just wait. One will appear. It always does.' Lo and behold a minute later we turned down the next aisle just as a car pulled out, and we got the spot. From then on, whenever I look for parking, I think about Julie and her magic parking skills, and *voila*, a spot finds me! I guess her parking karma rubbed off on me."

"That's so interesting," I pointed out. "How many times did a parking spot magically appear before you changed your negative belief about parking?"

"Not that many . . . maybe three?" Sarah thought for a moment before she added. "But after that, even if I had to drive around for a while to find a spot, I still believed I had princess parking charm. I don't know why. In fact, it sounds ridiculous now that I'm telling you this!"

"Have you ever gone to buy a new car, and suddenly everywhere you look you see the exact car you're considering, in the exact color you want?" I asked good-naturedly. "It's not as if those cars suddenly became abundant wherever you drive.

Sarah nodded in agreement. "That happened to me when I was about to buy my red VW Bug convertible just after I got out of college. Suddenly they were everywhere!"

"Prior to wanting that car, your brain simply didn't notice red VW Bug convertibles, *because it didn't need to*," I explained. "With all the visual information thrown at you on a daily basis, your brain edits out anything it doesn't need—like a certain type of car—because it's just noise. But I bet once you test drove a red VW Bug convertible and liked it, you started thinking about buying one. And from then on, your brain took active notice of red VW Bug convertibles *everywhere*. Your new 'dream car' became a signal in the sea of visual noise you're confronted with every day. So you took notice."

"I think you're exactly right, Kate. Because honestly, I don't even remember ever seeing *any* VB Bug convertibles, of any color, on the road until I test drove the red one."

"Let's use that same principle to examine your limiting beliefs and see whether there is anything your brain is deleting that might help you dissolve those beliefs in favor of new beliefs that serve you better," I offered. "So tell me, if you believed the statement '*I am qualified to be a C-level executive*,' what evidence might you see that supports that?"

"I suppose I would be in a C-level role, right? And I would feel successful in that role."

"True. What else?"

"I guess I could look around at others in similar C-level roles and determine whether I'm qualified compared to them."

"That sounds fair. Do that now."

Sarah counted on her fingers before she finally answered. "I can think of six people I know pretty well who are in similar C-level roles. Four men and two women, including my boss,

who was promoted to SVP a few months ago. Compared to me, I feel like they all have a lot more experience."

"Ah. So they were hired with all that experience," I stated flatly.

"Well . . . not exactly." Sarah sat quietly for a moment. "Now that I think about it, I watched them grow into their positions *after* taking on their new roles. When they started, they didn't have that much more experience than I have now."

"Nicely noticed!" I commended. "So if we were to give *you* the same consideration, what experience do you have *right now* that confirms you know you're ready for a C-level opportunity?"

Sarah laughed as the obvious answer came to her. "Well, they recruited me for a C-level opportunity in the first place . . . *and* I did make it to the final rounds of interviews. That means my experience and skills have been vetted against the qualifications required for the role." Sarah smiled even bigger as the reality of her situation sank in. "The interview team believes I'm qualified enough to advance to the next round. It's kind of hilarious that I have been missing that point all along. Or maybe I knew it, but downplayed it because I was sure *they* were missing something. In reality, I respect and admire the interview team. I truly do. So I think they're probably good at assessing my qualifications."

I could see the wheels in Sarah's head turning. "With evidence like that right in front of me, it seems that I actually am qualified." Now it became easy for Sarah to poke holes in those other related beliefs, like whether she could successfully run a product team, or whether she was qualified to lead in a start-up. "I'm pretty sure that if I sat down and started to list all the evidence to the contrary for each belief, I'd come up

with a compelling body of evidence. It would be hard to look at all that evidence and still retain those old, negative beliefs."

Many of our fundamental beliefs are unconscious and rarely explored. Over time, they become as familiar to us as an old, comfy pair of shoes and therefore help us feel secure. We tend to hang on to beliefs like life preservers in tumultuous seas. They cause us to take much for granted and make us believe the world is actually as we see it. But beliefs work against us when we pay selective attention to the negative experiences that support those beliefs. It's only when we explore our beliefs consciously and actively seek out evidence to the contrary that we can start to turn negative beliefs into positive ones.

"There are still a few beliefs on my list that are harder for me to address," confessed Sarah. "The ones about work hours, stress, and that I won't be able to maintain the balance between my personal and family life—that last one especially—are tough. I've fought hard to secure that balance, and I don't want to lose it. But now that I'm less connected to my limiting beliefs about my C-level readiness, it feels way more comfortable to continue to explore my new opportunity."

Core Beliefs

Now that Sarah was aware of her unconscious beliefs, she was able to successfully revise and internalize new, more positive beliefs. But that's not to say that once Sarah (or anyone, for that matter) finds this awareness, everything will be perfect from then on. Occasionally you can still get stuck in a pattern of behavior that does not serve you. In such cases, even when you're aware and take action toward a resolution, sometimes you still might feel powerless to break free. These more

obstinate, less mutable beliefs are our *core beliefs*, and they're significantly more resistant to change.

Core beliefs are a person's most central ideas about themselves, others, and the world. These beliefs act as a lens through which they see every life experience and situation. Everyone's core beliefs are unique to themselves. Therefore, it's not uncommon for one person, for example, to experience a situation shared by others but think, feel, and react very differently from everyone else—which can turn out to be surprising to the rest of the group. This is how two siblings can grow up together but hold vastly different perceptions of their family life.

Most of our core beliefs stem from childhood, usually brought on by an extreme emotional response to an experience or event. For example, quite often core beliefs develop as a result of trauma, such as the unexpected death of a loved one, an illness, or a near-death experience. Or sometimes they result from something much more mundane, such as being scolded by a favorite teacher or being teased by your siblings to the point of embarrassment.

Core beliefs come in the form of *"I am . . .," "People are . . .,"* or *"The world is . . ."* Common examples of core beliefs include statements like these:

- I can't do anything right.
- I am smart (or I am not smart).
- Nobody appreciates me.
- If I work hard enough, I'll succeed.
- The world is a dangerous place.
- If I love someone, they'll leave me.
- I'm not good enough.
- I'm different; I don't fit in.

- I am not allowed to shine.
- It's not okay to make mistakes.
- I can't count on other people to help me.
- I have to work harder than others to succeed.

A core belief elicits a psychological response in our bodies and minds whenever we encounter a situation that triggers that belief. To make matters even trickier, the trigger can even be something similar to a previous situation and not necessarily a repeat of the exact situation itself. Our reactions to core beliefs are deeply entrenched responses, designed to keep us safe by changing our behavior to avoid potential harm. For example, a fight or flight response gets us away from what our psyche perceives to be a dangerous experience.

To put this into perspective, let's consider Debra, an executive at a financial services company. Debra is funny, charming, and charismatic and has infectious energy. Yet when she presents her ideas to her executive team, she buttons up. "I get really serious and formal," she confides. "I spend a lot of time preparing, and I practice over and over what I'm going to say. I rarely deviate from my script."

As a result, Debra is way less dynamic, and less herself, which makes her uncomfortable. "I know I'm not myself in these moments, but I can't seem to loosen up. I'd be more effective if I could just relax and be more authentic."

As we explored the behavior that Debra wanted to shift, I asked her to imagine herself in one of her presentations and then describe her feelings, paying close attention to where she feels them in her body. "Mostly I'm focused on what might go wrong," she offered. "I think the big feeling I have is fear and a sense of danger. I worry that if I act like my normal bubbly self, I might come off as *too much*, or say or do something

inappropriate—or even wrong! Any of that would cause the meeting to end badly."

I asked her to scan her body to identify the area and sensation associated with this fear.

"I definitely feel tightness in my chest and throat, and a queasiness in my stomach," she replied.

We then used her body awareness to explore the origin of her fear—usually brought on by a past traumatic event. A productive way to scan the past for traumatic events is to examine somatic feelings. Then we can explore those feelings to help determine what makes us presently *stuck*. When we quickly scan backward in time to briefly "pin" a past experience using a bodily feeling as a guide, we avoid painful feelings and memories, bypassing the resistance that our mind dredges up in an effort to keep us safe. I asked Debra to scan back through time to find experiences that match the same bodily feelings she had just identified. As she floated back through her life, she noted several instances of that feeling. I had her float back to the earliest instance she could remember, and she eventually landed on an experience. "This seems quite trivial, but I have never really talked about it with anyone. As I think about it now, it's still upsetting, even though I know it's not that big a deal."

"Are you able to share it with me?" I quietly ask.

"Yes. When I was about five years old, I was making a ceramic bowl for Mother's Day at school," she began. "I was known to be quite precocious and energetic. Plus, I was my teacher's favorite. I also adored Miss Russo, my teacher. She was pretty, energetic, and funny, and she made everything fun."

But in Debra's exuberance to embark on the next step in her pottery project, she inadvertently knocked over a container

of glaze, and it spilled all over her teacher's brand-new leather boots. "I was mortified," Debra reminisced, clearly still upset by the event. "But worse, Miss Russo was furious. She made me sit alone outside the classroom and would not allow me to finish my ceramic bowl. I was devastated. I had been so excited to make that bowl for my mother, and I was crushed that I couldn't finish it. And worse, I was petrified Miss Russo would call my mother and demand she replace the new boots I ruined. If that happened, I knew that I'd be in big trouble."

Debra was able to identify similar bodily feelings even earlier in her early childhood when she was routinely scolded by her mother and similarly *banished*, because she was being *too much* or too disruptive or too loud.

I asked Debra to tell me what she decided about herself in those moments when she was scolded by her mother or sitting outside Miss Russo's classroom, enviously watching the other kids paint the glaze on their clay projects.

"That I'm too much," she said flatly. "That when I get too enthusiastic, I get in trouble and things end badly. And that makes me a bad person."

Although Debra's mother and teacher never meant any lasting harm, whenever Debra does anything important today as an adult—for example, something she cares deeply about, but can't afford for it to end badly—her core belief kicks in, and she reverts to buttoning herself up to avoid an unhappy ending. Until our session, this trigger happened unconsciously. But to account for it, Debra always chalked it up to nerves or performance anxiety.

What gives most core beliefs their tenacity is that they are imprinted by two very powerful emotions: shame and guilt. Shame and guilt are intensely private and powerful, because

they are important at both the individual and relationship levels. Although we often conjoin shame and guilt, they refer to very different experiences and act very differently when it comes to our core beliefs. Shame reflects how we feel about *ourselves,* whereas guilt comes as a result of being aware that our actions have hurt or injured *someone else.* Shame creates core beliefs about ourselves; guilt creates core beliefs about ourselves in relation to others.

Why are shame and guilt such powerful emotions? Those who study evolutionary psychology and sociology have surmised that shame and guilt enable us to develop stable social relationships. They promote conformity to cultural values, beliefs, and practices that, in turn, help individuals maintain a sense of belonging in a complex social world. Therefore, shame and guilt have the potential to threaten two of our most core needs—our need to belong and our need to be loved. The need to belong and form attachments is universal for humans. Our tendency is to exist in families or *tribes.* But if we transgress and hurt others, or if we believe ourselves to be bad, or even unlovable, shame and guilt threaten our sense of belonging. On Maslow's hierarchy of needs, the needs to belong and be loved are only surpassed by our physiological needs (food, shelter, water, and sleep) and our need for safety (personal, financial, health, and well-being).

I knew it would take more than one core belief exercise to tackle Debra's reluctance to show up as her full, exuberant self. Similarly, I knew that the work we did to dissolve some of Sarah's limiting beliefs about her ability and readiness to become a C-level executive were only a start. I suspected that Sarah harbored deep insecurities about her own self-worth.

What's more, I knew Sarah's tendency toward perfectionism would reemerge during her job interviews. Perfectionism is rooted in attaching one's core beliefs to self-worth; in other words, to be worthy I must be perfect. The anxiety that accompanies perfectionism can sow unconscious doubts when we challenge ourselves to take the next step on a personal journey or quest. In an unconscious effort to relieve the anxiety, we find excuses to resist and back down. For example, we might decide the time is not right or to wait on moving forward because *everything* is not yet in place.

To revise Sarah's stubborn core beliefs, we'd have to go deeper. It was clear we needed to work on her core beliefs *and* self-worth before she could fully show up with confidence and credibility for her job interviews. Furthermore, we would have to relieve her perfectionism-driven anxiety so she could honestly evaluate whether the chief product officer job was something she *really* wanted, as opposed to something she thought she *should* want.

CHAPTER 9

RESOLVING TRAUMA

Sarah and I met again the week after we worked together to dissolve her beliefs surrounding her executive readiness so she could explore her new career opportunity with less fear and anxiety. As her meetings with the executives from her potential new employer progressed, she still found herself becoming increasingly agitated.

"I know I'm not at the point at which they're ready to make a decision, nor am I expected to commit to anything right now," Sarah reasoned. "But Kate, this process is really challenging. I'm exhausted, and there are days when I think I should just give up and stay where I am."

"Really? Challenging in what way?" I asked.

"It's so confusing! When I'm in discussions with them I'm energized and excited. But then I come home and immediately start to worry about everything that awaits me if I take this job," Sarah confides. "It gets even worse in the middle of the night when my brain wakes up at 2:00 a.m. I imagine my catastrophic failure in excruciating detail, and I can just picture my neglect of my family. Then of course, my health deteriorates."

"Well, that's perfectly normal. We call that catastrophizing. And I'm not surprised by your anxiety," I reassure her. "This opportunity pushes buttons that lie at the core of your beliefs about yourself. Your system is reacting to perceived

threats that this new opportunity stirs up. Your brain *knows* that you're being evaluated to determine if you are, in fact, *worthy* of this opportunity. I agree that it's an uncomfortable state to be in, but in this moment, when you're experiencing the discomfort of your reaction to this situation, you're being presented with an important opportunity to resolve the trauma that formed these core beliefs about yourself in the first place."

"When you use the word *trauma*, I really don't relate. As I've already shared with you, I had a pretty ideal childhood," Sarah reminded me, "and I don't remember any big traumatic events in my life."

"We tend to think of trauma as a word that starts with a capital *T*," I clarified, "like the death of a parent or a devastating accident or your family home burning down. But trauma can also start with a little *t*, like being bullied at school, enduring shame, or even breaking your arm. The impact of the trauma all depends on the emotional context in which your system processes the event. But even small events that cause extreme emotional reactions—particularly shame—can trigger trauma. In fact, trauma is common for those who suffer from learning differences as children, especially if they are subjected to ridicule by their family or classmates."

I could tell that my words suddenly hit Sarah like a gut punch. "I can definitely recall the dread of going to school," she reminisced. "It was devastating to be reminded every day that I couldn't keep up with the other kids, and humiliating when I was sent out of the classroom with the special ed teacher."

Trauma

Dr. Judith Herman, a former professor of psychiatry at Harvard Medical School, worked for decades with survivors

of atrocities and other unspeakable tyrannies. In particular, she supported the recovery of female survivors of domestic violence, particularly women who were oppressed and persecuted by their male partners. In her classic book, *Trauma and Recovery* (1992), she developed the perspective that "traumatic events overwhelm the ordinary systems of care that give people a sense of control, connection and meaning."

Or as Joshua puts it, "Trauma can be defined as an overwhelming experience in which we lose our connection with what is safe. As a result, we become disconnected from our ability to access the internal resources that help us heal. Instead, traumatized people become detached from feeling *normal*. As a result, they are often unable to take action to heal. They feel helpless, broken, unwanted, and inadequate. The key word in trauma healing is *safety*. Because without safety, we can't heal."

The root of trauma can be very specific or elusive. There is no right or wrong way to become traumatized, which makes it a moving target to resolve. As Joshua informs us further, "Trauma can stem from a one-time event or be the result of an ongoing experience, anything from abuse or serious injury to violence or war. When someone recalls a traumatic event from the past, it's likely they feel overwhelmed and unsafe. Such trauma can cause a lifetime of hypervigilance and flashbacks, resulting in a myriad of secondary psychological conditions, including depression, mood disorders, psychosomatic issues, and substance abuse."

Sounds awful, I know. And when you're the one to experience it, it is. But if trauma is so painful, why do we emotionally hang on to it? "Trauma is not primarily an emotional response, it's a somatic response," counters Joshua. "It's a safety mechanism to ensure survival. Our bodies hold on to

traumatic memories to protect us from future harm and damage. And yet, our bodies activate our trauma response whether or not our perception of danger is accurate or inaccurate, real or imagined."

Even though everyone experiences trauma at some point, reactions to trauma vary. One person's response to trauma might be anxiety, insomnia, or feeling disconnected, while someone else might feel confused, withdrawn, or have intrusive thoughts. Children deal with trauma differently than adults. A child enduring trauma might have symptoms such as wanting to stay home from school, suffering tummy aches, problems sleeping or eating, bursts of anger, and many other kinds of attention-seeking behaviors.

In Resmaa Menakem's discussion of trauma in his book *My Grandmother's Hands: Racialized Trauma and the Pathway to Mending Our Hearts and Bodies*, he points out how your system's interpretation of danger goes far beyond actual threats to our physical safety. "Remember that *dangerous* can mean more than just a threat to the well-being of the body. It can also mean a threat to what we do, say, think, care about, believe in, or yearn for."

Our trauma is triggered as a reaction to *perceived* danger. It happens at lightning speed, far faster than our thinking minds can engage. There is absolutely no time for the rational brain to evaluate whether or not the perceived threat is real. From the body's perspective, safety and danger are not cognitive concepts, they're visceral sensations. The body either feels safe, or it doesn't. And if it feels unsafe, the body will do whatever is required to reestablish a sense of safety, triggering the flight-fight-freeze response.

When trauma is triggered, we react out of proportion (most likely inappropriately) to the instigating event. As Menakem explains, "Whenever someone freaks out suddenly or reacts to a small problem as if it were a catastrophe, it's often a trauma response. Something in the here and now rekindles an old pain or discomfort, and the body tries to address it with the reflexive energy that's still stuck inside the nervous system. This is what leads to over-the-top reactions."

Generational Trauma

One of the things that can make trauma difficult to identify is that it can be passed down generationally, and in these cases, individuals don't remember it as present-life trauma. While trauma researchers have made great strides in understanding and treating present-life and single-episode trauma, they are just beginning to explore the impact of intergenerational trauma and how it's expressed.

Decades ago, Isabelle Mansuy, a professor in neuroepigenetics at the University of Zurich, designed a mouse experiment intended to study childhood trauma. In her study, Mansuy inflicts trauma by separating mouse mothers from their pups at unpredictable intervals, which creates stressful experiences for the mothers. When the mothers are returned to their pups, the mothers are still so frantic and distracted that they ignore the pups, which worsens the stress on the pups.

Unsurprisingly, the pups of stressed mothers displayed altered behavior as adults as compared to the control pups who were not raised by stressed mothers. The surprise came when the behavioral changes continued down the lineage line. The grandbabies of the stressed mothers were also stressed. In

other words, a mother's stress was transferred to her pups, who then passed the stress down to her pup's offspring. Further studies validated Mansuy's findings, including altered behavioral traits that persisted in offspring as far down as six generations of pups raised by stressed mouse mothers at the very top of the family tree.

Recent research into intergenerational trauma finds that trauma is transmitted to children through attachment relationships with parents who have experienced trauma, and that this trauma can have an ongoing impact throughout their children's lives, including a predisposition to further (or new) trauma.

Generational trauma begins decades prior to it showing up in a current generation. However, it impacts the way that every subsequent generation understands, copes with, and heals from trauma. Generational trauma can be at the root of anything from emotional numbness or hesitancies about discussing emotions to distrusting outsiders or exhibiting confrontational, aggressive behavior. Often it shows up, however, in anxious parents or caregivers who are overly protective of children and family members, even when a threat of danger is not present. As a result, it can create unhealthy relationship boundaries and survival patterns, which can subconsciously be passed down from generation to generation.

Historically, many oppressed or disenfranchised groups have been affected disproportionately by generational trauma, including black descendants of slaves, Native Americans, refugees, and descendants of Holocaust survivors, just to name a few. As Joshua wrote in a recent article on black trauma, "Trauma happens to all of us. Yet for most black Americans, the accumulation of 400 years of racial oppression results in a

far greater depth of trauma. Slaves' experiences of being held against their will, followed by their descendants' experiences of being openly and systematically discriminated against, results in a profound and overwhelming lack of safety from one generation to the next. This is generational trauma. Imagine this as the black experience, watching four centuries of trauma go by, repeated over and over again, with no end in sight."

Keeping this in mind, when you combine generational trauma with environmental anomalies (like a pandemic), what you get is a tinderbox of trauma that eventually ignites. Joshua puts it into perspective for us. "It is no wonder that past trauma has been triggered in so many people when black Americans watch their peers get killed at the hands of police and white supremacists," he states. "This episode is all too familiar within the black experience. Add to this the disproportionate toll COVID-19 has had on the health and economic prosperity of the black community, along with a devastating impact on the black and brown essential workers who suffer a higher incidence of infection. When you combine all of this, it becomes clear how and why COVID-19 and the death of George Floyd triggered a collective trauma and ignited a global powder keg that demanded social change."

Trauma and the Impostor Behaviors

Jasmin is the only black female executive at a midsize technology company in Silicon Valley. She is a self-made success story. After leaving her family and inner-city Chicago home at the age of sixteen to live on her own, Jasmin became an executive assistant. To her good fortune, her boss saw her talent and drive and encouraged her to get her GED. And after that she kept going. Though it took six years while working full

time, Jasmin eventually graduated from college with honors, earning a degree in data analytics. Upon graduation, she was immediately promoted into an analyst role. From there, her career took off, and she rose quickly in the ranks to become a senior director.

Regardless of her amazing success, Jasmin's Impostor Assessment showed high scores in rejection sensitivity, depressed entitlement, and lack of confidence. Even with these Impostor Behaviors, Jasmin explained how she's been able to achieve so much. "I've always been a really strong self-advocate. I had to be. My childhood was challenging. I really cared about school, but because of my family situation, there were many times when I wasn't able to complete my homework or even show up to school on time. My older sister just withdrew and took it, accepting whatever consequences came her way. But I fought back. I rallied to convince my teachers to accept my homework late and have my tardies and absences excused, so none of it would go on my school records."

When Jasmin started working with Lee, she sought out coaching because she wanted to be promoted to a VP at her company. But her manager and other business leaders told her she was too pushy and too confrontational and expected too much too soon. "The feedback I got is that I always make everything about *me*, that I take things too personally and push too hard for my own interests," said Jasmin. "I admit I'm sensitive and reactive. But I also know there are real racial dynamics going on here. Of course, I'm sensitive when I see racial bias tolerated in my company, especially when it comes to promotions. Whether intentional or not, there are barriers for promotion for women and minorities here, especially in technical roles. When I see this, I adopt my fierce

self-advocacy stance. I've been told all my life that I can't do things, that I'm not smart enough, I'm not educated enough, I don't have the right connections. But I've proved everybody wrong. I know my intensity might get in the way sometimes, but I'm afraid that if I don't push hard, I'll be left behind and won't be given the opportunities I deserve."

To help Lee understand the events that fuel her bold behavior, she asked Jasmin to float back into her childhood to see if she could pinpoint an experience that led her to be such a strong self-advocate. After a few minutes of self-examination, this is what Jasmin said. "In sixth grade we had a debate team, and I wanted to be on it," she said, zeroing in on a very memorable event for her. "The teacher invited several students to join, but I wasn't one of them. So I told my teacher that I wanted to be on the debate team, too, but she said no because the team was full, there were no openings. But when I looked at the lineup, I saw that all the debate team members were white. I tried to reason with my teacher, but it was clear that my conversation with her was going nowhere."

"Oh wow," Lee said. "That's very harsh. How did you handle the situation?"

"I marched into the principal's office and told him that I wanted to be on the debate team and that I didn't think the selection process was fair," Jasmin proudly declared. "I wanted to know why I wasn't even given a chance when I showed interest. I challenged the whole notion of teachers selecting debate team participants versus students trying out. The principal looked shocked, and he was speechless. He said he'd talk to the debate team teacher and get back to me. Later that day I got a note to go to the principal's office. When I walked in, he was smiling and told me they had added me to the team."

"How did that make you feel?"

"Of course, I was thrilled because I really wanted to be on that team," Jasmin said. "But another part of me was sad. It was yet another example of being left out, sidelined, because of my skin color. And I knew the same thing happened all the time to a lot of other people who aren't as comfortable raising a fuss as I am."

To get to the root of Jasmin's core belief, Lee had to go even deeper below her traumatic experience of exclusion. So Lee asked her this, "When the teacher wouldn't even consider you for the debate team, what decision did the little Jasmin make in that moment?"

"Oh, that's easy," she quickly replied. "I decided right then and there that because I'm black I'll *always* be overlooked and I'll *never* be given a fair chance. So I *always* have to fight for whatever I want, because *nobody else* will ever fight for me."

Jasmin's belief served as a powerful force that helped her shape her future success. And yet, it left her scarred by her experiential and generational trauma of continuously being overlooked and not being given a fair chance to prove herself simply because of the color of her skin.

Resolving Trauma in the Body

Joshua's approach to break through a recurring pattern of trauma is to use somatic awareness to explore and resolve it. "The word *somatic* is derived from the Greek word *soma* which means *living body*," explains Joshua. "Somatic work is useful to resolve issues that live in the mind *and* body as a result of traumatic events in our psychological past."

So what does emotional trauma have to do with one's physical body? "Our bodies hold on to past trauma, and this

trauma is then reflected in our body language, posture, and expressions," explains Joshua. "The imprint of trauma in our bodies is a safety mechanism that autonomously, instantly, and unconsciously activates in response to anything even remotely similar to the original traumatic experience the brain perceives as a threat. This response is designed to keep us safe by quickly getting us out of danger. Thus, when we successfully resolve the trauma in the body, the body no longer has a reason to overreact to situations that were previously threatening. Instead the body can relax, breathe, and restore itself to a sense of safety and resilience."

Somatic techniques use a *bottom-up* body-awareness approach rather than *top-down* cognitive approach to resolve trauma. Dr. Peter A. Levine, a world-renowned trauma expert and author of *Trauma and Memory: Brain and Body in a Search for the Living Past*, developed a groundbreaking method for trauma therapy that was inspired by his observation that animals are under a constant threat of death, yet show no symptoms of trauma.

In his research, Dr. Levine discovered that trauma is imprinted in our nervous systems not just in a fight or flight response, but also in a freeze response. This happens when neither fight nor flight options are available in a stressful situation and the only option left is to freeze. For example, when an animal encounters what it perceives as danger, it responds effectively by generating a massive amount of traumatic energy in order to deal with the threat. This traumatic energy releases when the animal either fights or takes flight (runs away) to successfully avert danger. After the event is over, the traumatic energy has been discharged and is no longer held in the animal's system.

But for humans, when (for whatever reason) we can't go into fight or flight, that massive traumatic energy has nowhere to go. So it stays trapped within the body, keeping it on high alert. This can show up in a variety of physiological symptoms such as high blood pressure, fainting, brain fog, chronic inflammation, infection, illness, pain, migraines, and other unexplained conditions. Thus, as the traumatic energy remains stuck, the body continues to believe it's still under threat, long after the traumatic event is over. After that, this traumatic energy can trigger anytime we have feelings or bodily experiences similar to those that took place during the original trauma.

People can hold on to stuck traumatic energy for years, or even a lifetime. So how do you get rid of it? "Somatic trauma therapy techniques move and release this trapped energy so that it's not as easily activated in the future," explains Joshua. "This reduces or resolves unnecessary traumatic triggers in the body without requiring the brain to recall or relive the specific events around the original trauma. What's more, because somatic trauma therapy doesn't require us to cognitively recall traumatic details, these somatic techniques can address trauma that goes way back in time—even preverbal trauma that occurred in infancy, for example. We can also use it to tackle generational trauma or any trauma that was not imprinted by a present-life experience."

To see how this works, let's revisit our friend Debra from chapter 8. Recall that Debra is the funny, charming, and charismatic executive at a financial services company, who awkwardly clams up whenever she has to speak in front of her executive team. She chalked her "stage fright" up to nerves, but after working with me, Debra realized she had a core belief

that her outgoing personality was shameful based on several childhood experiences. In summary, she was consistently told by adults that she was too loud, too exuberant, *too much*. As a result, when she became an adult, she believed her outgoing personality was inappropriate and *bad* in business.

Joshua's somatic technique to unlock trapped traumatic energy begins by relaxing the body and mind, then turning inward to focus on the bodily sensations associated with a specific triggering event. After asking her to take a few balancing breaths to relax her body, I used Joshua's somatic trauma therapy to work with Debra. "Slowly scan your body from your head downward," I began, "and notice any sensations you may experience in your body that go along with the feeling that you need to *button up* the authentic you. Note where you feel tightness, pain, tension, or heaviness. As you slowly scan, tell me the areas in your body where these sensations occur, and then describe the feeling as best you can. You might want to use words like sharp, tight, heavy, nauseous, chaotic, or whatever works for you."

As Debra scanned, she described a tightness in her upper body. "It's like there's a heavy weight on my chest. I can only take shallow breaths. I feel anxious; my neck and shoulders tense up. I feel my body getting warm, and I'm starting to sweat a little bit."

"Okay, good," I reassure her. "Now just stay with those feelings and notice your breath going in and out of your lungs. Slow down and even out your breathing. Relax while you stay with that feeling and notice what happens in your body as you breathe. You might try resting your hands on your thighs and slowly tap your hands alternately on your right and left leg while you breathe. Try to match the pace of your tapping with your heartbeat."

Debra did this, and I could see the tension slowly drain from her face. "That's great," I encouraged her. "Now keep breathing and continue to tap until you notice a change in your physical experience." Debra's breathing slowed and deepened, and the color began to return to her face. "As you do this, do any thoughts, images, or awareness come to mind?"

"Along with this tightness in my chest, I notice I feel angry. Which is odd, because I'm generally not an angry person. Rarely do I feel or express anger. But I am angry when I feel like I need to shut myself down to avoid being *too much* for other people."

As she continued to breathe, her shoulders dropped and her chin fell slowly toward her chest. "Everything okay?" I asked.

"Now I feel really sad," she replied quietly. "It's so sad that I can't just be me, that I need to temper my energy and enthusiasm. It feels like I'm suffocating my spirit and all of my creative energy."

Debra stayed with these feelings and continued to breathe evenly. But then after a few more minutes in this state, something wonderful happened. Debra became aware of her exuberance as an important source of vitality and strength. "You know what? I'm not willing to keep all this suppressed," she finally announced. "I've spent my whole life keeping the *real me* bottled up in certain situations. I'm all done with that."

"And how does that declaration make you feel?" I asked softly.

Debra took a long, deep breath. "My lungs opened up. I feel that heavy weight lifting off my chest, and my throat loosen up. This feels so much lighter, better."

I had Debra stay with these new feelings in her body for a little longer and reminded her to continue to breathe. As the heaviness continued to lift, she sat up straighter, and a faint slight smile spread across her face. "There were a few times in my life when I actually had the courage to show up fully as myself, and it felt great. Like the time I sang a tribute to my sister for her birthday. I was super campy, way over the top, and everyone loved it. It made my sister cry!"

Debra sat silently for a few more minutes breathing and smiling at her memory while butterfly tapping on her legs. "As I recall these moments of being the *fun* me, I see how much it connects me with others and how much of my passion and heart comes through. It's really beautiful." Debra's whole body relaxed as a couple of tears slowly fell down her cheeks.

As her breathing returned to normal, I asked her how this awareness might affect how she shows up at work. She looked at me as if a light bulb just went off over her head. "Wow, it just hit me. As an adult, I don't need to be afraid of getting in *trouble* for my behavior like I did as a kid. I have good judgement now. I can decide how much of myself to unleash in any given situation. And if I'm ever accused of being too much, I feel like I can stand up for myself and hold my own. I don't have to worry about being shamed and punished for being who I am."

This was clearly a big "*Aha!*" for Debra. I could see the wheels turning in her head and the implications of these new thoughts. I asked Debra to test drive her new awareness for me by putting herself in a future situation where she might have otherwise felt the need to dial back her authenticity. "It's timely that you bring this up," she laughed. "Next week I'm presenting a big status update on my project to the executive

team. For starters, if I show up with my exuberant self, I'll certainly be wearing something different. Rather than having on my suit, I'll wear my loud paisley blouse and this amazing pair of deep purple pants I bought in Paris last year. Just picturing myself at that meeting in those pants makes me feel more confident and energetic than ever. As I think about walking into the room, I feel excited, not nervous at all. And I'm smiling and laughing. It feels so much lighter and more like me!"

I knew this would be a breakthrough for Debra. And while she might not yet unleash her full exuberant self in every situation, she had now given herself permission to show up more authentically and to trust her own judgement about what's appropriate. I smiled as I, too, imagined her walking confidently into that room with a big smile on her face in a paisley top and purple pants. "Promise me you'll call me right after your meeting next week. I can't wait to hear how it goes!"

"You got it, Kate!"

The Trauma of Perfectionism

Our Live programs are designed to resolve Impostor Behaviors for executives and leaders from all walks of various industries. We've helped people from just about every type of organization you can think of, from huge corporations down to the solo entrepreneurs. At the end of every program, we survey our attendees to assess its impact, and the results have been much more positive than we expected for all but one stubborn behavior—*perfectionism*.

To put this in perspective, after going through the program, more than 60 percent of our graduates report they experience either *very much* or *extreme* improvement in the following four Impostor Behaviors:

- Depressed Entitlement by 74 percent
- Rejection Sensitivity by 65 percent
- Lack of Confidence by 73 percent
- Feeling Like a Fraud by 61 percent

However, when it comes to perfectionism, only 41 percent reported either *very much* or *extreme* improvement.

How is that possible when all the other behaviors dramatically change for the better? What is so different about perfectionism?

To find out, Joshua, Lee, and I put our heads together and discussed this finding. As a result we came to a hypothesis. Perfectionism is much more difficult to resolve because it's often a response to trauma. Joshua sums it up nicely for us as follows, "The *thing* that lingers below the subconscious and triggers perfectionism is a deep-seated fear of unworthiness. The core belief that most perfectionists carry around with them is that they're loveable and worthy *only* when they are perfect."

While perfectionism is often seen as a positive trait that gives us the energy to do our best, in reality it takes an enormous toll on our psyche and bodies. Perfectionism is not about high-quality work, healthy achievement, and growth. On the contrary, perfectionism becomes a problem when it's triggered by fear and used as a shield to protect us from pain, blame, judgement, and shame.

"Perfectionism often arises from psychological wounds in childhood," continues Joshua. "Children who experience emotional trauma, especially the kind that stems from a parent withholding love, come to believe that they must prove their worthiness of love by being extremely competent and flawless.

Perfectionism may also be hardwired within us when we're born, passed down through generational trauma as a survival trait. Regardless of whether you descend from slaves or aristocrats, its purpose is to prevent you from experiencing painful circumstances that occurred generations ago," explains Joshua. "For example, when slaves made mistakes, the repercussions were severe, such as beatings that left them severely injured or maimed, or being sold off and separated from their families. Although not as physically brutal, the mistakes (or failures) of aristocrats could bring disgrace to their families, resulting in a loss of wealth and social isolation."

With this realization, we began using our somatic techniques with clients like Sarah, whose perfectionism is not easily resolved using other methods. I suspected that Sarah's learning differences in childhood likely caused trauma that triggered her perfectionism well into adulthood. Therefore, I believed the somatic techniques I discussed earlier in this chapter offered a great way to tackle the perfectionism that fueled her current dilemma, which was this: Sarah felt the pressure of interviewing for a C-level job, compounded with the fear that the job would demand too much time, thus stealing the balance she'd fought so hard for between work and personal life. These pressures tapped into another deep fear for Sarah that is common for perfectionists—her fear of losing control.

So the next time Sarah was in my office, I told her we were going to try something new to her to address her perfectionism, which we both agreed was part of what was making her decision about her new job opportunity confusing. After guiding Sarah through a meditation to relax her body and mind, slow her breathing, and reduce her heart rate, I asked her to

think about her interviews for the new CPO job for which she'd been recruited. Then rather than go into the stories in her head, I instead asked her to shift her awareness into her body with compassion and curiosity and locate any uncomfortable physical feeling. "Take a moment and focus on *where* in your body that feeling lives, and then once you find it, embrace *how* it feels," I instructed her. "If it helps, you might even literally ask yourself, '*Where does this feeling live? And how does it feel in that place within me?*' But don't pressure yourself, and don't rush. You don't need to articulate anything right now. Just sit with it and *feel* it.

I gave Sarah a few minutes to carry out my instructions and then I quietly added, "Whenever you're ready, share with me what you've discovered and what you feel."

Sarah was quiet for several more minutes. When finally she spoke, she said, "I feel something in the center of my body, from my throat all the way down to my stomach," she answered. "I'm surprised by how intense it is."

"Good," I reassured her with a smile. "Just keep breathing, and now cross your arms. Then slowly butterfly tap on each arm as we work through this." Sarah did as I instructed. After that I added, "Now stop and observe the feelings in your body one part at a time. Start by focusing on your throat. Tell me what you feel."

Sarah cleared her throat. "It's super tight and hard to swallow. My throat feels dry, and there's a lump in it."

"Breathe and stay with that," I continued. "Focus your attention right there. And notice if anything changes."

For more than a minute Sarah was silent but swallowed several times. "It's starting to relax," she finally said with relief

on her face. "It's easier to swallow now." She rolled her head and shoulders to release some more tension.

"That's great. Do you feel good enough to move on to the next spot?" I asked.

"Yes," she confirmed. "My throat feels much more relaxed." Sarah slowly continued to focus her journey down her body, stopping along the way to release tension in her shoulders, her chest, and finally her abdomen. "Now I feel something in my stomach. It's super heavy, a little nauseating." She paused before she added, "It reminds me of what my mom used to say about me to her friends: '*When the going gets tough, my Sarah gets tummy aches.*' Which was true, by the way."

"That's okay. Just stay with me, and feel into your tummy," I guided her. "We're going to do something a little different. Now imagine there's a super warm and cozy cave *right there in your tummy*. Can you imagine that cave for me?"

She thought for a minute. "Yes, here it is. I'm outside it looking in. There's a fire glowing inside, reflecting off the brown walls of the cave and casting a really warm glow. There's also a rug on the floor and a bunch of cozy, furry pillows and blankets."

"Would you like to go in?" I asked.

"Yes, it looks very inviting. Ahh. It's so warm and cozy," she sighed comfortably. "Now I'm sitting in a pile of pillows, and I'm putting a blanket over myself. The light from the fire reflects off the cave walls, and it's so pretty. I love this spot."

"Sounds beautiful!" I replied. "Now imagine someone very kind and very wise joining you in the cave. It could be an ancestor or a person or even an angel or a benevolent spirit. Perhaps it's a friend or a parental figure, or maybe a fictional

character in a movie. Can you sense the presence of this kind and wise being?"

"Yes, it's my grandmother," Sarah replied softly, but with a hint of surprise in her voice. "I never met her because she passed away when I was two years old. But my mom always told me stories about her. She was so brilliant and courageous. She had a horrible childhood, and unfortunately her adult life wasn't much easier. Through it all she had such a bright and lively spirit. I feel her here with me."

"Oh, that's perfect. How lovely that you have your grandmother there with you," I said. "Just be with her silently and breathe. If you want, share your concerns about your interviews for this new CPO position, so that she's aware of what you're going through. Then just allow her to be present and support you in whatever way is best. She'll know exactly what that is."

After several minutes, Sarah got a big smile on her face. "I have to tell you, sitting with my grandmother's spirit in this cave . . . now it all seems doable," she said with great relief. "My fears and worries seem manageable. So what if I don't know everything? Or I don't have the perfect answer to a question. I realize if I'm expected to be perfect on the job, then the job isn't right for me. I can only do what I am willing to do. I have two small kids. I have a husband and a family and friends, all of whom need my attention. And I need time to exercise and take care of myself. If this new CPO position stands in the way of any of that, then I need to know now. I'd rather stay where I am than take a job that demands more than I'm willing to give."

"Very nicely noticed!" I was so proud of Sarah in that moment. "Continue to breathe as you move that awareness

through you, allowing you to integrate that wisdom into your system, all the way down to every cell."

Sarah sat and continued to steadily breathe for a couple more minutes. She was in a perfect state. With her encased in her warm and safe place, supported by her grandmother, I felt comfortable going deeper to explore the trauma from her childhood.

"With your grandmother by your side, I'd like you to float back into your childhood and remember those days in elementary school when you struggled with your learning differences," I guided her.

"Okay," she replied. Sarah sat quietly for a few seconds, and then observed, "Wow, I suddenly tensed up. And that queasy feeling in my stomach came back. I see myself sitting at my desk back in second-grade school, pretending to work on an assignment." She shakes her head in dismay. "I see the other kids working, writing and drawing, and I feel lost . . . stuck. I'm about to cry."

"You're doing great," I reassured her. "I know this is difficult, but stay there and feel your grandmother's presence with you. She's there to help and protect you. Breathe and move your awareness back into your body like you did before. If it helps, picture your grandmother comforting you. Perhaps she's holding you and gently rocking you. Whatever makes you feel safe and loved."

Sarah sat silently. Tears trickled down her cheeks. "Oh Kate, it's so sad. I feel so helpless and hopeless. The kids . . . they're making fun of me because I have to leave class to work with a tutor," she confessed. "But I'm so relieved my grandmother is with me. She's here to protect me, telling me it's okay, that there's nothing to be ashamed of. I can hear her

voice. 'You just need a little more time,'" said Sarah, channeling her grandmother, "'because you learn differently than other kids, but that doesn't make you any less smart. It makes you even more special, because you show your courage by staying with it even when it's hard. I'm so proud of you, and I love you. I will always be here with you when you need me.'"

Now I, too, felt myself tearing up. This was such a beautiful moment of healing for Sarah. "Now just breathe and feel your grandmother's presence and love," I instructed. "Allow yourself to float backward in time even further, to any moment from the time you were born, or even before. Allow your grandmother's love and warmth to be there for you no matter what you encounter. Feel her presence when you need her. Then float backward again . . ."

"I feel like I'm now at a time before I was born," admitted Sarah. "I don't have any sense of a physical self, but it feels so deeply comforting to have my grandmother here with me. Wow. This is a trip."

"Wonderful. Now let's just grow you up slowly from that point," I said comfortingly. "Float forward in time, with your grandmother by your side, pausing briefly at every point along the way whenever you feel afraid, sad, or alone. Your grandmother's love and presence will help you through that. And when you're all grown up, bring yourself back into the warm cave with your grandmother." I paused before adding, "Then let me know when you're settled in back there."

After several more minutes, Sarah said "I'm back in the cave now."

"And how do you feel?"

"So much more . . . *light*. The queasiness in my stomach and heaviness in my chest is gone. I feel calm and grounded,"

said Sarah with a bit of surprise. "I'm so grateful for my grandmother. I feel like I'll always have her presence with me . . . even in my everyday life."

"Wonderful. Now bring all of this awareness of your grandmother, her constant warmth, her loving presence, with you as you come out of the cave and back into the room with me," I said gently. "Allow this new awareness to integrate into your very cells, and take this experience with you in the days and weeks to come."

A couple of minutes later, Sarah took a deep breath and opened her eyes. She looked at me with relief and warmly said, "I haven't felt like this in a long time. If ever. I can't believe I've gone my whole life without realizing that my grandmother was there with me the whole time. It seems so silly that her imaginary presence could make such a difference, but it does. Thank you so much, Kate. That was an unbelievable experience."

"Oh Sarah, it was my honor to bear witness." I paused, basking in this breakthrough moment. But after a second, I smiled knowingly and said, "I want to try *one more* thing, if you'll indulge me. Take a moment, right now, to think about your interviews for the new CPO job. And then tell me . . . how does it feel?"

Sarah sat with my request for a minute and when she was ready, confidently stated, "Like all the pressure is gone. I get to decide. I'm in control. I realize how important it is for me to show up *as me*, to be who I am, flaws and all. I get to decide if this is the right company for me. It has to be a place that allows me to grow and shine—or be imperfect and make mistakes."

I remained quiet, because I felt like she had more to say. And it turns out I was right. A flash of insight spread across her

face and then she added, "It just hit me that I already have all that with GGG. I don't need to leave my current job in order to show up as me. There will be future promotions at GGG. I don't have to go anywhere else to move up. And I don't have to be so perfect, even at GGG. No one there, including my boss, has ever actually demanded perfection from me. It's been *my thing* to be perfect—*my thing* all along." She sighed, finally comfortable in her own skin. "I'm honestly excited to see how it plays out," she stated.

After Sarah left my office, I thought about our session. I could tell during our session that she was moving the trapped traumatic energy out of her body, because about halfway through her experience, I started to get really hot. In fact, I got so overheated, I had to take off my sweater and fan myself. This is my somatic signal that her energy is indeed on the move, the trauma is releasing.

Alone in my office, I sat for several minutes and reflected, in awe of what I'd just witnessed. I was so deeply honored and grateful to experience the wonder and joy of bearing witness to such a beautiful moment.

CHAPTER 10

APPLYING EXECUTIVE PRESENCE

Lee knew it would take more than a few sessions to resolve Jasmin's trauma, which was deep and generational. (Recall we met Jasmin in chapter 9.) Even so, after her first session with Lee, Jasmin shifted her reactivity to the point at which she was ready to explore new and more effective ways to self-advocate. Lee was excited to work with Jasmin to improve her leadership skills, so she could show up with greater professionalism and elevated executive presence.

We find that a first and critical inflection point for our clients in their career progression is when they transition from a manager to a leader. Management consists of controlling a group of people to accomplish a goal. Leadership, however, is the ability to influence, motivate, and enable others outside your management purview in order to contribute toward overall organizational success. What separates leaders from managers is how they use their influence to inspire, rather than how they wield power to control.

Jasmin had a performance review coming up in a few weeks, so she scheduled a coaching session with Lee to prepare. She had several issues she wanted to address in her upcoming review with her boss, starting with compensation. She had done some research and realized she was under the pay grade midpoint for her role when it came to experience.

She wanted a pay increase that would bring her in line with what was fair.

Second, Jasmin felt she was ready for a promotion. Two of her peers had recently been promoted to VP within three years of becoming a senior director. Jasmin was about to begin her fourth year as a senior director, so she wanted to better understand her path to promotion.

And finally, Jasmin's male boss, Rich, was pretty clueless about racial sensitivity. "He's an okay guy, and he means well, but he sometimes says some really insensitive things without realizing it," Jasmin revealed. "It all came to a head right after George Floyd was murdered. My other black colleagues received calls from their managers checking in and encouraging them to take time to process and recover in the weeks that followed. My boss didn't check in with me once. In fact, he never even acknowledged the incident. Instead, he kept pouring on the work without considering how this historic event might be impacting me. What he failed to realize is that although nothing happened to him, it was a devastating few weeks for me. I'm kind of shocked at how tone deaf he was during that time. I'd like to explore ways I might get more management support, possibly from another manager. I'll need your help, Lee, in figuring out how to navigate that."

Before they tackled her performance review, Lee had Jasmin reflect back on the previous work they had done to begin addressing Jasmin's trauma from her past. "It really helped for me to go into my body to gain insights into the traumatic experiences from my childhood. Though some positive things have emerged, it's been pretty devastating to come face to face with just how difficult it was for me when I was little," admitted Jasmin. "Every win was preceded by a struggle.

As a result, I noticed that I had several really prominent scars that I never acknowledged until now."

"Like what?" asked Lee.

"It's surprising to me now how unsafe I was as a child, although it didn't seem unsafe at the time. My parents were not physically or psychologically around much to take care of me. It's hard to fault them on that, since they were struggling with some pretty dark demons of their own. But regardless, I see now that I really was truly on my own."

"How did that play out for you in the long run?" questioned Lee.

"My whole life I've had to fight just to survive, let alone combat all the inequities I've faced. I've had to work so much harder than most people for everything I've earned." Jasmin paused for a second to reflect on what she had just said out loud, most likely for the first time ever. "When I think about it, it kind of breaks my heart," she said softly.

"It is heartbreaking. How do you see it now?" Lee interjected.

Jasmin thought long and hard before she answered. "When I was pregnant and I found out I was having a girl, I couldn't bear to think about her having to go through what I went through. *That* made me sad and took away a little bit of the joy I should've had about becoming a mother. But I refused to let that consume me, so I decided that my daughter would never have to endure everything I did, because I'll always be there to fight for her." She took a deep breath.

"Jasmin, you are a true warrior," acknowledged Lee. "And I have to admit I'm kind of in awe of you. You have achieved so much, all the more remarkable in the context of the challenges you've overcome."

"Thank you," Jasmin replied with a shy smile. It was obvious that no one had ever outwardly acknowledged her struggle before.

"I'm honored that you shared your stories with me," Lee continued, "and I'm excited to work with you to explore how to exert your power and courage in new ways that might serve you even better than your warrior ways."

"I look forward to that," Jasmin said with relief. "I know there will always be times when I need to fight. I doubt hundreds of years of oppression will be magically fixed in my lifetime. But I now understand how my instinct to fight is often just me being triggered by my past trauma. I know that things will be better for me, and everyone around me, if I can be less reactive and less combative."

The trauma Jasmin experienced as a black woman who grew up in such difficult circumstances is real and significant. Lee could see that it was getting in the way of her ability to elevate her executive presence. Jasmin's realization that she could put down her sword when appropriate was a critical first step in her journey. On the one hand there will be times that Jasmin needs to advocate for herself. And yet, on the other hand, Lee knew she would need to hone her executive presence to learn different, less combative techniques.

Power and Influence

In her research, Professor Deborah Gruenfeld of Stanford University and author of the book *Acting With Power: Why We Are More Powerful Than We Believe*, stipulates that a first impression matters. "People decide how competent you are in 100 milliseconds." Gruenfeld discovered that when it comes to projecting competence, 7 percent is attributed to your words,

35 percent to your presentation, and a whopping 55 percent to your body language.

We often start talking about *power* with our clients with regard to how one enters a room. Body language communicates power and status and sets the stage for who leads in a situation. Power comes with being perceived as authoritative, which encompasses confidence, credibility, and communication. Gruenfeld's research reveals the body language of power as follows:

To be perceived as *authoritative*, all people (women *and* men) are expected to

- be expansive, take up maximum space,
- speak in complete sentences,
- hold eye contact when talking, and
- refrain from monitoring the responses of others.

Gruenfeld's research also reveals, however, that women, unlike men, must balance being authoritative in order to fulfill leadership expectations with being perceived as approachable, which encompasses composure, connection, and communication.

Therefore, to be perceived as *approachable*, women are expected to

- maintain a tight, closed body,
- speak cautiously,
- avoid direct eye contact, and
- smile and nod in agreement.

Do you see the conundrum here?

Gruenfeld's research suggests that it's important for women to find the right balance between these opposing cues to match the situation, as well as accurately convey their

message and intention. If it sounds kind of like the challenge to pat your head while you rub your tummy, it is. With this finding, it's clear why Jasmin's tendency to show up for battle was not serving her well. She would need to learn to control and modulate her internal states in order to fully step into her executive presence. And yet, she'd also need to do this with authenticity.

"Do you know what method acting is?" Lee asked Jasmin.

"I think so. Isn't that when an actor *embodies* the character they play?"

"That's right," confirmed Lee. "Method acting requires the actor to fully embrace their character, including the character's emotional states, so they can deliver a sincere and expressive performance. This requires the actor to draw on her own inherent and authentic emotions, amplifying some and shrinking others to find the right emotional balance for a given scene. Let's explore this concept as you think about your upcoming review."

Lee had Jasmin relax and even her breathing. Then she had her float out of her body and view herself as if looking down into the meeting room. "From this perspective, just paying attention to the emotional state of both you and your boss, what do you notice?" asked Lee.

Jasmin took a deep breath before she answered. "I'm nervous," she quietly replied. "And I can tell that I'm already being protective . . . maybe I even have a little fight in me right out of the gate."

"What about your boss?" asked Lee. "How does he look?"

"Uncomfortable. I get the sense he's not looking forward to our discussion. He also looks a little shut down and guarded."

"It's great you can see those dynamics," confirmed Lee. "But now I'm curious. What would be the ideal way for you to show up in this meeting, *so that it benefits all?* Look at it from a higher place, in the context of what's in the highest and best good for everyone."

"I have to think about that for a second," replied Jasmin. With her eyes still closed she continued with her breathing, going even deeper within. Finally she said, "It would be in the best interest of everyone if I could show up to this meeting relaxed and curious, instead of anxious and defensive. I think if I walked into the room that way, it would set a different tone with my boss."

"Okay, let's replay the scene, but this time walk in relaxed and curious," instructed Lee. "What do you notice?"

Once again, Jasmin remained quiet while she replayed the scene in her head. "The energy in the room is completely different," she relayed. "My boss is actually smiling, and he seems more open and receptive." She took a deep breath. "This is a lot better. But when the time comes, I'm not sure how to get myself in this place, given we'll be talking about some pretty high-stake issues."

"We're going to prepare for this discussion by focusing on two things," reassured Lee. "First, we'll focus on the content of your discussion, and second, your delivery of it."

Given any interaction, whether insanely stressful or just mildly annoying, most of us spend more than 95 percent of our time zeroed in on content. Yet we completely ignore the body language, energy, and emotions behind the delivery. Unfortunately, this imbalance determines what shows up in that first 100 milliseconds of your initial presence and thus influences the outcomes of your meetings.

Lee assured Jasmin that in the upcoming meeting with her boss, it was particularly important to show up with a high degree of executive presence. "The feedback your boss has given you is that you're not demonstrating executive presence when you're reactive and combative," confirmed Lee. "That stance lacks composure and connection. And when you self-advocate, you communicate from a place of self-interest."

"Then how do I stand up for myself without coming across as self-centered?" asked Jasmin.

"That's a fair question," responded Lee. "However, I can assure you, you'll be perceived as much more powerful, and more likely to achieve your desired outcomes, if you shift your stance to one that favors a positive outcome for a higher good and not just you alone."

To get Jasmin started down that path, Lee recapped the three ideal outcomes she heard Jasmin say she wanted:

1. To increase her compensation
2. To understand (and advocate for) her path to promotion
3. To report to someone who can better support her as a black woman

"The first two are appropriate for your review meeting with your boss," Lee confirmed. "But the third topic encompasses a bigger picture, and is something you'll need to tackle separately. Do you agree?"

"Yes, that makes sense."

"Good. So focusing on the first two things in your list, let's float back into that higher place, where you're looking down at yourself and your boss in your performance review meeting." Lee waited a couple of seconds to let Jasmin get back to where she needed to be in her mind's eye. Then Lee

quietly added, "Tell me, from that place, when you get what you want, what's in it for your company? How does increasing your compensation and putting you on a path to promotion benefit the company?"

Jasmin nodded her head in agreement and then thoughtfully spoke. "In terms of compensation, our CEO wants to be a leader in diversity, equity, and inclusion. He wants our company to be known as a great place that attracts and retains top talent, regardless of their gender or skin color. My compensation is an issue of equity. It's critical to the CEO, and to the company, that we compensate all people equally and fairly. I've done my research and I know that my compensation is low. I think it's in the best interest of the business to adjust my compensation to what's fair in service of equity."

"That's great," exclaimed Lee. "Now you know how to open the discussion with your boss—by aligning your request with the company's values. Now let's role play that conversation."

Jasmin described how the meeting would progress. First she would receive her performance evaluation, then Rich (her boss) would tell her how she rated on the five-point evaluation scale. And then her compensation would be determined from that. Even at the top rating, however, her salary based on merit would increase only (at most) by 5 percent. But according to Jasmin's research, she'd need a 10 percent salary bump just to get to the midpoint. "So I guess I'd say to Rich, 'I've done research on compensation and here's what I've found.' And then I'd lay out the numbers, showing him that a 10 percent bump is what needs to happen to take my salary to the midpoint."

Lee smiled, impressed with Jasmin's preparedness. "Okay, still floating above your meeting, I'd like you to imagine that exact scene, and then tell me what's going on emotionally."

Jasmin centered herself into that moment and then said, "Rich definitely shuts down and gets defensive. He was planning to give me the maximum raise, so he has no idea that I wouldn't be happy with that. I don't think he actually knows what I should be paid. This really throws him off."

"Those are great insights," replied Lee. "It's critical for you to have that kind of awareness so you can show up with executive presence. Since this will be a contentious discussion, I suggest you give him a proposal in writing before your meeting, via email, so he can review it in advance. That way he won't feel so blindsided. What you noticed looking down on that scene is that Rich couldn't respond to or even process what you're asking. However, if you email your proposal to him in advance, you give him time to do his own research and decide how to respond."

"Yes, I see how that's a win-win situation for us both," replied Jasmin.

"But even before you have this discussion, I recommend that you meet with your HR representative first to discuss the situation," cautioned Lee. "Because even if Rich decides to give you what you want, he will need to go to HR first to do so. Therefore, having support of HR ahead of time will be helpful for both you and Rich. Does that make sense?"

"Yes, it does. I have a close relationship with Heather, who's our HR representative," said Jasmin. "So I'll meet with her to go over the salary data I've gathered."

"Now as far as your promotion goes, what's in it for the company?" asked Lee with a smile, knowing what the reply would be.

"That I won't look for another job," laughed Jasmin. "But I can't really say that."

"No, you can't. Instead, tell me how the company benefits when you're promoted?"

"Ah. I get it." Jasmin thought for a minute. "I'll try to come up with three things," she said using the Rule of Three introduced in our group work. "First, I've developed a leadership presence in our industry. As a woman of color, that's a big deal. With a VP title I'll be asked more often to speak as an industry thought leader. This benefits the company because it demonstrates that we really do value diversity. We're not just saying that."

Lee nodded but remained quiet while Jasmin thought some more. "Second, I've worked on a couple of partnership deals, and recently I've been asked to negotiate some technology acquisitions. Without the VP title I need to bring in my boss to secure the deals. A VP title will give me the clout I need to negotiate more powerfully and also hold full accountability for the outcome of our partnerships."

"Those are both sound arguments," confirmed Lee. "And your third?"

Jasmin paused. "Hmmm. I can't think of a third," she admitted.

"Not a problem. When you use the Rule of Three, but only come up with two, you can just say, *'There are more, but these two are by far the most important,'*" advised Lee. "However, before we move on, I'd like to offer one thing you might've overlooked. How about the fact that you've stepped up to a

leadership role as a founder of the Black Employee Resource Group (ERG), and you've been instrumental in developing the DE&I strategy to increase representation of black employees at the company? In doing this, you've made a significant leadership contribution to the company. Plus, you've become a visible role model to others who are looking for indications that your company walks the walk and doesn't just talk the talk. Promoting you sends a strong, positive message to your black colleagues, as well as others in the company, who care about diversity."

"Yes, that's a great one," agreed Jasmin. "How could I forget that? I spend a lot of time outside my regular job to make our company successful. And I took on a visible, and frankly really vulnerable and painful position, right after the George Floyd killing. At that time, I spoke to the entire company at a town hall meeting about my experience as a black employee—and a black woman. I was truly raw, and it took everything out of me to be that authentic and present in front of everyone. I know that town hall really brought the company together and demonstrated our commitment to inclusion." Jasmin stopped to reflect and then poignantly added with confidence, "It's important to me that both my leadership and investment of time and energy outside my day-to-day responsibility are recognized and rewarded. I want all that taken into consideration when I'm evaluated for a promotion."

To address Jasmin's third desired ideal outcome—being able to work with a more racially enlightened and compassionate executive—Lee and Jasmin came up with a plan for her to meet with her HR team to create an informal reporting relationship to a female executive whom Jasmin admired. In this case, the higher benefit was that this female executive

could provide support and mentorship to foster curiosity, creativity, and confidence, all of which are traits the company values in its employees. Right now she was getting none of that from her current manager.

After they completed Jasmin's plan, Jasmin eagerly drafted the emails she would send to her manager and to her HR representative prior to her respective meetings with each. She then role-played both meetings with Lee to fine-tune her language and tone.

"Your meetings with your boss and HR are also great opportunities for you to practice another key characteristic found in powerful, successful executives: *active listening*," advised Lee. "Though you have a strong desire for the outcomes you want, these meetings are not a time to advocate for yourself. That will take care of itself with the proposals you will send in advance. These meetings are a time for you to sit back and really listen to what the other side has to say. And when you do, listen with genuine curiosity: ask questions and gather as much information as you can. Then, if you need to take action, you can do so in a follow-up meeting. Make a deal with yourself to sleep on whatever happens before you act."

"That sounds really hard," Jasmin confessed. "I know I'll get pretty upset if things don't go my way."

"Let me show you a trick," offered Lee with a smile. "Imagine that you're a DJ and you have a mixer you use to dial up and down various emotions, things like confidence, composure, curiosity, calm, etc. We'll use this metaphoric mixer to develop your stance for the meeting. Let's talk about how you'd like to show up from the higher perspective."

"Let's see. I definitely need to be confident and determined," Jasmin began, "but not combative. So those are

medium to high, but they're tempered by my curiosity and something else. Hmm. How about ... empathy. I need to have at least some level of empathy for Rich so I can relate to his discomfort and meet him with curiosity rather than judgement. And from up here I can see how my natural energy level overwhelms him, so I need to dial that down. And I need to dial down the anger and indignation I feel just having to advocate for myself in the first place. That's not helpful in this meeting."

"Good. You get the idea. So here's how this works. You'll step through each emotion, one at a time, and experiment with dialing it up and down," instructed Lee. "Then decide where you want it, and we'll pin it there and go on to the next emotion. Let's start with confidence. Think of a time when you felt really confident, and really load up that feeling in your body."

"I remember the time I was asked to present at an industry meeting," said Jasmin. "I knew my topic cold, and I wasn't even nervous. I was just excited to share the cool stuff I was working on. I felt really confident then."

"Love that! So if the slider goes from one to ten, what's the number that corresponds to your feeling of confidence in that moment?"

"I'd say about a seven."

"Perfect," confirmed Lee. "Now using the imaginary dial, bring it down to maybe a three or four."

"How weird!" exclaimed Jasmin. "I can feel it ratcheting down. That's so cool!"

"Now move the dial all the way to a ten."

"Whoa. I feel invincible!"

"So where on the dial is the right level of confidence for your meeting with Rich?"

"Should be at about a six," said Jasmin. "I need to be confident, but not over the top. A five is too humble, and a seven might be too much."

Lee had Jasmin do the same "DJ exercise" for all the emotions she identified as important for her meeting, landing on the right setting for each one. Then Lee had her feel into the first emotion at its proper setting, then build on that with the second emotion, then the third, and so on, until Jasmin internalized the ideal emotional stance for her meeting.

"How does that feel?" ask Lee.

"Good," replied Jasmin. "And very different than I would have had if I had my review meeting with Rich before this session."

"How so?"

"I feel less combative and way more open and curious." Jasmin sat with this sensation for a few seconds, and then added, "Wow. This is such a new approach for me. I like it, but I'm really going to have to practice getting to this point on my own."

"I understand how you would feel that way, but don't put too much pressure on yourself to see big differences overnight. This work builds on itself, and change happens gradually. Over time you'll be able to look back and more clearly see the accumulative effects of your efforts." Lee replied genuinely. "Now let's try a little experiment. Imagine I'm Rich and we're discussing your promotion, and I suddenly say, *Jasmin, I agree that you've stepped up your leadership, but I really don't think you're ready for a promotion.'* What happens to your stance?"

"Of course my immediate reaction is to be angry and prepare for battle. But given the emotional settings we preselected, the parts of me that are *curious* and *calm* appear in

my head, and I dial those up, bringing *calm* from a five to a nine and *curious* all the way to a ten." Lee let Jasmin enjoy that sensation for a moment, which prompted Jasmin to add, "I really like having that visual of a mixer to focus on when my emotions start to get the better of me. I can see how I can use that visual to maintain my composure."

"Well done, Jasmin!" Lee responded. "Remember, one great way to amplify your curiosity in any situation is to ask *how* or *what* questions. Doing this will elicit practical answers to help you understand what he's thinking. Questions that spotlight *how* and *what* are more neutral than *why* questions, which tend to focus on opinions. And when opinions come into play, we run the risk of casting blame and judgement."

"Can you give me an example, Lee?"

"Absolutely. Imagine asking your boss, *'How will you know when I'm ready for a promotion? And what is it that will let you know?'* Do you see how less confrontational that is to asking, *'Why don't you think I'm ready?'*"

"Yes, I do," replied Jasmin with a sense of relief. "Rich's answer will actually allow me to understand what I need to do, in real and practical terms, to demonstrate my readiness, rather than just giving me a vague and subjective explanation."

"True, but it will also cause him to be clear about what he needs from you. Questions that focus on *how* and *what* are a gift because of the clarity they provide for everyone involved."

When we're working with leaders to elevate their executive presence, we often assign them a "how and what diet," where they commit to a week of asking only *how* and *what* questions, even when their employees explicitly ask for advice or input. This teaches leaders how to show their employees ways to come up with their own conclusions. In turn, employees

become comfortable with proposing solutions rather than rely on their leaders to solve every problem. These coaching weeks are transformative for the leaders we work with, who take quantum leaps in their leadership skills as a result.

In the end, Jasmin's meetings with her boss and HR representative went well. Heather, her HR representative, hired a consultant to do a compensation audit for her role. They concluded, as Jasmin had, that her compensation was considerably below the midpoint for her pay grade. They approved a 5 percent compensation adjustment in addition to the proposed 5 percent maximum merit increase. And they even scheduled a six-month review to give them a second chance to true up her salary before her next annual review.

Heather also reached out to Martha, the EVP heading up product release, who agreed to become a dotted-line manager and mentor to Jasmin. Jasmin and Martha set up a schedule to meet twice a month. This regular contact with a female leader gave Jasmin the support and mentorship she craved. As a result, her need to be a fierce self-advocate diminished.

Solutions Not Problems

The leadership advice Lee gave to Jasmin was also relevant for Sarah. When we next met, Sarah reported that she had continued with her interviews, but after our last session, she had reevaluated her new opportunities compared against the benefits of staying at GGG. "So many things changed after we did the cave exercise together, Kate. I realized that a lot of my aspiration to pursue new opportunities outside of GGG is all about title and money and has a lot to do with my ego. Don't get me wrong; I am ambitious, and I want to step up to the next level, but I also want it to be the right opportunity, at

the right time. I feel like I've just found my footing at GGG, in terms of balancing family and work, and I want to just chill for a moment to regroup and restore my energy. It's been a tough few years."

"That makes perfect sense," I agreed. "I'm happy that you're considering all your options and taking into account everything, not just your need to achieve more and prove yourself. It's so healthy for you to think about the other aspects of your life, including your family and your desire to have time to yourself. There's no doubt that becoming a C-level executive at a start-up comes with greater demands."

"I appreciate you saying that. Because to be honest, I thought *maybe* I was just backing away from a challenge that I wasn't sure I was up for," admitted Sarah. "But now I realize that even though I'm ready for a step up, I may not be willing to take on the 24/7 demands of a start-up."

"Then let's talk about GGG. Now that you're thinking of staying, how might you get the most out of your role there? If you could wave a magic wand and change anything to make your job more fulfilling and impactful, what would it be? "

"That's easy," said Sarah with a smile. "First, I'd be in serious consideration for a promotion. A new VP position in my area is opening up, and I'm pretty sure they have me in mind to fill it, but I'd like to be sure."

"That sounds fair," I reassured her. "Anything else?"

"Yes," Sarah continued quickly, "The second thing is . . . after they hired Terry as my boss, I no longer get enough time with the company executives to be tapped into the pulse of the business. It used to be that I was in the weekly executive staff meetings. But now Terry goes to those meetings, and he's not good at keeping me in the loop. I'd like to be more involved

in strategic decisions like I was before." Sarah hesitated for a second but then added, "And frankly, Kate, I would do a much better job and make a bigger contribution to the success of the company if I were in the loop."

To address the first issue of promotion, I suggested Sarah have an informal meeting with GGG's CEO to let him know her desire for a promotion into an executive role and to learn more about his future plans regarding the executive team. When they met, Sarah learned that he did, in fact, plan to expand the executive team in about six months and that she was a top candidate.

She also asked him what she needed to do to demonstrate that she was ready for the promotion. "He told me that my current contribution to the business, and the level at which I'm operating in my current role, was exactly what he needed to see. But he also added that he'd like me to work on how I project confidence with my colleagues and the other executives and gave me great examples of how that might look."

"Like what?" I asked.

"In my previous presentations, he noticed that I sometimes go into more detail than needed and that we had to cut off discussion without reaching conclusions," Sarah said candidly. "So he suggested that I set up context first, then give the punch line up front versus at the end. And that if I have twenty minutes to speak, I keep my presentation to ten minutes so that there's ample time for discussion."

"Those are great suggestions, and they sound very doable," I replied.

Next, Sarah met with her boss, Terry, to express her interest in promotion and to relay her discussion with the CEO. During their meeting Terry identified several growth areas for

Sarah that would better position her to fill the VP role when the time came. She and Terry created a development plan, which Sarah eagerly put into action.

Addressing Sara's access to the executive team and being involved in strategic company decisions took a little more finesse. To resolve this issue, I had Sarah clarify her intention and then helped her create a proposal that outlined a clear benefit to the business. As we worked together on her proposal, I asked her to tell me specifically what she wants.

"I'd like to be included in the weekly executive staff meetings," she declared.

"Great, and what will that do for you *and* the company?"

Sarah took a moment to put the pieces together in her head before she answered. "Well, as we're positioning the business for the next round of funding, I'd learn a lot of information in those executive meetings that would help me make more effective and strategic decisions about which partnerships to prioritize, as well as how to structure those partnerships to the company's advantage." Sarah stopped and got quiet for a few seconds. The ideas buried in the back of mind were definitely coming to fruition. "I also think we need to make some strategic decisions about what we do—*and don't do*—with our partners. Such a discussion should be in the context of the overall corporate strategy, and I know that the executive staff meeting, and other strategic offsites, are the forums where that happens."

Sarah was on the right path, but to help get her completely on track, I rephrased the question to challenge her to focus more on the *what* instead of the *how*. "Okay, so you'd like executive involvement in order to get the strategic insights you need to optimize your partnership engagements *and* to ensure

strategic partnership trade-offs are included in the overall company plan. Is that right?"

"Yes, that's it," agreed Sarah. And then smiling, she added, "I see how you did that."

"Separating the *what* from the *how* opens doors to creative solutions that may not exist when you presuppose *how* the desired outcome happens. This allows you to present the problem and then discuss a range of possibilities."

I knew from my own experience that it's difficult to selectively include nonexecutives in executive staff meetings, as it ruffles feathers within the ranks and can create morale issues among peers. Even though what we came up with was a viable solution for Sarah, I wanted her to remain open to alternatives that would achieve the same result without creating personnel issues.

"Let's structure your proposed discussion with a Problem-Solution-Result (PSR) format," I began. "First, concisely state the problem in the context of the company."

Sarah nodded in agreement and then said, "How about this: *The partnerships I manage are highly strategic to our business. When I'm not included, nor in the loop at a high level, then I can't effectively ensure our partnerships are aligned with our company strategies. That means neither I nor my team's efforts can operate in the highest good for the company.*"

"That's great!" I praised. "I suggest you also give an example to illustrate the problem, then propose a solution. Obviously including you in the executive meetings is one possible solution, but can you think of a second one that's a little more creative? Maybe one that might not stir up issues with your peers who are not included in those executive meetings?"

"I see where you're going with this, Kate," replied Sarah with a sly smile. "Yes, I can think of something. When GGG was a smaller company, I reported directly to the CEO. I'd often meet with him to discuss key issues. He benefited from learning more about our partners and their challenges, and I benefited by having his insights. So perhaps I could set up a regular thirty-minute one-on-one meeting with him every two weeks to give him critical updates on our partnerships *and* also ask for his strategic guidance."

"Yes, that makes sense. However, the question that arises for me is why can't your boss provide that for you?"

"Terry doesn't have the same technical depth in analytics that I do. But the CEO does. So he's the logical choice. Terry's competent in other ways, but he just doesn't have the experience to give me the guidance I need. Meeting regularly with the CEO, and briefing him on the important intricacies of our partnerships, gives him the insight he needs when working with the executive team on strategy."

"That is solid reasoning," I concluded. "And as a by-product of these meetings, you'll be more visible in a valuable way, so that when the VP role opens up, you'll be in a stronger position to be promoted. All you have to do now is write this up in a clear and concise email. Be sure you state the problem, propose the solution(s), and focus on the benefits to the company."

"Wow, Kate. I'm just noticing what a better place I'm in than I was a few months ago," Sarah gave a big sigh of relief. "I was so worried about getting out of GGG, but now I really feel like I can make things work there. In the end, I think staying at GGG is a much better fit than jumping ship to an

unknown situation that may require more effort than I want to give."

"I'm delighted to hear that!" I said sincerely. "Time is definitely an ally when it comes to this work. It's not unusual to see breakthroughs weeks, months, or even years down the road. However, the frequency of change happens differently for different people. It's not one size fits all."

"I see that now. Looking back from when I first met with you, the effects from our work together are definitely cumulative," agreed Sarah.

"I can tell! You look more relaxed and untroubled than ever," I said, happy that Sarah had found a groove that gave her comfort.

"Yes, it's amazing how much more in control I feel. Making reasonable, professionally crafted proposals that demonstrate value to the company, instead of just to me, is a game changer. I'm confident GGG and I will come to terms, and I feel good about my chances of getting that promotion."

"And if you don't get it?" I asked with genuine curiosity.

"Then I'll deal with it when the time comes. Either way I won't take it personally. I feel so much more grounded and confident of my value as a team player . . . and that makes me calm and at ease. Thank you so much. This process has been life-changing."

Sarah leaned back in her chair. A beaming smile grew across her face.

CHAPTER 11

THE JOY FACTOR

When Sarah reached out to set up a coaching session, it had been almost two years since we last met. Although we had exchanged short messages every couple of months, I was still excited to hear more about her journey. She told me she was at a turning point once again, so I was curious what it could be and where she would head next.

She stepped through my office door looking rested and relaxed. The energy she emanated felt solid and grounded, yet her eyes and sly grin sparkled with enthusiasm. She sat down with her cup of tea and let out a deep sigh.

"It's so nice to have you back, Sarah," I said earnestly. "I've missed our time together."

"So much has happened, Kate! I feel like such a different person from the very first time I walked through your door. It's almost hard for me to relate to *that other Sarah*." She paused and took a sip of tea. "Last night I thought a lot about the work we've done together, and it inspired me to reread the journal I used to write down my thoughts after each of our coaching sessions. It was enlightening to recall how things evolved for me over time. My *big moment* occurred during our last session when all of the pieces suddenly clicked into place. It was then that I finally allowed myself to be comfortable in my own skin."

"I'm delighted to hear that." I replied warmly. "The work we do together does build and deepen. One of my clients compared it to advancing up levels in a video game. With each new level, we improve our skills and resolve challenges. But then at the next level new challenges emerge, so we keep learning. However, we're always smarter than we were at the previous level. I guess that's the human condition—endless opportunities to learn and grow."

"Yes, that's exactly what it was like for me, as well. I felt different on the inside after each of our coaching sessions," admitted Sarah. "Even my boss noticed the changes along the way. Recently, he commented on how much more calm and confident I am now than when he first joined the company. We've found a way to work together really well. At first I was upset when they had passed me over for his job. I couldn't believe they picked Terry over me, because all I could see was how incompetent he was. It took a while, but finally I realized that he does, in fact, have many strengths that I don't have. Since then, we've both learned how to leverage our differences to work well as a team.

"That's great to hear. Tell me more about that VP promotion you got several months ago." I asked, silently hoping all had turned out well for Sarah.

"They didn't even interview any outside candidates," beamed Sarah. "The CEO told me how much I had grown and that I was showing up with way more confidence. He could see I was ready, so I got the promotion *and* a huge bump in salary. I have to admit—I felt like it was well-deserved."

"How have you handled balancing this new position with everything else in your life?" I could tell Sarah was succeeding nicely, but I wanted to hear it from her.

"Even with the increased responsibility, I manage things quite well between my family and work. I have enough flexibility that I can work from home a day or two a week. Plus, I adjust my schedule so I can attend most of the kids' activities. And I almost never work on the weekends or in the evenings now."

"How wonderful!" I congratulated her. "I'm curious, what do you think was the biggest turning point for you."

"It was the session in which we worked on resolving the trauma I had from elementary school, when I struggled with my learning differences. That shift really put my perfectionism in check, which freed up my energy for more productive things. That realization alleviated a whole lot of anxiety and stress, which led to a huge breakthrough for me." She smiled before poignantly adding, "I almost can't relate to how I was when I constantly worried about everything."

"So now . . . you *never* worry about anything anymore?" I said in jest.

She laughed at the thought. "No, I still get anxious once in a while if I'm involved in certain high profile situations. But I don't sweat the small stuff like I used to. It's such a huge relief."

"I'm so happy for you, Sarah. I'm inspired by the deep work you've done. And from the moment you walked in my door today I can tell that you're so much happier and more composed." I gave her a second to bask in her glory of success before I casually added, "So what's next? You hinted that you're at another turning point?"

"I am. I remember you telling me that once we work through resolving my Impostor Behaviors that I'd reach a phase at which I'd become keenly aware of my own interests

and passions . . . and that I'd want to act on them. I think you called it transformation? That's where I am now."

"Really? How so?" I inquired.

"This might sound crazy . . . " began Sarah tentatively. "I love my work. And I'm paid really well. However, I'm not sure it brings enough meaning and purpose into my life. This becomes more clear the older my kids get. With career demands on my time, I make big family sacrifices to work at my level. I want to make sure it's all worth it. Does that sound ungrateful?"

"Not at all. In fact, you're totally justified in your thinking," I assured her. "Because when you factor the *whole you* into your life, your priorities change. Given all the work we've done together, this is your natural progression into the next phase of the process. As you become more aligned with your true self and core values, your emotional energy elevates to a higher good. As a result, you will be guided and supported in unexpected, yet beautiful, ways."

"I already feel like that's happening," revealed Sarah. "I was at a conference about a month ago, and I met a woman who runs a venture capital fund that's focused on social ventures in life sciences. She happened to be seated next to me at the dinner, and we hit it off. She told me she has a couple of portfolio companies that need an experienced and well-connected CEO, so I've started to explore those opportunities with her. And then there's another great role at a company that's an even better fit, but it would mean a big change for me. Maybe too big. It's a CEO position at a start-up and would entail a substantial salary cut. Even though I know I could do it, I'm nervous about stepping up to CEO level at this stage. I'm not sure if this is the right time, with my kids still so young."

"All of that is important and relevant," I offered. "The key is to make sure whatever you decide is in service of the highest good, and not a reaction to fear or doubt."

"How do I do that?" asked Sarah.

"We need to explore a bit deeper, so you can gain clarity and decide what's most aligned with your true intentions. Are you up for that?"

"Yes. Although I have to admit, that sounds scary and exciting all at the same time. But I feel like it's exactly what I need."

The Energy of Emotions

Numerous widely read experts like Chip Conley (author of *Peak: How Great Companies Get Their Mojo from Maslow*), Mihaly Csikszentmihalyi (author of *Flow: The Psychology of Optimal Experience*), David R. Hawkins, and Esther and Jerry Hicks (authors of numerous books on human consciousness), and Jim Loehr and Tony Schwartz (authors of *The Power of Full Engagement*), among others, have studied the impact emotional state has on performance. Each of these authors identifies similar states of *peak performance*—which is when individuals function at optimal levels, also known as *being in the zone* or in a state of *flow*. This happens when we operate with a combination of positive emotions and high energy.

Directly related to flow and *being in the zone* is the emotion of *joy*. A 2019 *Harvard Business Review* article titled "Making Joy a Priority at Work" identified the *joy gap*. In a survey of more than 500 workers, researcher Alex Liu found that while 90 percent of workers expect to experience joy at work, only 37 percent report actually feeling joy, leaving a joy gap of 53 percent. Liu's assertion is that while companies

make massive investments in technologies designed to more closely link their employees, customers, and stakeholders, they struggle when it comes to inhouse dynamics. The problem is company cultures are generally too layered with stressful situations. But Liu identifies joy as a big part of the solution. People intrinsically seek joy, and joy connects everyone more powerfully than almost any other human experience.

But in our daily work, how can we track our emotional states so that we can strive for joy and flow, not just in our work, but also within the teams we lead? Hawkins and Hicks developed two similar scales that map the emotional energy behind emotional states, often referred to as *states of consciousness*. The underlying theory behind their work is that thought patterns generate energy, which vibrate at various frequencies. The higher the emotional state, the higher the frequency. While the science behind these findings is not universally accepted, there is plenty of evidence that links positive emotions and thinking to better health and greater goal achievement.

Hicks created a list of twenty-two commonly felt emotions ranging from the highest positive levels of: *joy, appreciation, freedom*, and *love* to the lowest negative levels: *fear, despair, desperation, grief,* and *powerlessness*. We've adapted this concept to create the Flow Scale, as shown in Figure 1.

Referring to the right side of Figure 1, notice that the pleasant emotional states are in the top half, while unpleasant emotional states are at the bottom. The state of **FLOW,** a high-performance and highly creative state, exists when energy is high and the emotional state is pleasant. Moving down Figure 1, the state of **RENEWAL,** a productive and relaxed state where energy is conserved and replenished, results from the combination of pleasant emotional states with lower energy.

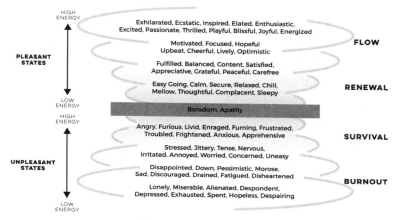

Figure 1 - Flow Scale

Conversely, in the bottom half of Figure 1, the **SURVIVAL** state, which often results when we're triggered, happens when we experience unpleasant emotions combined with high energy. And when that becomes chronic, the state of **BURNOUT** often occurs when triggered energy subsides, but our unpleasant emotions persist.

Although I coined the term *The Flow Scale*, it's an amalgamation inspired by three existing resources. The first is the emotional scale developed and popularized by Esther and Jerry Hicks in their book *Ask and It Is Given: Learning to Manifest Your Desires*. The second is the *Mood Meter* created by the Yale Center for Emotional Intelligence. And finally, the third is the work of Jim Loehr and Tony Schwartz in their book *The Power of Full Engagement*. In our work, we find The Flow Scale helpful in order to identify the emotional energy and states associated with your experiences. It also shows you how to increase your emotional energy and elevate your emotional state to experience more joy.

The Joy Factor

When we're at a career crossroads, faced with a decision about whether to stay or take on a new role, we most often evaluate these opportunities within a narrow range; for example, we ask ourselves questions like, *How much does the new job pay? What will my role and scope of responsibility be? How aligned is the opportunity with my interests and aspirations?*

But what if we instead asked this question: *"Will this new opportunity put me in flow and bring me joy?"* Usually flow and joy are not primary considerations when making career decisions, but they should be. Because if all things are relatively equal when deciding between jobs (such as money, title, and scope), the closer you get to joy and flow in your day-to-day work, the more you'll work with grace and ease, which means the better you'll perform, which leads to performing at your peak, which in turn yields greater success. We know this intuitively to be true, and yet rarely do we consider joy and flow in our assessment.

I introduced The Flow Scale to Sarah as a tool to examine her job at GGG versus her new opportunities outside her company. "First let's take a look at your current role in the context of The Flow Scale," I instructed her. "Make a list of the primary tasks you do every week in your current job. Include things like meetings with the product team, mentoring employees, creating and managing budgets, and whatever else you can think of. Then using The Flow Scale, determine the emotional state that best defines your overall experience in your job. Then fine-tune your emotional experience by determining the emotional state associated with each primary task you listed for your job."

I gave Sarah about five minutes to get started on this exercise, and then I asked her to share some of what she learned. "Well, I'm definitely in the right career," she concluded. "The design and technical work I do personally, as well as how I lead and collaborate with my team, brings me about as close to joy and as '*in flow*' as I can get."

"*Close to joy*? What does that mean?" I asked.

Sarah thought before she answered. "I believe in these tasks, and when I do them, I feel *inspired, enthusiastic, passionate, joyful, and energized*," she said carefully.

"In other words, you have quite a positive experience with that aspect of your work," I summed up.

"Yes, but when I think about my day-to-day work, I'm doing the things that bring me joy and put me into flow only about 50 percent of the time.

"Wow. How do you feel about that, Sarah?"

"A little stunned actually."

Now that Sarah was an executive, she had to spend a lot of her day on the other end of her Flow Scale doing things like creating and managing budgets (which brought her to *boredom* and *frustration* levels on the scale), managing difficult employee dynamics (*frustration, stress, and anger*), and the endless meetings, emails, and communications required to keep everyone informed. She also spent more time than she wanted involved in office politics (*irritated, discouraged, and drained*). "This is an eye-opener," she marveled. "Even though I find joy and flow in 50 percent of my job, the further I move up the ranks, the more removed I become from the things I love to do, which are designing products and learning new technologies. I guess my overall experience at GGG lies somewhere between *flow* and *burnout* on The Flow Scale."

"It's no wonder you're considering other opportunities," I replied. "To get an even deeper perspective, let's take a minute to explore the things on the negative end of your scale. Pick one of the things on your list that you really don't like, and then use the scale to determine if there are ways you can elevate its emotional energy, so that it's at least marginally above the *boredom and apathy* level."

Sarah knew immediately which one to pick. "I'll start with the endless meetings, emails, and all the different types of communications I have to do in order to keep others informed."

"Sounds good. But now let's narrow that down *even further*," I encouraged. "Focus on just the meetings and communications. What is your emotional level on your joy scale when it comes to *only* meetings and communications?"

Sarah made a scrunchy face like she'd just sucked a lemon. "Ugh. I'd say it's around *pessimistic, frustrated*, and *bored*," she admitted with candor. "All the team leaders do these weekly status updates for the CEO and executive staff. I usually do mine on the weekend, and it's such a drag because it takes about an hour or two to complete. And frankly, I think it's a big waste of time. I know for a fact that team leaders don't read each other's reports—I certainly don't. But my CEO relies on them to keep his finger on the pulse of the business."

"Is there anything you can think of that would bring up your level of enthusiasm when you do these reports?" I asked. "Even if it's just a few levels—to *contentment*, maybe? Or *hopefulness*? Or possibly *optimism*?"

Sarah had to give this some considerable thought, since she had clearly decided these reports weren't really necessary. "I guess I'd move up to *hopeful* and *optimistic* if I thought people actually had genuine interest in the information I wrote.

Also I wouldn't mind doing them as much if they didn't take up so much of my time. The CEO has a specific format we have to use, which is why it takes so long to write these reports in the first place."

"Then let's explore some ways you might change that report format so that it bumps up your emotional level," I offered. "First, let's see what we can do to optimize the process. Since doing this report eats into your personal time, I think it's worth proposing that you and your CEO work together to create a new report format that meets his needs *and* brings you *contentment*, *hopefulness* and maybe even *optimism*."

"I'm not sure I know what that would look like," confessed Sarah.

I showed Sarah a weekly report format that we recommend our clients use to help streamline their lives, in their own circumstances. To keep things simple, our template has three sections, no more than three items per section, and no more than two or three sentences per item. The three top-level sections are as follows:

1. Breakthroughs
2. Challenges or Risks with the Mitigation Strategy
3. Requests or Input

A Breakthrough is something significant that happened during the week, and as a result it cleared a roadblock or made something possible. I asked Sarah if she could think of any Breakthroughs that happened at work in the last week.

"Yes! Last week my engineering team finally fixed a product component that kept failing in QA," Sarah replied proudly.

"That's a great example. As a result, what's possible now that wasn't before?"

"We can finally move to the next phase of development. Before they found the solution we were stuck, experiencing a day-by-day slip in the product's release schedule."

"Do you see how powerful it is to report that breakthrough?" I pointed out. "Not only does it give your CEO a positive update on the product status, it also brings visibility to the accomplishments of your team."

"I love that! When I consider that point of view, I know I can find more breakthroughs. I'm sure we have them every week, but they probably go unnoticed and unreported because we don't acknowledge them like we should."

Satisfied that Sarah understood the relevance of the Breakthroughs section of our report format, I moved on to the next part. "What about the Challenges and Risks section?" I inquired. "Did any come up last week?"

"Definitely. As you can imagine, there are always lots of those. The challenge will be to keep it to the top three," Sarah said with a chuckle.

"Just give me one for now" I replied.

"Okay. Last week we had a supplier unexpectedly go out of business, so we have to find a new source for a really specialized component. We're not even sure when and how to do this."

"Since the resolution for this one is unclear, I suggest you add *next step* and *timeline* information to your report," I proposed. "That way you set expectations, and give yourself the leeway to report progress based on your mitigation strategy."

"That makes sense," Sarah agreed. "The next step is for Jamie to reach out to at least three vendors to see if any of them can source or manufacture the component for us. I've asked her to get back by end of day Tuesday."

I could tell that Sarah was quickly getting the gist of the cursory level of detail that went into this new report format, so I decided to move on to the last section, Requests or Input. "Is there anything you might ask of your CEO, or others on the team, to help you resolve your challenges and risks?"

Sarah's face lit up with revelation. "Now that you've brought it to my attention, there is!" she declared excitedly. "My CEO personally knows several of our vendors really well. I could ask him to reach out to check if any of them can help. That might move things along more quickly. I don't know why I didn't think of that before!"

"As a former CEO, I can tell you that my team generally underutilized me as a resource, simply because they didn't ask when they needed help," I revealed. "I always welcomed an opportunity to be of assistance, but I couldn't if I didn't know there was a problem in the first place."

"I'm pretty sure that's exactly the case at our company, as well," Sarah confirmed. "Our CEO is definitely an untapped resource."

"So now the key question is this: With this new format, which I think will take only thirty minutes or less to complete, does your reporting on product status and updates bring you closer to flow and joy?"

Sarah gave my question some considerable thought before she answered. "It really does," she replied with intention. "I now see how I can use these reports to bring greater visibility to my team's accomplishments and success. I just hope it's enough for my CEO. He seems to value quantity over quality sometimes."

"Here's what I recommend to address that. Reach out to your CEO, let him know the problem with the current format,

and tell him you will be submitting your report in a new format that you'd like him to evaluate," I advised. "Reassure him that if this new format doesn't work, you can always revert back to the old one. After he's had a chance to digest your status updates with the new format, set up a ten-minute meeting to get his feedback on how it works for him and if you need to adapt it to better meet his needs."

"That sounds great. I can't wait to hear what he thinks. You know, this might even be a relief to him. Now he won't have to wade through pages of information just to get to the key issues. I'll let you know how it goes."

After that I instructed Sarah to keep a daily list of the things she does over the next two weeks. After she had a solid list, I instructed her to categorize those list items into buckets, track the amount of time she spent doing each bucket item, and then rate them using The Flow Scale. For each item that rates negatively, I told her to ask herself two questions:

1. Is there anyone to whom I can delegate this task?
2. If not, is there anything I can do to raise the flow rating from negative to positive?

And since she was pondering if she should stay where she was or take on a new opportunity, I counseled her to evaluate any new opportunity she might be considering on The Flow Scale, as well. "For example, use the job description of the new CEO role offered to you, but then factor in your own realistic assumptions about how you think you'd actually spend your time working as the CEO of a start-up," I advised. "Ask the same questions we just went through (for your current job) in regard to the duties and responsibilities you'd have (in the new job)."

"Thank you, Kate. I now understand that when I align my work more closely with joy and flow, I'll be more successful—which eventually leads to the other things I want in a career, like money and greater leadership opportunities."

"And as a follow-up to comparing your current and new roles in the context of joy and flow, I'd like you to do two things over the weekend. First, write a letter from your seventy-year-old self, giving advice to your current self. I'll give you a guided meditation to help you step into a beautiful day in the future, from which you can look back and offer wisdom and perspective. This is a powerful exercise that brings our clients unexpected insights and tremendous clarity."

"I'd love to do that. I can hardly wait to hear what seventy-year-old Sarah has to say!" she said playfully. "What's the other thing?"

I shared with Sarah that the day before I had listened to an interview with Esther Perel, the Belgian born psychotherapist and author of *Mating in Captivity* on Krista Tippett's podcast *On Being*. Perel explores the concept of *erotic intelligence*. One of the things she discussed resonated with me in regard to peak performance and finding flow in our work. Perel revealed that she has her clients finish the following two statements (borrowed from the late therapist Gina Ogden) as part of the therapy she provides:

1. *I turn myself off when* [something happens].
2. *I turn myself on when* [something else happens].

According to Perel, what turns us off are the things that sap the energy and liveliness out of us. The same is true in reverse. What turns us on are the things that energize us.

These statements are highly relevant in our discussions around how our emotional energy relates to work, because finishing those statements reveals two important insights:

1. The responsibility we have for our own emotional states

2. The agency we have with regard to our experiences

"I can see how finishing those statements could improve my sex life, but I'm so glad you're just referring to work in this case," Sarah said with a laugh.

"In addition to writing the letter from your future self, free-write as many work *turn-offs* and *turn-ons* as you can. Keep both in mind as you catalog the emotional energy of your various tasks at work."

"Oh, wow," said Sarah, "I can already think of a bunch right off the top of my head."

"Like what?" I asked

Sarah's impromptu list was so comprehensive, I felt like she practically did the exercise right before my very eyes. Without hesitation, she told me she *turned off* at work when she was involved in

- meetings in which she had no meaningful contribution,
- working on things unrelated to her core contribution, skills, or enjoyment, and
- situations in which she was not challenged to learn or grow.

However, she listed quite a few things that turned her on at work, these being just a few from a very long list:

- Solving an engineering problem, either alone or with her team

- Brainstorming new product concepts and designs with others
- Engaging in debate and collaboration to develop best practices
- Listening intently to what customers need from their products

Sarah's reasons behind *turning off* at work clearly revealed that she had an opportunity to be more discerning about the meetings she attends and that she'd benefit from delegating some of the administrative work she does. On the other hand, her reasons for *turning on* at work provide a clear blueprint for what she would like more of and will be incredibly helpful as she evaluates future opportunities.

"Wow, what a great way to point me in the direction of joy and flow!" Sarah concluded. "This really drives home your point about how important emotional energy is to a healthy, rewarding work life. If I'm doing everything on my work life's *turn on* list, I have absolutely no doubt that I'm working in the right place and at the highest level possible to maximize my impact. And I'm sure I'll be paid well because I will be making a huge contribution. Thank you so much for this insight, Kate!"

"You're welcome," I replied with a heartfelt smile. "I'm delighted to have discovered important, yet simple, ways to bring joy and flow into your work. You'll have to let me know how it goes."

"Oh, I definitely will!" concluded Sarah.

CHAPTER 12

ENVISION

When we think of envisioning, we most often think of the visionary as a rare and uniquely gifted individual who ponders the future, imagining new products and advancements in unusually creative ways. When I ask men and women in the groups we facilitate to raise their hand if anyone considers themself to be a visionary, very few hands go up. For most of us, vision seems wildly unattainable. But we know that it's not. Cultivating vision can be taught and learned, just like any desired skill.

Sandra Cisneros, author of *The House on Mango Street*, tells a delightful story that illustrates the power—and accessibility—of vision. Like so many who achieve great things, Cisneros had a vision of her future success early on in her life. When Cisneros was in sixth grade she went to the library and riffled through the card catalog looking for her next book to read. When she came upon a fingerprint-smudged, dog-eared, raggedy card, she said to herself, "This must be a good book." In that second, she got a spark of vision. She realized that one day she wanted her name as an author to appear on a card just like that one in the library catalog. In that moment, in her mind's eye, she saw a vision of a book. And when she looked at the spine, she saw her name on it. She couldn't see the title, but she said to herself, "This is what I want."

Now Cisneros gives this advice to children. "See with your third eye and imagine what you want your future to be. In my case, I couldn't tell anyone about what I had envisioned, because I had six brothers, and I wanted to protect my dream from their ridicule, so I kept it a secret. Even if you don't tell anyone, I want you to see that dream and to walk towards it every day. And when you come to a point at which you're in a safe place, *then* you can say it aloud for others to hear."

The Power of Vision

James Kouzes and Barry Posner, acclaimed authors of the book *Everyday People, Extraordinary Leadership*, are highly regarded as leadership scholars. In their work, they surveyed tens of thousands of people around the world about the characteristics people look for in colleagues and leaders. Honesty tops the list for both. But for leaders, vision ranks a close second. In contrast, only 27 percent look for vision in colleagues. Vision, it turns out, is what distinguishes leaders from the rest of the pack.

Perhaps you've taken the Myers-Briggs Personality Assessment. For those of you who haven't heard of it, this assessment is a series of questions that categorizes personalities into four main groups as follows:

- Introversion (I) or Extraversion (E)
- Sensing (S) or Intuition (N)
- Thinking (T) or Feeling (F)
- Judging (J) or Perceiving (P)

One letter from each group gives you your overall test result. For example, if your test indicated that your personality was strong in Introversion (I), Intuition (N), Feeling (F), and Perceiving (P), your result would be INFP. According

to Myers-Briggs, natural visionaries result in either INTJ or INFJ, which are only 2.1 percent or 1.5 percent of the population respectively. That means a very small percentage of people are considered natural visionaries. It's no wonder most of us don't think of ourselves in that way.

My research in deconstructing visionaries (to identify what makes them different from everyone else) revealed that vision isn't necessarily an attribute you have to be born with. Fortunately, vision is a skill we can cultivate and practice, like learning how to play a musical instrument. Logically you may ask, if vision doesn't come naturally, why should we work at it? The short answer is this: Vision creates a perspective of a desired future in the present. This perspective can help guide you when you're at an important crossroad in your work and life. In simpler terms, creating a compelling vision of the future will guide you to greater success.

Remember in chapter 11 when I asked Sarah to write a letter from her seventy-year-old future self? This is a tool we use to tap into our client's innate visionary capacity so they can gain perspective on the present from an envisioned future. Having a future perspective provides wisdom *in the present,* so that when we're at a crossroad (making important life decisions), we have signposts that help guide us. I was excited to hear what Sarah had discovered through her letter, along with the other exercises I gave her when we last met.

"Well, Kate, it turns out my seventy-year-old self is a badass!" she said proudly. "She's wise, insightful, and incredibly vibrant."

"Of course she is!" I agreed. "I'm so happy you two had the chance to meet!"

"You gave me a lot of work to do over the past two weeks, but it was so worthwhile," admitted Sarah. "I have a much better perspective on what I would *really* like and how I might get there."

"I'm so delighted to hear that. Where would you like to start?"

Sarah had already anticipated this question and had given her answer a lot of thought. "Let's start with what I learned by taking the emotional temperature of my current job versus the new job opportunity. That comparison was fascinating, and it actually revealed a lot."

"Sounds good. Let's dive in!"

"To simplify, I distilled it down using the rule of three," Sarah explained. "When I took a look at how I spend my time in my current job, I gained three important insights. First, before I actually evaluated my day, I *assumed* I spent about 50 percent of my time on work that brought me joy. But after taking a closer look, it turns out I only spend 30 percent to 40 percent of my time doing things that put me in the joy and flow zone."

"That sounds low," I revealed. "Ideally, what percentage of your time at work would you like to invest in things that bring you joy and flow?"

"Seventy-five percent or higher," Sarah said confidently. "Maybe that's a pipe dream, but if I feel joy and flow three-fourths of my work day, I think I'd really love my job, and I'd be incredibly happy and productive. Which brings me to point number two. The biggest thief of joy is email! I realized to my horror that I spend about a third of my time responding to email, and none of it is joyous. Instead it ranges from anger

and discouragement to disappointment, overwhelm, and frustration on The Flow Scale. That's not where I want to be."

"I certainly understand that," I concluded.

"The third big energy drain is meetings," she concluded. "Not all meetings are in the negative energy range of the Flow Scale, but I did identify five recurring meetings that I simply don't want to attend anymore because they drag me down. Once I came to this realization, I politely declined to attend two of them in the future. And for the other three meetings, I've decided to send a couple of my staff members and have them report back on anything I need to know. This frees up five or more hours per week! And at the same time, I'm giving some of my staff the opportunity to up-level their visibility, collaborate with other cross-functional colleagues, and practice concise reporting!"

"That's pretty awesome!" I congratulated. "It sounds like you're on the right track dealing with unnecessary meetings, so let's talk about your email situation. As you can imagine, you're not alone in that challenge. In our work, we've found that email is a problem that steals joy from almost all of our clients."

There's a great *Harvard Business Review* article by Matt Plummer called "How to Spend Way Less Time on Email Every Day" that we recommend to just about all of our clients. In the article, Plummer explains why email is the biggest emotional drain on a professional person's life. According to the McKinsey 7S Model (a tool that uses seven internal factors to determine the well-being of an organization) the average professional spends 28 percent of their time, or 2.6 hours per day, on email. I suggested Sarah read this article, because Plummer talks about a system that Sarah could use in order

to get her emails under control and put *even more* hours back into her week.

"When you use the tools I've offered to reduce time devoted to emails, plus you implement your new meeting schedule, you'll have the potential to free up about seven hours a week. How do you feel about your current job if you do that?"

"Well, Kate, I feel pretty good about it," Sarah sighed with relief. "I now know that I have a lot more control over my time than I realized. I can actually do things that allow me to focus less on busy work and more on innovation." Sarah stopped for a second to think. "But I've also discovered something else," she continued slowly. "While exploring other CEO opportunities, I realized I have a soft spot in my heart for healthcare equity. I have a bunch of ideas for medical devices and infrastructure software that can improve outcomes for women and underrepresented groups, many of whom are overlooked by medical research."

"Do you have to switch jobs to address this new insight?" I asked.

"Surprisingly, no," Sarah replied happily. "Even though it was these other companies that awakened my innovation, I have some ideas about how I could do the same things at GGG. When I applied The Flow Scale to the outside CEO job description, I realized that a lot of my time as a CEO would be spent on fundraising and operational tasks, but not on innovation, research, and customer and partner interaction—those are the things that bring me the most joy. So even though it might sound counterintuitive to some, I've decided to put any CEO opportunities on pause while I explore what I can joyfully accomplish at GGG."

"That's so interesting! You seem pretty clear on how to proceed. I'm curious whether your letter to yourself influenced your decision?"

"It really did. Would you like me to read it to you?"

"Yes, please do!"

Sarah unfolded a piece of paper she took from her purse and began to read.

Dear Sarah,

I write this letter to you from my favorite chair in the garden. It's late afternoon, and the sun casts a sharp golden glow over the hills. I can see a hint of fog spilling over the coastal range to the west and smell an ever-so-slight scent of an ocean breeze from miles away. I am happy and content and at peace. My life is a blend of reading, researching, gardening, cooking, walking, biking, and tinkering in my shop. I still love to make things, and I do so every day. Allen and I have found a loving rhythm to our lives together, and for that I am deeply grateful.

When I see you there, having created such a lovely life for yourself, I am overwhelmed with pride. You have done so much in your young life—and overcome even more. I can see how vital it has been for you to tame your anxiety and perfectionism. Your newfound composure will serve you well and empower you to make decisions about how to evolve your work and life in alignment with your interests, passions, and values.

What delights me is the love you have for your work. You take pride in solving problems through engineering. The creativity of your work brings you great satisfaction, especially when your creative ideas are brought

into the world. You don't know it yet, but you have several groundbreaking innovations ahead of you that will help so many. This is your superpower. When you find a problem that matters to you, you are unstoppable. What's most important is that you work on things that you care deeply about and that you're learning and growing as you push the envelope. You will tackle big problems far bigger than you think you're capable of. Your work will impact millions of people around the globe.

It's easy to get complacent as you move into the next phase, and it's also easy to be seduced by money and success. Up until now you've followed the shiny objects that other people have dangled in front of you. But that path won't bring you joy. It will bring you satisfaction and comfort on some level, but it will tax your soul and spirit.

I'm thrilled that you've become aware now of how critical it is to find flow and prioritize joy. Now it's time to pursue what you care deeply about, and as your father always said, quoting Joseph Campbell, "follow your bliss."

You will always be taken care of financially. What there is for you to discover is the work that will feed your soul, now and for decades to come. So long as you're focused on the research and technologies you love, the right opportunities will find you. They will feel daunting, because each new challenge will be bigger than the last, but you have what it takes to rise to meet these challenges.

Over time, your work will evolve so that you can mentor and teach. You've always wanted to return to academia, and you will do that in the future, but not until you've brought a few of these new groundbreaking technologies into the world. When you do teach, it won't

be a full shift. You will keep one foot in the business world so that your research and teaching remain practical and relevant.

One of your greatest gifts is Allen. In him you have found a husband who loves and adores you. Allen is a good man and a remarkable father. He is your constant companion and your biggest fan, and it is with him that you have the support you need to take risks and grow. Take care of your relationship. Nurture it. It's easy to get swept up in your kids' activities and lose touch with each other, but your lives will be so much richer when you take the time you need to stay close and connected.

Your children are so delightful. Enjoy them, especially in the next few years. Before you know it, they'll be on sports teams and at sleepovers and then in high school and driving and then off to college. Your time with them is precious, and they deserve your full attention, so try to be especially present when you're with them.

I know as a mother you worry so much about whether you're doing enough and how you balance your work with spending time with children. There is no way to be a perfect mom. It doesn't exist. You can only be the unique mom you are. You and Allen are an amazing team, and between the two of you, the kids are loved and cared for, and they have what they need to thrive. As they get older, they will recognize you for your passion and success, and though it often took your time and attention away from them, it will inspire them to chart a course in their work life that brings them joy.

Through it all, you must be kind to yourself and take care of yourself physically. You drive yourself so hard, and

you've just learned in the last few years how to be less demanding and self-critical. Do more of that. Find ways to nurture yourself every day. Your life is a marathon and not a sprint. The path of your career is a long one, so take your time. Breathe. Move. Dance. Hike. Get out into nature. Ride your bike.

What matters most, through everything, is that you find joy. Every day. Notice what brings you joy (and more importantly, what doesn't) and seek out new ways to gravitate toward what you love. By doing what you love and staying true to who you are and by being committed to what you care deeply about, you will leave a beautiful legacy. Unexpected and delightful things await you. I promise.

With much love and admiration,
Your Seventy-Year-Old Self

My colleagues and I have heard so many beautiful letters from our clients to themselves over the years, filled with wisdom, encouragement, and insights that bring comfort and guidance. While these letters are powerful, it's even more powerful when our clients feel a visceral sense of the future within their own bodies.

To put them into a receptive state, we use a guided meditation to bring our clients "above the clouds" into a place of high emotional energy (passion, appreciation, freedom, and love), all those joyous emotions at the top part of The Flow Scale. From this higher place we float into the future and step into a future self, living in their highest and best good. Ideally, this is a powerful embodiment that brings great insight and wisdom and creates a future that their system believes to be real and remembers, almost as if it's already happened.

The Orange Books

Chase is an associate professor at one of the premier business schools in the US. His research has been published in, or covered by, leading journals such as *Academy of Management Journal*, *California Management Review*, the *Wall Street Journal*, *BusinessWeek*, and the *Harvard Business Review*. He grew up in Central America and immigrated to the United States with his family when he was ten years old.

Chase sought out coaching to clarify his professional path. In the few weeks before we met, a couple of his most trusted advisors had asked him some variant of the question, "Where do you see yourself in ten years?" Unfortunately, Chase had no answer. He learned from a colleague about the vision work we do and contacted me to see if a vision session would bring him an answer to that elusive, yet important, question.

"I do research and teach about organizational planning and leadership, so you'd think I'd have a clear answer to the ten-year question. But I don't," Chase confessed.

"From what you've told me about your past, I get the sense that you're a man who tends to follow your instincts to have diverse opportunities and varied experiences," I speculated. "Perhaps your future isn't as clear cut and mono-dimensional as that ten-year question implies. Let's go above the clouds and find out."

I took Chase through a guided meditation to bring deep relaxation, turning him inward to notice and release areas of tension or stress in his body. Then I had him begin to float his mind upward toward that place above the clouds, slowly spiraling and climbing higher and higher in emotional energy, leaving any negative feelings, stress, thoughts, and expectations

down below. Once he floated above the clouds, I asked him to tell me, with his eyes closed, what he saw.

"I see mountain peaks. It's like I'm above Mt. Everest. The mountain tops peek out of the clouds, very sharp, pointed and covered with snow. They're surrounded by a sea of white clouds with a bright blue sky underneath."

"Tell me about the quality of the air," I instructed.

"It's clean and fresh," he replied peacefully. "For some reason it reminds me of the air you smell and feel right after a good rainstorm. And there is a little bit of wind, but not too strong."

"Let's take a moment to notice some things you're deeply grateful for."

"I'm grateful for my health," he said almost immediately, "and for my family and their health. I am grateful that I've made it this far after starting out with very little and living a very different life in a different country. I'm grateful for being excited about my life and the work I do, for the intellectual nature of it, and that it's seen by so many people. That makes me feel good, because when I'm in front of large groups and things go well, it's super energizing. I know my work makes a difference and helps people in whatever they're trying to do. It makes me feel like I'm on the cutting edge of knowledge, pushing boundaries in my field. My work forces me to develop, learn, and get outside my comfort zone, so I don't get stale."

"That's lovely," I said with genuine admiration. "Now let's float into the future. Go ahead and let yourself drift forward in time, and go as far as you'd like, stopping at a place where it's useful to see where you've gone and where you can see your path forward from that future perspective."

Chase took a deep breath and sat with that for a second before he continued. "I feel like my work is driven by some sort of magnet that draws me in. It's bigger and stronger than me. It's like a shining light that absorbs and pulls me, rather than me thinking about what I need to do. I see it as a funnel that's wide where I'm standing, but narrows the closer you get to the source of the light."

"What about when you move toward the future?" I asked.

Chase shifted in his chair, as if his body physically wanted to move into a specific direction. Once he settled in, he said, "The future in the funnel is very happy and warm. When I look down I see the planet with lots of people. Everything seems so small and insignificant. I'm in a much more reflective mode in this future. It's not all about accomplishment and striving to get to the next thing. I can't really explain it . . . except to say it's a very reflective, calm, and peaceful state of mind. I'm not constrained. I'm happy and warm. I have a sense of accomplishment, and that's important. Being here in the future is utterly and deliriously happy."

"Imagine floating down and inhabiting yourself in a normal day in the future," I suggested.

"I see myself on the grass, in our backyard having fun with the kids," Chase replied with a smile. "It's a sunny, beautiful day, and I'm energized. I can't tell my age, or the age of the kids, but I'm fairly confident we're about seven years into the future. Interestingly, work doesn't even show up. I assume because I don't have to work."

"Does that make sense within the context of your life?" I asked.

"I have to admit, I'm extremely surprised to find myself there and not in the office. In this future, Chase doesn't appear

to have any thoughts related to his profession," he said with a bit of a chuckle. "I'm also surprised no one is there—except my family. Even when I play soccer, I love to have spectators. I love people in the classroom." Chase thought further about this before he continued. "Impressing the collective has always been very exhilarating to me; I like having my articles read, my citations quoted, reviews of my work, teaching. I even read the evaluations after every session. But now none of that seems important. Validation doesn't seem to make me happy like it used to."

"Let's see if you can go inside to discover what might be going on in your professional life," I whispered. "Can you walk into your office for me?"

"Yes," he replied, reflecting back from the future. "The first thing I would do when I get there . . . I'd sit down and . . . *write*. It's more of a book than the research-oriented writing I did before. Green grass and nature . . . gives me the opportunity to disengage and get excited. It seems like I'm writing for more of a general audience, not for academics. I see a book I've written with an orange cover. I can't make out the title, but the cover is clearly orange. It's right above me on my shelf. Hmm, that's odd."

"What?" I quickly asked.

"I don't see any plaques or awards on the shelf, which were always very important to me. But that's fine, because I get excited when I think about holding that book with the orange cover. Being in the flow and writing from flow seems important now."

"Was there a turning point that got you here?"

"A nudge. I needed to nudge myself to do it," he said slowly. "I don't know if it was a monetary thing or a shift in

my state of mind. All I know is that I gradually became more comfortable with writing. And at some point I just sat down with a clean sheet of paper and typed as many thoughts and ideas as came into my head. I just kept doing that. It became a very easy, enjoyable, organic part of me."

"What about the book? When did it come out?" I wondered out loud.

Chase went even deeper to ascertain this detail. "At this point in my future . . . it's been about six to twelve months since the orange book was published. When I hold it in my hands, it feels extremely real."

"Anything else notable?"

Chase shook his head no. "Not really. Just . . . *simplicity*. I have a lot fewer things in that future than I would have imagined. Maybe they're still there somewhere, but their absence is surprising. I'm not nearly as defined by my work as I used to be. Because even though the work is there, now it seems so natural and emergent—it's almost like an extension of me. I've accumulated so much over my lifetime that I just want to pour it out on paper. It's about . . . writing. Now I see that my bookshelf holds many of my books, every one of them enjoyable to me. And they all have orange in their covers."

"Any insights as to how you got to this future state?"

"No . . ." Chase searched his mind for more elaboration but then only came up with, "But you know what? How I get there is irrelevant, not as critical as I thought when I called you. I see now that it will happen organically, and that I don't need to know *how* the path unfolds. Only that it *will*. And that's enough."

Chase left that day comfortable not knowing much about the details of his ten-year plan. But he felt great knowing that

he would arrive at a place where his writing would flow. And that he'd have not one but many orange books to show for his efforts.

"And now when you're asked where you see yourself in ten years, what will you say?" I asked as he was heading out the door after our session.

Chase smiled warmly. "I'll tell them that I'll be home, playing soccer with my kids in the backyard. And that I'll be the author of half a dozen successful books, proudly displayed on my bookshelf. And that's exactly where I want to be."

Above the Clouds

Now it was Sarah's turn to go above the clouds and float her into her future self. After taking her on a guided meditation, I asked Sarah to look around once she got there and tell me what she saw.

"A blanket of white clouds against a cobalt-blue sky as far as the eye can see. Faint colors of pink, orange, and yellow lie low on the horizon. It's just so open and expansive and beautiful. I just love it up here," she happily exclaimed.

"From this higher place, what insights, if any, do you have about yourself today?" I asked.

"It's incredible to realize how many of the things I worry about are actually insignificant. I look around and see how much I already have: success, accomplishment, and so much love. From here I can't possibly see how I would want anything more."

"What a beautiful insight!" I gave Sarah a couple of seconds longer to enjoy her newfound gratitude. Then I whispered, "Now, let's float slightly up and to the right, drifting into a future place. Just trust that you'll know exactly when to stop."

Sarah sat quietly for about a minute and then said, "Okay, this is good. I think I'm about three or four years out."

"Good. Now float down into a day in your life in that future. Settle into your future self's body, putting your fingers through her finger slots, and your toes through her toe slots, looking through her eyes, and breathing through her lungs. Just settle in there for a minute, and tell me what you notice."

Sarah smiled at the thought of inhabiting Future Sarah. "I'm working in an office. My kids are in school. Both of them! I see them having fun on the playground at the local elementary school while I'm at work. They look so happy, and they love it there." Sarah stopped and wrinkled her brow in curiosity. "But wait, I'm in a different office. There are floor to ceiling windows and beautiful maple furniture. It's super minimalist. I have a vase of fresh, colorful flowers on my desk. And pictures of my family."

"What do you sense about your work or where you are working?" I inquired.

"I have a big white board that covers an entire wall," she explained, "and there are a bunch of schematic designs, sketches of device concepts, and engineering equations. And I sense people in the other adjacent rooms—maybe a dozen or so. I'm the CEO, or maybe the chief technology officer? I feel good about the work we're doing. It's aligned with things that I care deeply about—gender and race equality in healthcare, providing low-cost solutions. It feels like our work is . . . big."

"Really? How big?"

"Global. But I'm not doing all the work alone. I have a really smart and supportive team. And I'm involved with organizations and leaders in the industry who collaborate with us to make our products accessible to everyone." Sarah stopped

for a moment to bask in her vision. "Kate, this feels so amazing," she admitted. "This is what it feels like to experience true joy in my work. The office aesthetics, the light streaming in the windows, the huge white board capturing all our thoughts and ideas. It just feels so . . . *perfect*."

"Tell me about the people around you," I requested. "Are they different from the people you used to interact with?"

"I'm definitely attending global events and invited to the table to solve important global health problems. I'm meeting heads of government, other executives in my industry, economists, public-health experts. It's so exciting! I was kind of intimidated at first to join these events, but many of these people have become friends. And now I feel like I belong."

"Now that you're here, I'm curious what you believe about yourself that you didn't believe before you went above the clouds."

Sarah didn't hesitate on this one. She knew exactly how to answer. "The reason I'm here is to make a huge impact on people's lives. I am an innovator. I invent life-changing products," she declared confidently. "It's the work my team and I do that's made it possible for people with very little means to get the *right* treatment." She paused to let the validity of her own words sink in. "It feels like our company is at the core of a huge global network that makes this possible. Wow, Kate, this feels so rewarding. And it's so much bigger than I ever would've imagined."

"What do you believe about the world now that you may not have believed before?" I gently asked.

"Five years ago it was tough," Sarah reflected. "So many difficult things were happening in the world. But now, from this place in the future, I feel really hopeful. I think technology

has created unity across the globe. People and their ideas are in service of good health. And now well-being spreads freely. We get so much more done through open collaboration than we ever did when the focus was on ownership of intellectual property."

"Looking back, tell me about the path to get here," I instructed. "Was it harder or easier than you thought it would be?"

"Honestly, it feels like it happened all on its own . . . naturally."

"How so?"

"I just kept focused on what I love doing, the important problems I wanted to solve, and the things that bring me joy. I can't really explain it . . . all I know is that I didn't have to search; it all came to me. People. Ideas. Technologies we could use to find solutions. Everything I needed came with relative grace and ease, just as I needed it."

"How do you feel about that?"

Sarah took a deep sigh. "Relief. It takes a lot of pressure off. No more planning, scheming. I don't need to control everything. Now I let things evolve by staying focused. I don't worry so much about whether I'm on the right path. I just keep moving forward in a direction that brings me joy and puts me in flow."

"Any advice for yourself from this perspective?"

Sarah smiled warmly. "Trust," she whispered. "I can trust myself, my instincts. When I operate from this high place, in service of something bigger, everything happens naturally. The right opportunities show up. And I can just . . . enjoy."

I brought Sarah back from her future place above the clouds, into the present. A beautiful, contented smile adorned her face as she opened her eyes.

"Given this vision of your future, what might you do differently when you wake up tomorrow?"

Sarah chuckled. "I was just thinking about what I can do right now to turn that vision into a reality as soon as possible." Suddenly she stopped, almost as if she tripped, but then caught herself before she fell. "No. I'll allow things to evolve in their own way, in their own time. I don't have to push to succeed. I don't need to squander my energy on things that don't matter."

I was so proud of Sarah in that moment. "And what does that look like in the *immediate future*?" I asked.

"I've given that a lot of thought, even before this session," she said poignantly. "I need to find a structure that ensures my time isn't hijacked by tasks that aren't important nor aligned with how I want to spend my time and energy."

"How about this," I offered. "Imagine you come into my office three months from now. Tell me about a breakthrough *then* that's put you on the path toward realizing your vision. What would you have done? How would you know you're where you need to be?"

"Hmm. Three months from now . . ." Sarah thought out loud. "By then I think I would have collaborated with the CEO to create my new role. I'd tell him about my vision of making affordable healthcare products and services. It's funny . . . as I say this to you, ideas are already popping into my head of how to make them available to healthcare providers *today* that lack the infrastructure those products and services require."

"Wow, that's exciting. Do you think you can make that happen in three months?" I eagerly asked.

"Yes, I do," Sarah said firmly. "And I need to. Because if the CEO and board are not willing to shift with me, then that's when I'll know I need to pursue other opportunities, ones that keep me moving toward my vision."

As Sarah left my office that day full of positive energy and possibility, I sat and reflected on our first meeting and how far she had come.

When we met, Sarah was painfully stuck. Her confidence had taken a big hit, and she was struggling to manage the demands of her work while trying to summon the energy and time to be present and engaged with her family. She was living with the false belief that she must work harder than others to be noticed as competent at her job and to have her contributions valued. This drove her to overfunction, to take on too much to prove her abilities, to work to exhaustion, and to forgo, or even reject, recognition, accolades, praise, and appreciation she received. Eager to advance, she was frustrated, or resentful, when others around her were promoted, and yet she didn't feel ready for, or deserving of, taking the next step. Plus, she feared any advancement would negatively impact her family.

This is the complicated inner conflict that we see in so many of the men and women with whom we work.

We are often asked why our focus is on the individual and not on changing corporate culture. The truth is institutional change simply takes too long. In the meantime, challenging workplace dynamics take an emotional, physical, and psychological toll that derails professional potential and achievements. We suffer at societal and organizational levels from the

loss of talent, contribution, leadership, perspective, and experience. But that's nothing compared to *even one person* missing out on a life that is less creative, engaged, accomplished, and satisfying than it could and should be.

What Joshua, Lee, and I want for others is exactly what we saw with Sarah. By first developing self-awareness about her Impostor Behaviors, she resolved them over time and broke free, elevating her confidence and composure. Abolishing her limiting beliefs brought her into transformation to orchestrate the exact life she desired: professional success, and personal fulfillment, along with time and energy to engage with her family.

Imagine that kind of transformation *everywhere*: in our companies, institutions, and society as a whole. The impact when everyone has the tools to develop healthier, more conscious and caring relationships with themselves is massive. With it comes greater fulfillment, the ability to tackle global challenges today and in the future, and the power to leave an important, meaningful legacy.

RESOURCES

Joshua, Lee, and I invite you to embark on your own journey to resolve limiting behaviors and increase self-awareness so you can cultivate greater Composure and elevate your Executive Presence.

We provide many FREE resources to support your journey on our website: www.composurethebook.com.

1. Download our FREE **COMPOSURE Companion Workbook.** This workbook extracts the essential principles, lessons, guidelines, and tips shared in the book and includes writing exercises, links to audio and video guided meditations, and exercises to help you to learn and effectively apply the learnings from the book to your daily life.

2. Create a virtual book club and read the book together with our FREE **COMPOSURE Discussion Guide.**

3. Join us in one of our **FREE Intro Workshops**.

4. Go deeper with our **Live Workshops, Corporate Programs, Courses, and Coaching**.

You might also want to check out some of the books and research we referenced.

Books:

- *Why do So Many Incompetent Men Become Leaders (And How to Fix It)* by Tomas Chamorro-Premuzic

- *Mating in Captivity: Unlocking Erotic Intelligence* by Esther Perel

- *Accidental Genius: Using Writing to Generate Your Best Ideas, Insight, and Content* by Mark Levy

- *WE CAN: The Executive Woman's Guide to Career Advancement* by Robin Toft

- *Trauma and Recovery: The Aftermath of Violence—from Domestic Abuse to Political Terror* by Judith Herman

- *My Grandmother's Hands: Racialized Trauma and the Pathway to Mending Our Hearts and Bodies* by Resmaa Menakem

- *Trauma and Memory: Brain and Body in a Search for the Living Past: A Practical Guide for Understanding and Working with Traumatic Memory* by Peter A. Levine PhD (Author), Bessel A. van der Kolk (Foreword)

- *Acting with Power: Why We Are More Powerful Than We Believe* by Deborah Gruenfeld

- *PEAK: How Great Companies Get Their Mojo from Maslow* by Chip Conley

- *Flow: The Psychology of Optimal Experience* by Mihaly Csikszentmihalyi

- *The Power of Full Engagement: Managing Energy, Not Time, Is the Key to High Performance and Personal Renewal* by Jim Loehr and Tony Schwartz

- *Ask and It Is Given: Learning to Manifest Your Desires* by Esther Hicks and Jerry Hicks

- *Everyday People, Extraordinary Leadership: How to Make a Difference Regardless of Your Title, Role, or Authority* by James M. Kouzes and Barry Z. Posner

Research, Articles, Podcasts, and More:

- *On Being with Krista Tippet*: Mary Catherine Bateson, Living as an Improvisational Art, *https://onbeing. org/programs/mary-catherine-bateson-living-as-an-improvisational-art/*.

- *On Being with Krista Tippet*: Esther Perel, The Erotic Is an Antidote to Death, *https://onbeing.org/programs/ esther-perel-the-erotic-is-an-antidote-to-death/*.

- *On Being with Krista Tippet*: Sandra Cisneros, A House of Her Own, *https://onbeing.org/programs/ sandra-cisneros-a-house-of-her-own/*.

- "Women in the Workplace," McKinsey & Company, Lean In (2019).

- Clance, P. R. & Imes, S. A. (1978), "The imposter phenomenon in high achieving women: Dynamics and therapeutic intervention," *Psychotherapy: Theory, Research & Practice,* 15(3), 241–247, *https://doi.org/10.1037/h0086006*.

- Chamorro-Premuzic, T. (2013, August 22), "Why Do So Many Incompetent Men Become Leaders?" *Harvard Business Review,* *https://hbr.org/2013/08/* *why-do-so-many-incompetent-men.*

- Pelham, Brett & Hetts, John (2001), "Underworked and Overpaid: Elevated Entitlement in Men's Self-Pay," *Journal of Experimental Social Psychology* - J EXP SOC PSYCHOL. 37, 93-103, *https://doi.org/10.1006/jesp.2000.1429.*

- "Does Pay Transparency Close the Gender Pay Gap?" by *Payscale,* *https://www.payscale.com/data/pay-transparency.*

- M. Katherine Weinberg et al., "Effects of Maternal Depression and Panic Disorder on Mother-Infant Interactive Behavior in the Face-to-Face Still-Face Paradigm," *https://www.ncbi.nlm.nih.gov/pmc/articles/* *PMC3125719/.*

- Mischel, Walter and Ebbesen, Ebbe B. (1970), "Attention in Delay of Gratification," *Journal of Personality and Social Psychology* 16 (2): 329–337. doi:10.1037/h0029815. ISSN 0022-3514. S2CID 53464175.

- Gretchen van Steenwyk et al., "Transgenerational inheritance of behavioral and metabolic effects of paternal exposure to traumatic stress in early postnatal life: evidence in the 4th generation," *https://www.ncbi.nlm.nih.gov/pmc/articles/* *PMC6190267/.*

- Alex Liu, "Making Joy a Priority at Work," *https://hbr.org/2019/07/making-joy-a-priority-at-work*.

- Matt Plummer, "How to Spend Way Less Time on Email Every Day," *https://hbr.org/2019/01/how-to-spend-way-less-time-on-email-every-day*.

- Many of the theories and techniques I reference in the book are derived from the excellent training I received in Neuro-Linguistic Programming at NLP Marin, *https://www.nlpmarin.com/*.

ACKNOWLEDGMENTS

Let me first thank Stacy Dymalski, my brilliant story whisperer, editor, and creative partner who guided my writing and who transformed my ugly first drafts into a tight and readable manuscript. Stacy brilliantly captured my voice to bring *Composure* to life and make it significantly more delightful. I am especially indebted to Joshua Isaac Smith, whose unique genius and expertise in trauma, cognitive, and somatic therapy sparked thoughtful and rigorous conversations that created the foundation of principles and practices that underly our work. I am grateful beyond words for Lee Epting, my trusted business partner and dear friend. Lee compassionately unveiled our work to the world through the stories of thousands of men and women globally who attended our workshops and coaching programs. Lee, my sweet friend, thank you. None of this would have happened without you. And to Meta Orear for creating trust in the path and insights that guided us to the highest and best good.

I must also thank my husband, James White, who invites me into nature, on the trails and over the sea, to renew my energy and spark my creative spirit. His love and support feed and sustain me and give me the energy and safety to do what I do. And to my children, Mariah and Cole Driver, I love you both with all of my heart. You inspire me always and share with me a lens into race and privilege that shapes how

we support those who are most likely to experience a lack of safety and belonging in the workplace. Thank you to my parents, Jean and Jerry Purmal, for instilling the belief in me that I could do anything I set my sights on. And to my Grandma Margaret Delila Gundlach and Uncle Del Thomas Gundlach, and to the lineage of gifted creatives that preceded me and inspired me to write.

To our cover designer, Jenn White Topliff, who brought us so many ingenious cover concepts that we struggled to choose; to Katie Mullaly for the interior layout; and to Ali Wright for the workbook and website design. To Drew Tweedy, who contributed to many of the stories and ideas captured within, and to Keith Hollihan for jump-starting this book. To Harpal Dhatt for her collaboration on the assessment and our foundational research. To Carl Buchheit, Michelle Masters, and Carla Camou at NLP Marin, who taught me many of the transformational practices we built upon to create our programs.

And finally, to our clients who were so generous and vulnerable in sharing their experiences and inspiring us through their transformation.

ABOUT THE AUTHORS

In addition to being a sought-after executive coach, **Kate Purmal** is an independent corporate board director, speaker, and serial entrepreneur. A senior fellow at Georgetown University, she has over fifteen years of experience working as a CEO, COO, and CFO to start-ups and privately-held technology and life sciences companies. As a result of her vast experience in technology and corporate America, Kate is a passionate advocate for diversity at the highest levels of business. She has spent decades as an executive coach, bringing out brilliance in leaders and their teams, personally coaching more than one hundred global CEOs and executives in dozens of industries. She is a frequent guest lecturer at leading business schools, including University of Michigan Ross School of Business, Stanford Graduate School of Business, the McDonough School of Business at Georgetown University,

and Kathmandu University School of Management in Nepal. Voted one of *San Jose Business Journal*'s Most Influential Women in Business, she's also won two DEMOgod awards, been named to the Top 25 Women Redefining Success, and has been profiled in the *Wall Street Journal*, *USA Today*, *New York Times*, *Inc. Magazine*, *Working Mother*, *Working Woman*, and the *San Jose Business Journal*. *Composure* is her second book. She is coauthor of *The Moonshot Effect: Disrupting Business as Usual*.

Kate has two grown children and lives in San Diego with her husband, James, and their German Wirehaired Pointer, Lucy, and red Standard Poodle, Chancellor.

Lee Epting has spent over thirty years building high-performance teams and delivering market-winning technology products for the US, Western Europe, and emerging and global markets. She previously ran multibillion dollar P&Ls for some business units in the world's largest technology, mobile communications, and mobile phone manufacturing companies: Samsung, Vodafone, and Nokia.

Throughout her career, Lee has leveraged her access to the world stage to spearhead projects that ensure underserved populations have access to mobile technology in emerging markets.

Recently Lee turned her focus and talent to provide leadership coaching and development for corporate executives and entrepreneurs. She shares her knowledge and experience in leading high performance teams to deliver projects that go beyond "business as usual."

Lee has a college-age son and lives in Venice, Florida, with her husband, Ciro, and their Norfolk Terrier, Ruby.

Joshua Isaac Smith is a trauma therapist and behavioral specialist focusing on neuroscience-informed approaches to mindfulness, leadership, and resilience. He coaches executives and teams globally and leads courses in resilience, leadership, agile team building, and mindfulness in trauma therapy. He is a Leadership Fellow and co-facilitator of Leadership Conversations at St. George's House, College of St. George, Windsor Castle, and was formerly Assistant Director of the EMDR Centre London.

Joshua is the innovator behind "Yogaboxing," which combined his many techniques including EMDR, biomechanics, yoga, chi gong, and African dance into short and uplifting fitness workouts.

As a former technology entrepreneur, Joshua was once CEO of a telecommunications company based in southern California before selling and retiring at thirty-two. He has been seen by an estimated 10 million people on CBS news, ITV, Channel 4, and Living TV and has been a radio guest on numerous occasions, including the BBC and LBC. His work has been featured or mentioned in top print media including the *Sunday Times*, *South China Post*, *Health & Fitness*, *Shape*, *Marie Claire*, *Evening Standard*, *Daily Mail*, and *Metro*.